ASSIGNMENT SHANGHAI

SERIES IN CONTEMPORARY PHOTOGRAPHY
CENTER FOR PHOTOGRAPHY
GRADUATE SCHOOL OF JOURNALISM
University of California, Berkeley

KEN LIGHT, Editor

Chicago's South Side, 1946–1948,
by Wayne F. Miller

Assignment: Shanghai
Photographs on the Eve of Revolution,
photographs by Jack Birns,
edited by Carolyn Wakeman and Ken Light

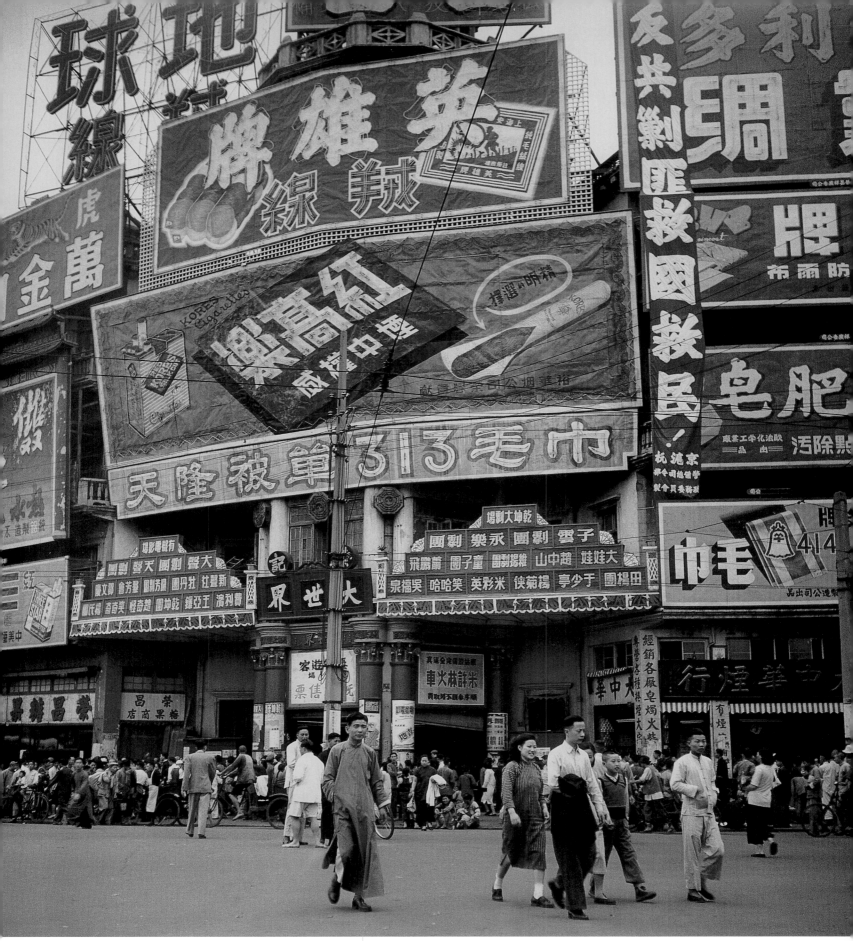

ASSIGNMENT **SHANGHAI**

PHOTOGRAPHS ON THE EVE OF REVOLUTION

University of California Press Berkeley Los Angeles London

Published in association with the
Graduate School of Journalism, Center for Photography,
University of California, Berkeley

Photographs by Jack Birns

Edited by CAROLYN WAKEMAN and KEN LIGHT
Foreword by ORVILLE SCHELL

University of California Press
Berkeley and Los Angeles, California

University of California Press, Ltd.
London, England

Library of Congress Cataloging-in-Publication Data

Birns, Jack, 1919–
 Assignment: Shanghai : photographs on the eve of revolution /
photographs by Jack Birns ; edited by Carolyn Wakeman and Ken
Light ; foreword by Orville Schell.
 p. cm. — (Series in contemporary photography ; 2)
 ISBN 0-520-23990-3 (alk. paper)
 I. Shanghai (China)—History—Pictorial works. 2. Shanghai
(China)—History. 3. China—History—Civil War, 1945–1949.
I. Title. II. Series.
DS796.S257 B57 2003
951.04′2—dc21
 2003005036

Manufactured in Italy

12 11 10 09 08 07 06 05 04 03
10 9 8 7 6 5 4 3 2 1

The paper used in this publication meets the minimum require-
ments of ANSI/NISO Z39.48-1992 (R 1997) *(Permanence of
Paper).*

EDITORS' ACKNOWLEDGMENTS

This book was made possible through the effort and support of many
colleagues. We especially thank Harriet and Jack Birns for wel-
coming us to their home and patiently answering our many ques-
tions during this long process. Roy Rowan's journalistic eye and
keen memory helped identify photographs taken half a century ago.
Tom Engelhardt offered his discerning editorial judgment. Mielikki
Org contributed skilled research assistance. Leslie Sheryll of Kelton
Labs helped make new prints from old and important negatives. The
talented editorial, design, and production staff at University of Cal-
ifornia Press—James H. Clark, Sheila Levine, Rose Vekony, Nola
Burger, and Anthony Crouch—guided and supported our efforts.
Without the assistance of Kathi Doak at Time, Inc., and the expert
counsel of Penny Hays, who provided access to picture files and
original negatives, this book could not have happened. As always,
our thanks go to Susie Tompkins Buell for generously supporting
the Center for Photography at the Graduate School of Journalism
and this publication. And, finally, to Melanie Light and Robert Tier-
ney, whose patience and wise advice make doing projects like this
a little easier.

TITLE PAGE PHOTOGRAPH A banner hanging outside the Great
World Entertainment Center declares: "Oppose the Communists,
Destroy the Bandits, Save the Nation, Save the People." Shanghai,
January 1948.

CONTENTS

ORVILLE SCHELL

AS IF PRINTED FROM A SHORT SERIES OF FRAMES snipped out of the middle of a much longer documentary film, these images by *Life* photographer Jack Birns freeze a moment of China's history, providing us with a graphic glimpse of a great city, Shanghai, poised on the precipice of political revolution in the late 1940s.

The photographs in this book are part of a school of popular black-and-white documentary photography that reached a crescendo in *Life* magazine during the middle of the last century. Its practitioners included Dorothea Lange, Henri Cartier-Bresson, Margaret Bourke-White, Wayne Miller, Carl Mydans, Inge Morath, and Cornell and Robert Capa. They merged a gritty, current-affairs realism with a keen eye and fine sense of composition to bring the far-flung world into the homes of Americans, not yet numbed by the glut of televised images that would soon follow.

In this era before magazine publishing became a kaleidoscope of niched offerings, *Life* not only cultivated and sustained a group of the greatest photographers of the period, and perhaps even of American history, but also teamed them up on collaborative projects with equally great writers, such as John Hersey, Theodore H. White, and John Steinbeck. While it is true that these projects—and the so-called "halcyon days" of journalism they represented—were the product of the stern censorate of Henry R. Luce's Time-Life-Fortune empire (and all that it stood for politically), the journalists Luce hired nonetheless achieved a unique, often extraordinary, corpus of work under his tutelage.

Among *Life*'s most accomplished photographers was Jack Birns, whose China negatives lay undisturbed in Time-Life's archive for half a century. Many show everyday scenes and ordinary people: workers, beggars, police, prostitutes, soldiers, politicians, and refugees. Others record the upheaval of China's civil war. Exhumed now and seen through the lens of more

than fifty years of hindsight, they acquire new meaning that only history can confer. They give us a sense not only of what Shanghai was like fifty years ago but also of why the warfare, poverty, corruption, decadence, and chaos of the time proved such fertile soil for the Chinese Communist Party.

Equally important, these photographs serve as a reminder of the turbulent and contradictory century through which China has just progressed. Indeed, Shanghai itself has embraced four identities so distinct that were it not for a few enduring physical landmarks that provide some sense of continuity, it would be hard for an outsider to understand these phases as logical chapters in one urban narrative.

At the end of the nineteenth century, China, known as the "sick man of Asia," was an atomized and defenseless land preyed upon by almost every "great power." Shanghai was then an insignificant rural backwater on a tributary of the Yangzi River. Yet by the 1920s Shanghai was well on the way to becoming one of the busiest ports in the Far East and an epicenter of cosmopolitan culture, commerce, and politics.

In 1949 Shanghai was transfigured once again, this time with jolting completeness, into an isolated citadel of Spartan proletarian self-reliance, part of China's defiant and proud revolution that interrupted the momentum of capitalist development. Mao Zedong envisioned the city flourishing instead as a workers' bastion under the tonic ideology of communism.

Then, under Deng Xiaoping in 1978, China precipitously changed course again. Shanghai began to abandon its revolutionary Maoist identity, open up to the outside world, and embrace a new if cryptic form of global Leninist capitalism.

During each of these reincarnations, the city of Shanghai changed its character in radical ways. The *Life* photographs of Jack Birns catch it on the cusp of one of these tectonic transformations, poised to be refashioned from a quasi-colonial entrepôt of trade, culture, and intrigue into a model of proletarian revolution.

This rich trove of photos stands as a monument to a dramatic moment in Shanghai's history, to an era of distinctive American journalism, and to a fine photographer. But it also stands as a monument to the changeability that has been so evident in China during the last century. The city's shifting identity casts an uncertain historical shadow across the future. If China's economic growth continues, Shanghai may finally reestablish itself as a great cosmopolitan center. But if prosperity and stability prove elusive, Shanghai's latest burst of modernity may someday seem yet another failed start, its grandeur as disconnected and out of time as that of the city Jack Birns experienced and depicted on the eve of revolution.

JACK BIRNS

IN 1946 I STARTED WORKING IN LOS ANGELES as a freelance assignment photographer, shooting anything that came my way. *Life* sometimes used young freelancers on minor stories that the highly regarded staff would disdain. I was hungry, and I worked hard. After six months I set a freelance record and then happily accepted the offer of a China job, though not without worry. The possibility of failing on a major foreign assignment was a gut-wrenching thought, and I expressed my fears to *Life*'s Los Angeles bureau chief Jack Beardwood. "If *Life* didn't think you could handle it, they wouldn't have picked you," he said. In the pit of my stomach, a small voice still jibed, "OK, smart guy, do you think you're up to it?"

Only after settling in Shanghai did I learn that my beat included not just the hot news of China's civil war, with Nationalist soldiers retreating on every front, but also the story of uprisings in half a dozen countries in Southeast Asia. With correspondent Roy Rowan, *Life*'s Shanghai bureau chief, I covered it all. What drove us was the prospect of an exclusive story, a "scoop" that beat all media competition in the area and, even better, beat the other *Life* staffers jostling for space in the magazine. Our personal drive for excellence gave Rowan and me the coveted news lead position for each of the Southeast Asian countries we visited.

The China of fifty years ago was a tough place to report, especially if you couldn't speak the language. The telephones didn't work, and on the rare occasions when you finally made a connection, you often couldn't hear the other party. All communications went through translators, who sometimes took it upon themselves to alter both the questions and the answers. And no matter how well educated or well meaning, the translators had no sense of what made news or how Americans reacted to news, nor did they understand the urgency of handling breaking stories. But somehow the hardships, constant danger, and separation from my young wife and first child became secondary to the exhilaration of documenting the news.

The days were long, from sunup to midnight. The food was catch-as-catch-can, sometimes just baked sweet potatoes hot from a street vendor's portable iron fire. The travel was hard, and we relied on U.S. Air Force war-surplus C-46 and C-47 cargo planes flown by ex-servicemen with whimsical attitudes and hair-raising flying habits. One pilot bragged that he flew better drunk than sober and always got loaded before flying. Cargo planes were basically flying trucks, and we sat on sacks of white flour, bags of mail, or wooden boxes holding a thousand belts of .30 caliber machine gun bullets. But the journalistic result was worth every bit of exertion. For the years 1948 and 1949, the team of Birns and Rowan held the record for the most pictures and pages published in the magazine.

China was also tough on cameras. Subzero temperatures in Manchuria and stifling humidity in central and south China wreaked havoc on equipment, which could not easily be fixed. One European stateless person in Shanghai knew how to take a camera apart and put it together, but he had no experience with professional models like my Rolleiflex and Contax. I could only pray that the equipment would hold together during thousands of exposures in the most extreme weather conditions, knowing that I was for a long while the lone cameraman for a U.S. publication in China, with the awesome responsibility for news coverage of all Southeast Asia. I realized I had to serve as the photo eyes for all Americans.

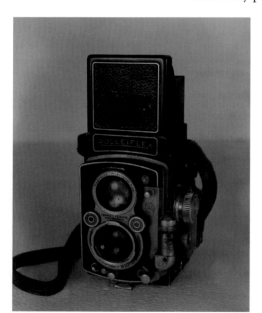

Birns's Rolleiflex. 1947.

Most of the images in this book were not made on direct assignment, nor were they ever published. *Life* editors made no comment in turning down my stories. My goal was to record the grim daily lives of a people who had endured a half century of warfare, from the Boxer Rebellion in 1900 to the civil war in 1947, but these everyday scenes were simply not considered newsworthy. I was irked that my photographs weren't published, but the view from Rockefeller Center was different from my view in Shanghai. I figured it was their magazine. I got to take the pictures, and they got to choose.

One story that I covered with correspondent Roy Rowan showed a sad but determined group of cotton thieves along the Bund, Shanghai's waterfront. These were unfortunate, uneducated refugees from the countryside who had fled to the city in search of work. I watched some forty men, women, and children descend on a $20 million shipment of U.S. cotton donated to China by the U.N. to clothe the country's poor. The crowd ripped open the bales and tore away tufts of raw cotton to sell for pennies to unscrupulous cotton merchants. The government got the rest and carted it off, but very little relief cotton ever reached the interior. The story showed the arrest of a peasant woman and the frisking of another young woman by a stony-faced cop. These photos, more about daily lives than political events, didn't make the magazine.

A photographer doesn't have the luxury of sympathy while shooting a story, but many images stayed etched in my mind. When I photographed a charity crew collecting the corpses of children from hospitals and city streets, I felt a heavy sadness. When I covered mindless street

executions, I felt not just anger and revulsion but also nausea. Afterward, with the three miscreants sprawled grotesquely on the dirt lane and the sullen mob melting away, Rowan and I sought out a bar and each slugged down two double Scotches, which only made my stomach feel worse.

At other moments I felt fear, the kind that clutches your heart so hard you can't breathe. At 2:39 A.M. on May 17, 1949, I was on the last of seven U.S.-piloted cargo aircraft trying to escape from Shanghai's Longhua military airport. If the Communist mortar crew managed to plop a shell into the lead plane, or directly ahead of it on the runway, we would all perish in a grinding crash of metal and fire. Happily, the Reds didn't bring their weapons around quickly enough, and we took off safely. But it was a terrible way to leave China.

In a war you can only cover one side, but during those eventful months, I favored neither the Nationalists nor the Communists. I could see that the long-suffering Chinese were ill served by both sets of leaders, and I felt great sympathy for the ordinary people. At the time I had no idea that my photographic coverage of China's civil war would someday offer a stark pictorial record of a turning point in history.

Many of these pictures have never been seen before. I hope they will speak to the viewer today.

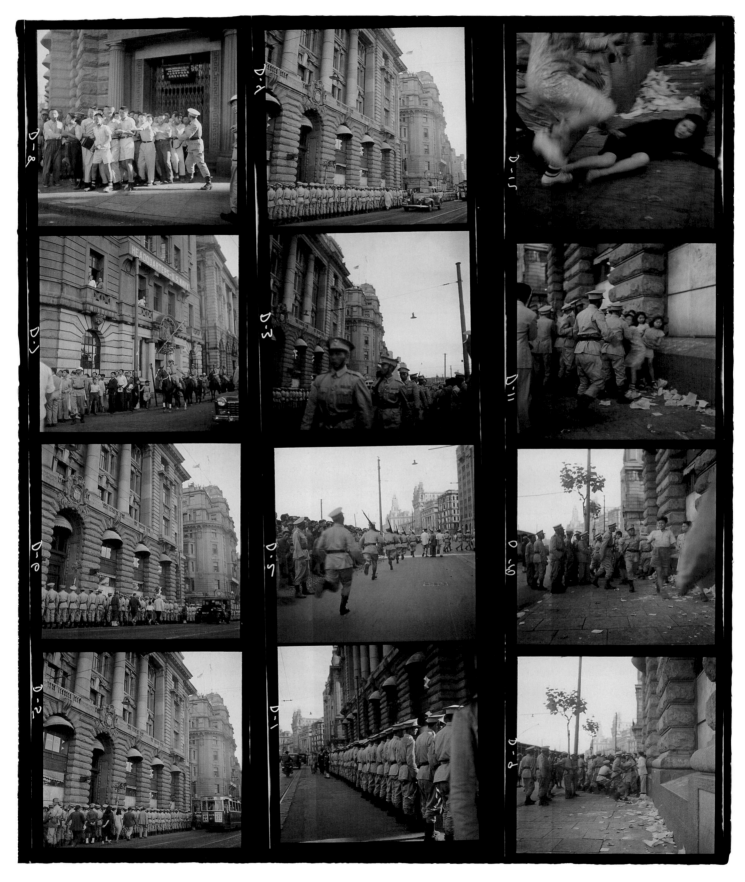

Student demonstrations (contact sheet).
Shanghai, June 1948.

CAROLYN WAKEMAN

NEWLY ASSIGNED BY *LIFE* MAGAZINE to report on China's expanding civil war, Jack Birns wondered whether he could succeed as a foreign correspondent. At twenty-eight, he had never traveled abroad and knew no one with firsthand China experience. Shanghai seemed remote and vaguely threatening, a place where people "talked funny, ate funny, and preyed on foreigners," he would later write in an unpublished manuscript. Before boarding the battered troop transport USS *Marine Adder* for a stormy three-week Pacific crossing, he packed a Smith & Wesson .38 police revolver in his footlocker. But Birns had worked hard to break into *Life's* elite circle of staff photographers. Settled into a suite in Shanghai's Broadway Mansions Hotel on December 15, 1947, he looked out across the nighttime cityscape and vowed to cover China as it had never been covered before.

After more than a year hustling as a freelancer in Los Angeles, working nights and weekends to shoot Hollywood stories for magazines like the *Saturday Evening Post, Colliers, Redbook, Time,* and *Fortune,* Birns landed his first assignment for *Life* in February 1947. Six months later he set a freelance record of thirty pages in the magazine, as well as a cover photo. Managing editor Wilson Hicks, spotting Birns's ability and drive, called him to New York to offer a prestigious foreign assignment. "We have lots of essayists, Jack," he said, "but you're a news photographer, and we'd like to send you to China. We need a guy who can get in quickly, get out fast, and get film back to us in a hurry."

With a circulation topping five million copies in the late 1940s, *Life* served as the prime-time news of its era, the visual source of politics and history. The wildly popular pictorial weekly supplied Americans with the most influential images of the pre-television age. Gritty photographs of war and insurrection ran alongside glimpses of European royalty or villagers

in exotic lands to give the look and feel of the world. Tantalizing shots of life closer to home fed readers' curiosity with pictures of celebrities and crime, oddities and customs—from Betty Grable's allure to a tornado in Kansas or the life cycle of the black widow spider. "To see life; to see the world; to eyewitness great events; to watch the faces of the poor and the gestures of the proud; to see strange things—machines, armies, multitudes, shadows in the jungle and on the moon": such were the magazine's exuberant goals. From its launch in 1936, *Life* grabbed an ambitious and talented staff.

Crusading publisher Henry R. Luce had already built a powerful media empire with *Time, Fortune,* and the weekly newsreel "March of Time." *Life* was his newest venture, and it pioneered a bold magazine format that interspersed amusing, sometimes shocking, photographs among serious current events stories and long picture essays. It also blended news with editorial comment to spread the conservative, chauvinistic values of Time, Inc. To define his vision of "an American century," Luce chose a *Life* editorial in February 1941 as his vehicle. His stirring words urged Americans "to accept wholeheartedly our duty and our opportunity as the most powerful and vital nation in the world and in consequence to exert upon the world the full impact of our influence, for such purposes as we see fit and by such means as we see fit." The place where American influence should be most fully exerted in the postwar era, Luce felt, was China, where he was born and raised, the son of Presbyterian missionaries.

A devout Christian and staunch Republican, Luce placed Nationalist leader Chiang Kai-shek's picture seven times on the cover of *Time* magazine. If given sufficient help, Luce believed, America's World War II ally would not only safeguard China's destiny but stem the spread of Communism in Asia. Not all the reporters Luce dispatched to China reached the same conclusions. After Theodore White, *Time*'s Far Eastern editor, filed reports documenting Nationalist repression and corruption, the squandering of Chiang's popular support, and the siphoning off of American aid by Nationalist officials, Luce recalled his long-favored correspondent to New York. A long picture essay called "A Report to the American People on China" (October 13, 1947) defined Time-Life's message about China's plight. The caption accompanying a shot of war-weary Nationalist soldiers editorialized: "Unless we help, China's weakened armies will fail, and the country will fall to the Russians." Two months later Chinese ambassador Wellington Koo bestowed on Henry Luce the Special Cravat of the Order of the Auspicious Star, honoring the Nationalists' most influential American advocate. That same month Jack Birns arrived in Shanghai to photograph China's epic struggle.

Based on the West Coast, Birns had never been involved with the politics emanating from Time-Life's New York office, nor did he ever meet Henry Luce. He approached his China assignment as a professional opportunity rather than a political cause. "I was a rookie, and this was my big chance," Birns would recall half a century later. "*Life* was the news center. When *Life* arrived at the news kiosks, people grabbed those magazines, so for a photographer, getting into *Life* was the ambition, the dream." Birns understood that Luce "never wanted to show China in a bad light," but he resolved to photograph what he saw and describe what he knew. He worried far more about competing for space in the magazine than about how the Luce press presented the China story.

On his first morning in Shanghai, Birns plunged into the teeming streets of Asia's most cosmopolitan city in search of a story. What struck him immediately was how the wealth and comfort of the foreign-administered International Settlement and French Concession, where residents from many countries enjoyed immunity from local laws, collided with the misery of the Chinese city. The imposing facades of the foreign banks and trading companies lining the waterfront Bund; the fashionable hotels with their elegant foyers, rooftop restaurants, and jazz clubs; the glittering shopping arcades and art deco department stores stocking silks, furs, and caviar exuded the fabled glamour of the "Paris of the Orient." But what drew his eye were the women in rags trailing pedicabs that carried stylishly dressed passengers, the transport coolies straining to haul backbreaking loads, the sidewalk vendors hawking cheap household goods, and the destitute refugees living in shacks along the muddy banks of the Huangpu River. What he set out to convey was the human drama unfolding as civil war pressed closer to China's financial, cultural, and commercial capital.

The ruling Nationalist Party had been battling the Communist threat for two decades, ever since Chiang Kai-shek, backed by wealthy Chinese industrialists, foreign capitalists, and underworld racketeers, launched a bloody attack on Shanghai's striking workers in 1927. After embattled Communists withdrew to establish a base in the mountains of southern Jiangxi province, Chiang determined to eradicate the remaining opposition. Even when Japan occupied Manchuria in 1931 and bombed a densely populated Shanghai district the following year, Chiang refused to commit his full military resources to counter the foreign aggression. The Japanese were a disease of the skin, he famously remarked, while the Communists were a disease of the bones.

In 1934, squeezed by a series of "bandit suppression campaigns," the Communists fled Nationalist encirclement and embarked on what became known as the Long March. More than a year later, having crossed six thousand miles of punishing terrain, the survivors, led by Mao Zedong, established a guerrilla headquarters in China's remote northwestern loess hills. Although full-scale war with Japan in 1937 briefly united the rival Chinese armies under the banner of national salvation, the Nationalists and Communists never reconciled. In 1945 both sides rushed troops to claim weapons and territory after Japan's surrender, dangerously escalating the conflict. President Harry S. Truman, fearing civil war in China, sent General George C. Marshall to help shape a coalition government, but the fragile truce agreement soon broke down. With unexpected speed Communist commanders extended their control beyond the scattered rural base areas where land reform and political education had already enlisted support for revolution. When Birns reached China late in 1947, the Nationalists maintained control of the major cities, but the momentum of civil war had shifted to favor the Communists.

Shanghai showcased the Nationalists' dilemma. The government's ongoing reliance on newly minted paper currency to meet spiraling costs spiked runaway inflation, threatening both the accumulated fortunes of the extravagantly rich and the livelihood of the working class. Flagrant graft and embezzlement eroded the government's credibility even among the business

elite, which found its commercial profits appropriated to replenish government coffers. Meanwhile desperate refugees fled the countryside at a rate estimated at six thousand a day, swelling the ranks of the urban unemployed in a city whose population suddenly approached five million.

For a freshly arrived English-speaking photographer, the progress of the war was hard to fathom. The local Time-Life staff routinely combed the Chinese press for clues to military developments, but releases from the government's Central News Agency were notoriously unreliable. Birns sought information from many sources. On Saturday nights he frequented the Correspondents' Club, on the seventeenth floor of the Broadway Mansions, to dance

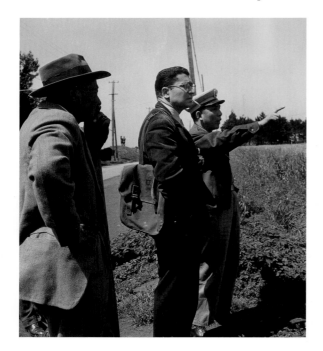

with his wife and mingle with a colorful assortment of U.S. military personnel, Nationalist officials, Russian agents posing as journalists, and freewheeling American commercial pilots. There he swapped rumors and listened for leads, but the only way to find out what was happening in the conflict deciding China's future was to hitch rides on U.S. war-surplus cargo planes for a firsthand look.

In March 1948 *Life* linked Birns up with Roy Rowan, a veteran of the United Nations Relief and Rehabilitation Administration's China mission. Rowan had journalistic talent, a lively sense of humor, and a keen eye for detail. Dropping in at Shanghai's Longhua military airport, the *Life* reporters grew chummy with American pilots flying for China's Civil Air Transport, run by Chiang Kai-shek's friend and adviser General Claire Chennault. Veterans of Chennault's famous "Flying Tiger" squadron handled the crucial airlift of supplies and ammunition to cities isolated by the Communist advance, and Rowan later described how he and Birns would "hopscotch to remote air-

Birns surveys Shanghai's defenses. May 1949.

strips all over China, looking for action." Sometimes they heard rumors about heavy skirmishing that had never occurred; other times they chanced upon unreported battles that had already finished. Most of their trips turned out to be wild goose chases, Rowan noted, but occasionally their "aerial barnstorming" paid off.

Life's New York editors initially kept close tabs on their inexperienced China team, firing off several cables a week. "At first they were very specific about what to write, but then they left us pretty much alone," Birns recalled in an interview. "All they would do is tell us, 'Maybe it's time to take a look at Taiwan,' but they never told us how to shoot anything." Expanding their beat far beyond China, Birns and Rowan chased down stories from around Southeast Asia to cover a region that sprawled from Manila to Bombay. They caught hazardous last-minute cargo flights to report on insurrections, piracy, smuggling, and currency scandals in Malaya, Thailand, the Philippines, India, Burma, Macao, and Hong Kong. *Life* gave those special reports prominent play. Hard-driving stories, like the harrowing account of a British-led Communist-extermination raid in Malaya in July 1948 that kept Birns trapped in a drainage ditch under heavy cross fire, earned the *Life* team a reputation not only for their astute news sense and timely, nimble coverage but also for their daring.

Over seventeen months Birns logged some ninety thousand air miles, covered five wars, and shot nearly three thousand rolls of film. He supplied more pictures to the magazine over two years than any of the other thirty-seven staff photographers, and his breaking stories created startling headlines, sometimes with riveting images of still-unfolding events halfway around the world. His distinguished contribution to *Life*'s Asia coverage won him the Overseas Press Club of America's 1948 award for "the best picture reporting from abroad, judged from its interpretative quality on foreign affairs." *Life*'s editors sent him a string of laudatory telegrams, and the magazine ran a letter of congratulations praising Birns's accomplishment. Daniel Longwell, head of *Life*'s editorial board, sent an additional message to Birns, who missed the ceremony while reporting in Burma, to express personal pride in the award: "I believe this dinner was the first time that my belief in the camera as the equal of any kind of journalism has been so thoroughly justified." But despite such acclaim, many of Birns's most evocative China photographs and several of his important news scoops failed to make the magazine.

Eager to show China's misery up close during his first month in Shanghai, Birns filed a rapid sequence of picture articles that the New York editors ignored. One early story tried for a "holiday angle" as Christmas approached, with Birns following a three-wheeled bicycle cart that was collecting the bodies of indigent children who had died of illness, starvation, or exposure. During the festive holiday season, he wrote in an accompanying letter, Americans should know that a rickety charity truck in Shanghai was carrying more than seventy small, stiffened corpses in collective coffins to a cremation field on the western edge of the city.

Next Birns documented Shanghai's refugee crisis in a series of photos showing impoverished families seeking temporary shelter in a mortuary and coffinmaker's workshop. Fearing eviction, the squatters at first reacted angrily to the arrival of foreign reporters. Interpreter Betty Li fainted when the encounter grew threatening, and Birns removed his flash attachment, "ready to bash some heads." The *Life* group left quickly in the bureau's Ford sedan, prepared to abandon the story, but the next day several of the squatters, alerted to *Life*'s political influence, appeared at the office to plead with the reporters for a second visit. When Birns returned, they posed obligingly for his camera, allowing him to capture poignant shots of the refugee families. That series, titled "Living with the Dead," also didn't run.

For a follow-up story, called "Winter Shelters for the Destitute," Birns photographed Shanghai's mayor, K. C. Wu, visiting a center for the homeless. "To stay on good terms with the Mayor's office and to get some shots which might round out the mortuary squatters story, we shot this additional stuff," he wrote to Dorothy Hoover at the New York office, alerting her that the scene had probably been staged. "The people pictured at these shelters were not there yesterday; they were picked up from somewhere else and brought to the shelter, it seems to me, for the purpose of picture taking only." But again the editors didn't bite. From Birns's first month of work they chose only his candid photographs of General Chennault's Shanghai honeymoon, shot on assignment, highlighting one as Picture of the Week (January 19, 1948).

Trying for an upbeat feature story, Birns offered a panorama of the city's billboards to illustrate Shanghai's vibrant Westernized commercial culture. The Americanization of billboard

advertising might work as a news peg, he wrote to Hoover, noting how ads for soap and cigarettes promoted Hollywood stars like Lana Turner and Rita Hayworth, bringing sexual overtones into mass commercial appeals. Those pictures also failed to run, and Birns later described his frustrating first weeks as a time to "get his feet wet." But even after he figured out that the New York editors saw no news interest in images of everyday life and human misery, he continued to file what he described as "forthright, unhappy stories about beggars, and cotton thieves, and dead baby collectors that tear at one's heart, [because] they are the reasons why the peasants and the poor listened to the voices of Communist agents and were desperate to believe."

In late January 1948 *Life* editors sent Birns to Mukden, the capital of mineral-rich Manchuria and a vital link in the Nationalists' defense, for his first assignment from a war zone. At first he could find "only peaceful, pastoral scenes rather than war," he wrote to foreign editor G. W. Churchill, but then at the U.S. consulate, looking for leads, he got what he called "a story-saving break." Major John K. Singlaub, who headed intelligence-gathering efforts in Manchuria for the U.S. Navy's External Survey Detachment (a precursor of the CIA), offered his jeep and English-speaking driver. Suddenly Birns had the chance for an exclusive story on the defense of Mukden.

Given access to prisoners held in a military compound, he photographed everything he was shown, relying on his interpreter for explanations. A dozen women standing awkwardly in bulky, padded coats were identified as "comfort girls" used by the Communists, and two men at a table reading back issues of *Life* magazine upside down were said to be undergoing re-education. Birns thought the men looked posed, but he had no way to verify the details. By then Singlaub had "made some calls to the Chinese Nationalist military to stage winter maneuvers for my camera," Birns later wrote. Recognizing an opportunity to launch his career, he struggled with frozen cameras in the bitter cold and shot starkly compelling pictures of soldiers silhouetted against wintry fields or crouching beside cannon emplacements in knee-deep snow. The story got bumped at the last minute by a feature on Nelson A. Rockefeller's wedding, but four pages of Birns's Mukden pictures ran several weeks later (March 15, 1948). The caption accompanying his photograph of infantry marching across a bleak Manchurian landscape gave no clue that the scene had been arranged for the *Life* photographer. "These men, trained in Burma's hot jungles under General Stilwell, are fighting to save the few strongholds Nationalists have left in Manchuria," read the text.

Not long after returning from Mukden, Birns noticed in the English-language *Shanghai Evening Post and Mercury* that government troops had just prevailed in a skirmish with a Communist unit about thirty-five miles south of Shanghai. Hoping for vivid pictures of a Nationalist victory, he grabbed his camera bag and called for his driver. They careened over rutted roads to reach the town of Songjiang, where the local prison commandant, seeing their *Life* credentials, allowed Birns to photograph a pile of captured weapons and more than thirty prisoners. Birns then pressed to see the enemy's leader. The world should know the full story of how Nationalist soldiers had bravely fought the Communist bandits, he insisted, and

when his flattery prevailed, Birns got access to the scene of the attack. On a riverbank beyond the village wall, he confronted a dozen bodies trussed and disemboweled, along with the dripping head of Communist commander Ding Xishan (Ting Hsi-shan), recently hacked from his body. The bloody mass dangled at the knees of a prison guard about to nail it to the wall as Birns, told that Ding had collaborated with the Japanese, quickly filmed the grisly scene from two directions. (Local histories offer further details that explain Ding's brutal treatment: after the war he rose in the officers' ranks of the Nationalist militia and served in the Nationalist paramilitary police, but when assigned to the Songjiang garrison force he secretly started to work for the Communists.)

Knowing he had a scoop, Birns rushed the film to New York, and foreign editor Churchill sent a return cable saying, "That was real shooting. Ting in for Picture of the Week." Managing editor Edward K. Thompson laid out the gruesome images for two and a half pages, but Luce was enraged. "Pull that damn picture," he yelled, immediately killing the story. That same week the publisher lunched with China's ambassador and renewed his pledge of unwavering support for Chiang Kai-shek's struggle. "It was the only known atrocity of the war," Birns later wrote, "but publisher Luce angrily refused to run it, and the Ting story languished in *Life*'s files for half a century." In 1998 the magazine finally featured the pictures showing Nationalist brutality.

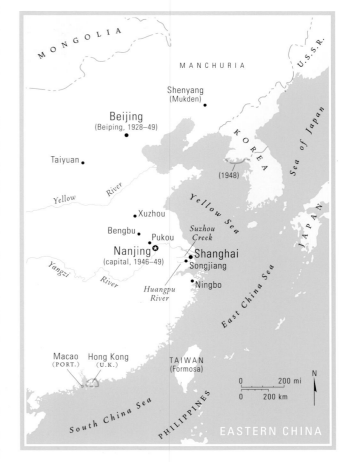

Birns also covered spreading unrest in Shanghai. On January 31, 1948, a riot broke out when taxi dancers and nightclub owners converged on the Bureau of Social Affairs. Having received a phone call from the mayor's office with a "hot tip," Birns was the only journalist on the scene. A hike in licensing fees levied on the women who danced for a price with patrons of the city's cabarets had set off the third riot in two weeks, he wrote to Churchill. The demonstrators, peaceful at first, carried banners declaring, "Now there are only two ways for us: the waiters starve, the girls sacrifice." Then "all hell broke loose," Birns reported. Calling his story a "lucky break," he filed a vivid description of the scene: "people started to beat up police, police beat up people, and the mob of several thousand then took the Bureau of Social Affairs apart. Glass flew in all directions, furniture sailed out windows, people were cut by glass…. I think there are enough good pictures of a spontaneous, ugly riot to make a pretty good spread." The light was bad, Birns told his editors, and he had to raise his camera over his head to get above the mob, so "Lord only knows what is on the film." Two days later he rushed to cover a strike at a textile mill and managed to photograph police frisking and detaining women workers while one woman sprawled in a pool of blood. It was the eighty-seventh dead body he had photographed in China in his first seven weeks, he cabled. None of his reports on Shanghai's urban protests made the magazine.

Even the stories he covered on assignment did not always appear. A year later editors sent him to locate the Nationalists' treasure, which was rumored to be heading for the island of Taiwan, where Chiang Kai-shek had relocated some three hundred thousand troops after the fall of China's crucial northern cities. Needing a ruse to get the information, Birns introduced himself as an investigator for the China Economic Assistance Program and persuaded the managing director of the Japanese-built Bank of Taiwan to give him a candid briefing. Speaking in whispers, the bank official described the transfer of the central government's assets. Amazed at his scoop and worried about Nationalist censors, Birns hurriedly sent a series of cables to New York via his wife, who had moved with their young son to the safety of a Manila hotel. "In tiers of four, stored on four-inch-thick wooden shelves, are nearly 950 barrels and chests full of yellow gold ingots and bars," Birns cabled on February 12, 1949. "This gold originally part of $500,000,000 gold bullion loan President Roosevelt made China in 1944." Dramatic details about the secret nighttime transfer to Taiwan of the China Central Bank's holdings via a U.S.-donated LST (tank landing ship) on December 5 and aboard C-46 cargo planes in two later shipments could have made shocking headlines about China's vanished treasury, but the story never ran.

By then Birns and Rowan had grown resourceful. Four months earlier the editors had sent them to Beijing (then Beiping) to do a profile of General Fu Zuoyi. "He was the 'great white hope,' slated to lead the defense of North China, until he defected to the Communists," Birns later commented. When the scheduled interview was postponed, the *Life* team found themselves bored during a week when "nothing was happening." Looking for a story, they photographed the traditional painter Qi Baishi in his studio and wrote about his professed indifference to political change. They followed the famous Hollywood cameraman James Wong Howe hurriedly filming Lao She's novel *Rickshaw Boy* in advance of an expected Communist takeover. Finally, they devised a whimsical story to appeal to *Life*'s editors in the run-up to the U.S. presidential election.

At home it was political season, and Republican candidate Thomas Dewey, with Luce's backing, had made China an important issue in the political campaign by calling repeatedly for increased aid to America's neglected friend and ally. With scant news to cover in Beijing, the *Life* reporters hired a group of professional mourners to fashion campaign posters, a "Good Luck Dewey" banner, and a papier-mâché elephant, symbol of the G.O.P. Then, Birns said, "we marched them down to the old city for some pictures."

Harry Truman won the election in a surprise upset, but *Life* still ran a full-page Good-Luck-Dewey parade picture the following week (November 8, 1948). The caption read, "A few home-sick Americans were credited with organizing the parade pictured above. Marching by the Forbidden City, the Chinese youngsters are carrying banners which, in Chinese and English, express gratitude to Dewey for his repeated pledges of determined U.S. aid." Birns said that a United Press International reporter had picked up the story and written "a straightforward piece without telling that it was a phony," but *Life* readers could guess from the caption that

the story was faked. He had no regrets about staging the Dewey parade. "It was fun, it was cute," he said. "We needed small ways to find amusement, and I'm glad we did it. Those were tough conditions, and humor gave us some relief."

Over the next six months Birns would find few lighthearted stories as he recorded the Nationalist military debacle. On his second trip to Manchuria, in late October 1948, he found the provincial capital a ghost city with no preparation for a last-stand defense. *Life* headlined the breaking story, "Fall of Mukden: Eyewitnesses Record Last Hours of Key City in Battle for China," and ran a dramatic lead. "Last week the fall of Mukden to the Communists brought Nationalist China to its darkest hour since 1942. One of the last planes into the Manchurian capital carried the *Life* reporter-photographer team of Jack Birns and Roy Rowan, who then got out just ahead of the Chinese Communist armies with the pictures on these five pages and the only eyewitness report of the city's last hours" (November 8, 1948).

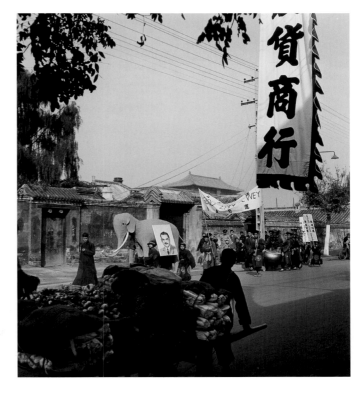

"Good Luck Dewey" parade. Beijing, October 1948.

Two weeks later *Life* carried a six-page article about the battle for the strategic city of Taiyuan, in central Shanxi province. Birns's dramatic photographs showed a solitary sentry on duty, an overcrowded hospital set up in a middle school, and crates of ammunition dropping at night from the holds of C-46 cargo planes in a desperate resupply effort. The Taiyuan story closed with a full-page shot of General Yan Xishan at his desk, threatening suicide rather than surrender and posing for reporters beside a shoe box overflowing with white capsules identified as potassium cyanide. Later Birns recognized problems in their Taiyuan reporting and noticed that the hospital pictures showed "no bloody bandages, no amputees and no one in sight who was racked by pain." After Yan Xishan escaped to Taiwan on a special plane with his family and his cash, Birns guessed that the hospital scene as well as the cyanide pills had been staged for the foreign press. "Unfortunately, *Life*'s editors, reporter Roy Rowan, and I might have been hoodwinked by the wily general," he wrote.

Determined to cover the climactic battle for Xuzhou, where the Nationalists committed fifty-five divisions with six hundred thousand men to defend the Yellow River plain, Birns and Rowan found themselves caught in a village that suddenly became the front line. They spent a tense night with howitzer shells screaming overhead, aware that Nationalist officers expecting defeat had already changed into civilian clothes. After withdrawing to Bengbu, Birns shot wrenching pictures of demoralized troops waiting to evacuate in a bone-chilling rain. By then the outcome of the civil war was no longer in dispute, and he began to document the dimensions of the Nationalist defeat.

Week after week he filed pictures of soldiers and civilians fleeing the battlefields, the threatened countryside, and the supply-starved cities. He constructed a visual narrative of people in transit as Chinese abandoned their homes and villages in search of safe haven. His camera captured the exodus taking place on foot and by train, sampan, coastal steamer, cruise ship, and cargo plane. Among those rushing to evacuate Shanghai were American intelligence staff, British diplomatic families, and Italian nuns in stiffly peaked white hats. Birns also documented the departure of several thousand White Russians seeking temporary refuge at a former U.S. base on a remote island in the Philippines.

As the Communists drew closer to China's most Westernized city, Wilson Hicks cabled instructions: "Whatever happens, want stark, gutsy 'Last Days of Shanghai' essay." Birns sent a long picture series titled "Fun and Sin," showing tattooed American bartenders and heavily made-up hostesses idling in the steamy clubs along the waterfront as the city emptied of customers. He showed the few remaining foreign children at the Shanghai American School surrounded by vacant desks, the carts abandoned along once bustling streets, the sandbags protecting commercial banks, and the workers boarding up shop windows. Most "stark and gutsy" were his pictures of barbed wire and bayonets blocking entrance to and exit from the city's western suburb, of political prisoners digging zigzag slit trenches, and of the garrison command setting homes ablaze in the affluent Hongqiao district to create an open field of fire—all merely gestures of preparation for the vaunted defense of Shanghai that would never take place.

Life's Shanghai bureau shut down after the last U.S. Navy ship pulled away from the harbor on April 24, 1949. Birns covered the withdrawal, showing the destroyer escort *Diachenko* stacked with goods from the U.S. consulate and the USS *Chilton* carrying away ammunition and armored vehicles. He rushed those films off to New York but later wrote, "I could have saved myself the trouble since *Life* never ran the pictures. It was not a story Americans could be proud of." On May 8 Birns boarded the last scheduled Pan Am flight for Hong Kong, but a week later he and Rowan, hoping to photograph the Communists' takeover, made a daring final trip back to Shanghai with an American pilot on an arms run. As the boxes of .30 caliber machine gun bullets were being hurriedly unloaded at the Longhua airport, Birns and Rowan learned that enemy gunners already controlled access to the city. The reporters tried to grab some sleep on the hangar floor until a round of Communist mortar fire hit nearby and sent them scrambling back aboard two separate C-47s for a perilous takeoff on a darkened runway. The defense of Shanghai was only a sham, Birns later wrote, and the load of ammunition paid for by the U.S. taxpayer was in fact delivered to the enemy. Birns was back in Hong Kong on the night of May 24, when Communist soldiers silently lined Shanghai's streets and the city changed hands without a battle. For the next thirty years American journalists would cover China's difficult journey through revolution from across the border in Hong Kong.

Half a century later Birns's China pictures unfold a story of dignity and resilience in the midst of enveloping poverty, repression, and fear. They invite our reflection on the collapse of Nationalist rule and the failed promise of Communist liberation. But at the same time these haunt-

ing images make us ponder the startling irony of Shanghai's resurgence. After 1949 a rigid socialist ethic heralding China's proletarian achievements largely erased the city's legacy of commercialism and foreign influence. For forty years, deteriorating townhouses, utilitarian workers' apartments, and unadorned cooperative shops defined the urban landscape. Then, in 1992, Deng Xiaoping launched an economic boom, and Shanghai rebuilt. Skyscrapers, museums, malls, suburbs, roads, and bridges transformed the aging city. Theaters, boutiques, bars, billboards, and neon lights reappeared. Shanghai emerged once again as a vibrant international center of finance and culture, where the conspicuous wealth of prospering entrepreneurs collides with the poverty of rural migrants. In Jack Birns's memorable photographs we find both the dramatic portrait of an era ending and also a glimpse of the cosmopolitan heritage that Shanghai is rediscovering today.

REFERENCES

Jack Birns, "China As It Was (1947–1949):
A Pictorial History of China's Civil War Period"
(unpublished manuscript, 2000).

Roy Rowan, *Powerful People: From Mao to Now*
(New York: Carroll & Graf, 1996).

SHANGHAI STREETS

Billboards line the broad streets of the International Settlement and the French Concession, where bicycles, rickshaws, pedicabs, and handcarts compete with motorized traffic. Vendors and entertainers hustle their wares, their skills, and their ingenuity along busy sidewalks. Domestic life unfolds in crowded alleys where laundry hangs on bamboo poles above children at play.

OVERLEAF A billboard above a busy intersection features a Western woman advertising Banker Cigarettes. Shanghai, January 1948.

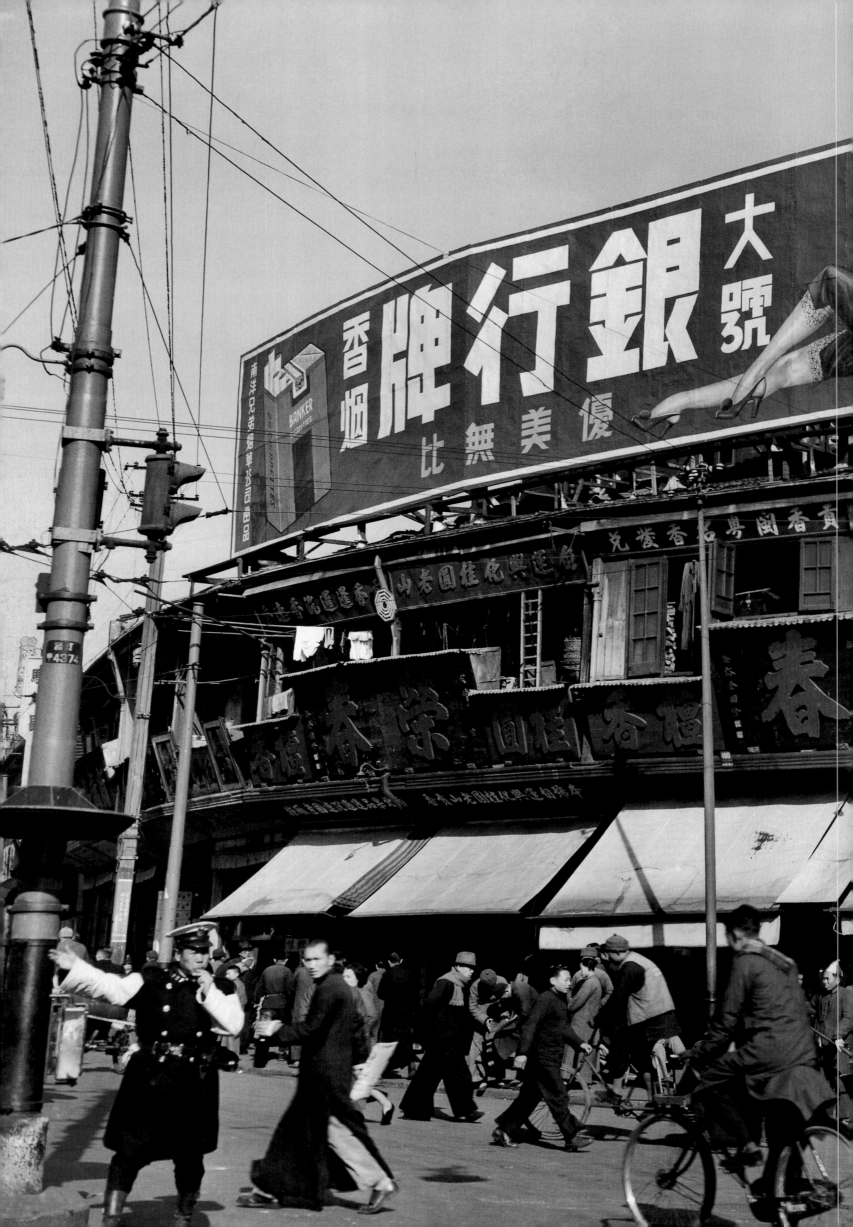

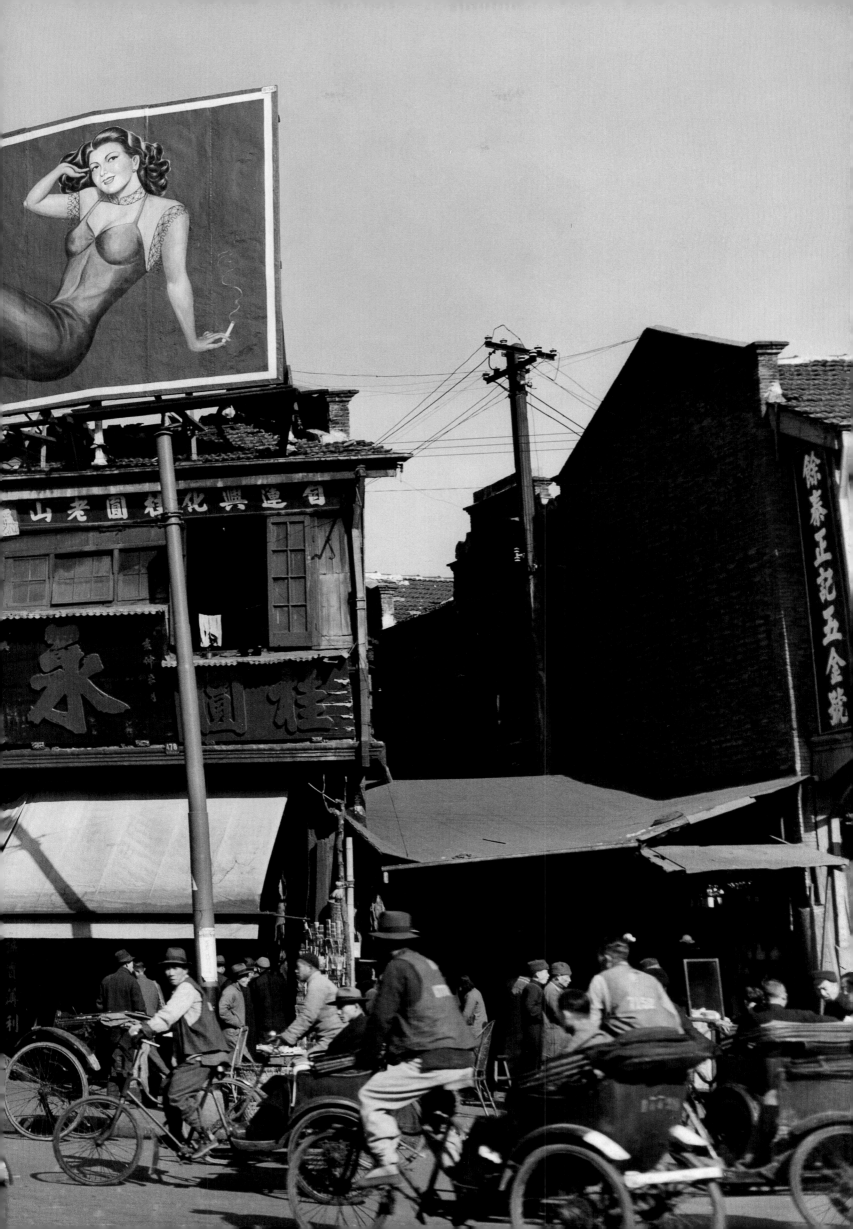

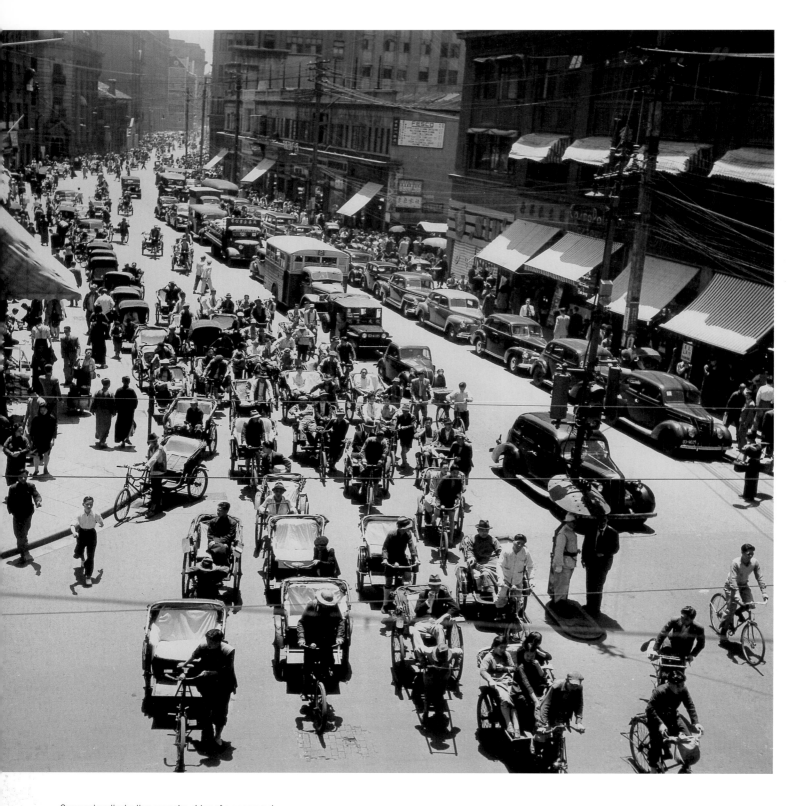

Cars and pedicabs line opposite sides of a congested
commercial street. Shanghai, May 1948.

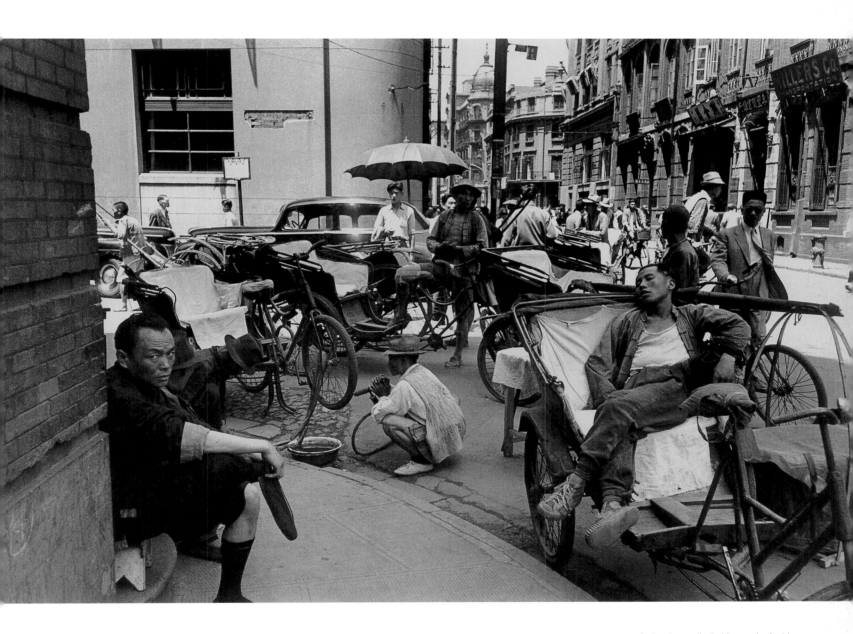

A sleeping pedicab driver waits for his passenger's return. Shanghai, May 1948.

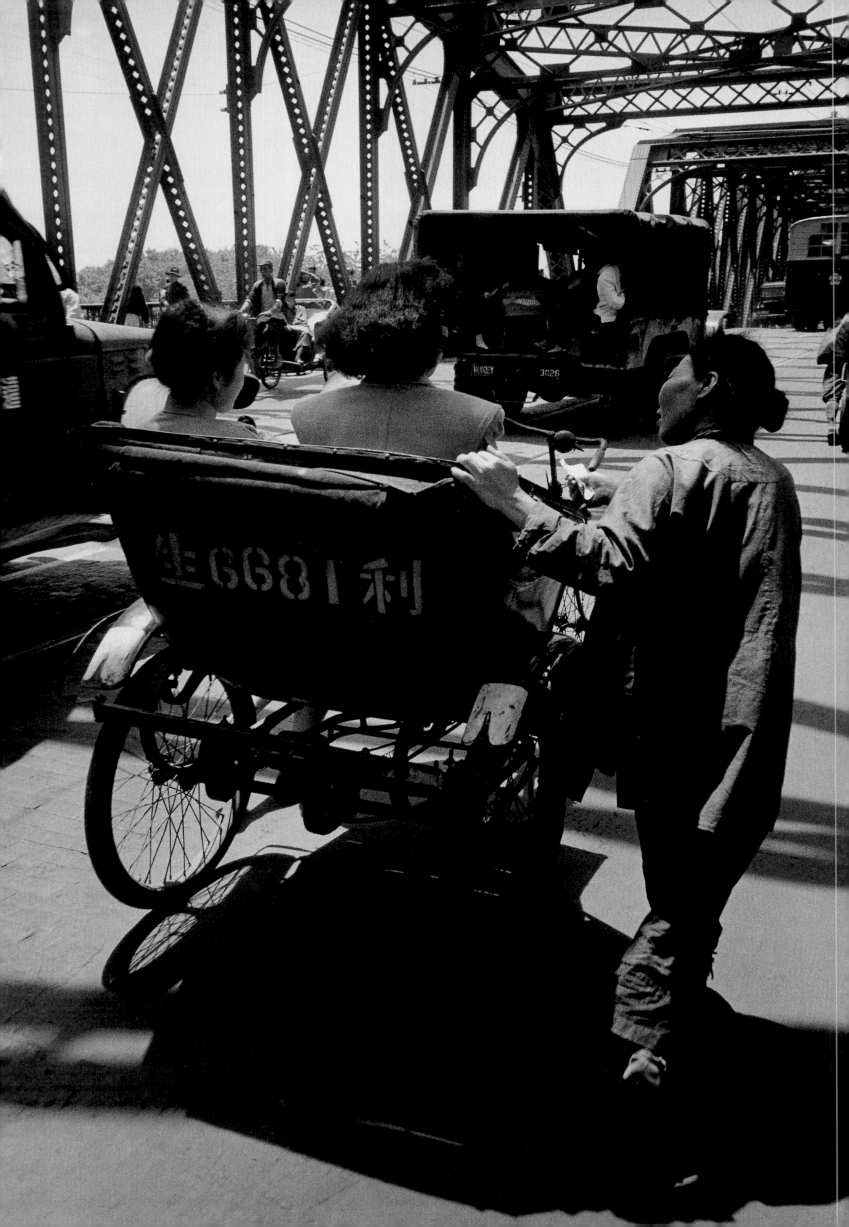

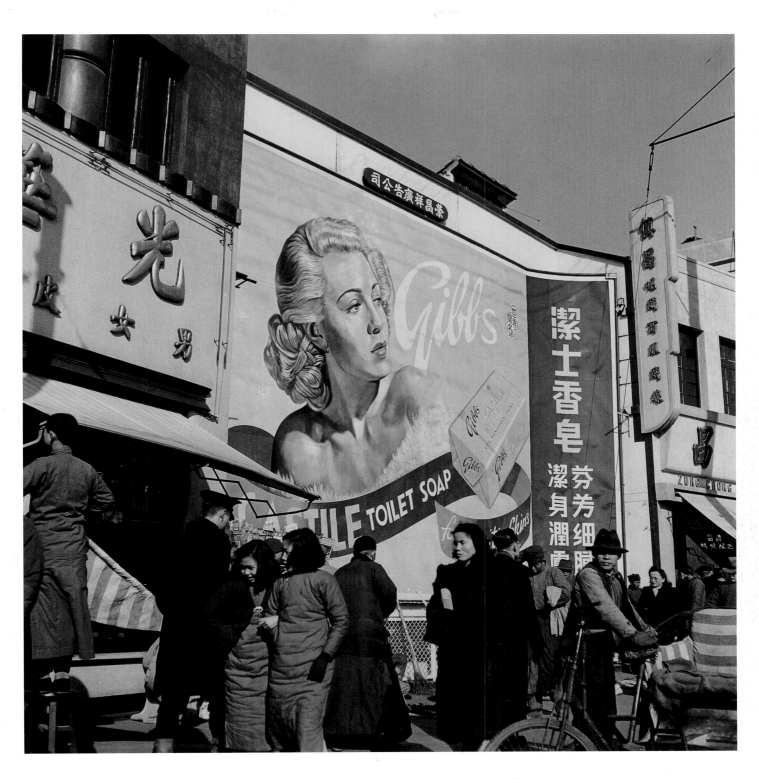

A woman in a fur coat passes a billboard image of
Hollywood star Lana Turner. Shanghai, January 1948.

A woman begs amid traffic on the Garden Bridge over
Suzhou Creek. Shanghai, May 1948.

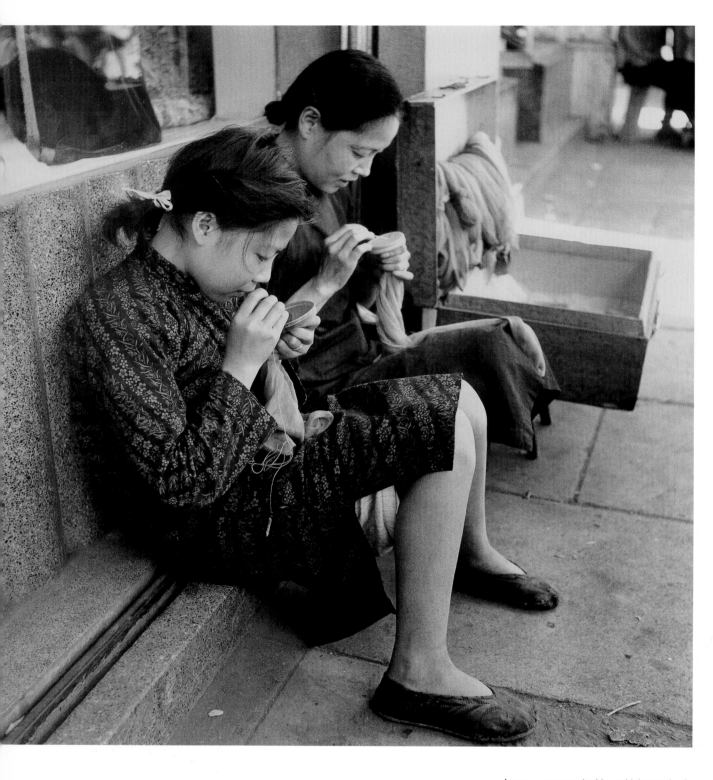

A young woman embroiders with her mother in
the International Settlement. Shanghai, May 1948.

A sidewalk vendor peddles snakes and patent
medicines. Shanghai, May 1948.

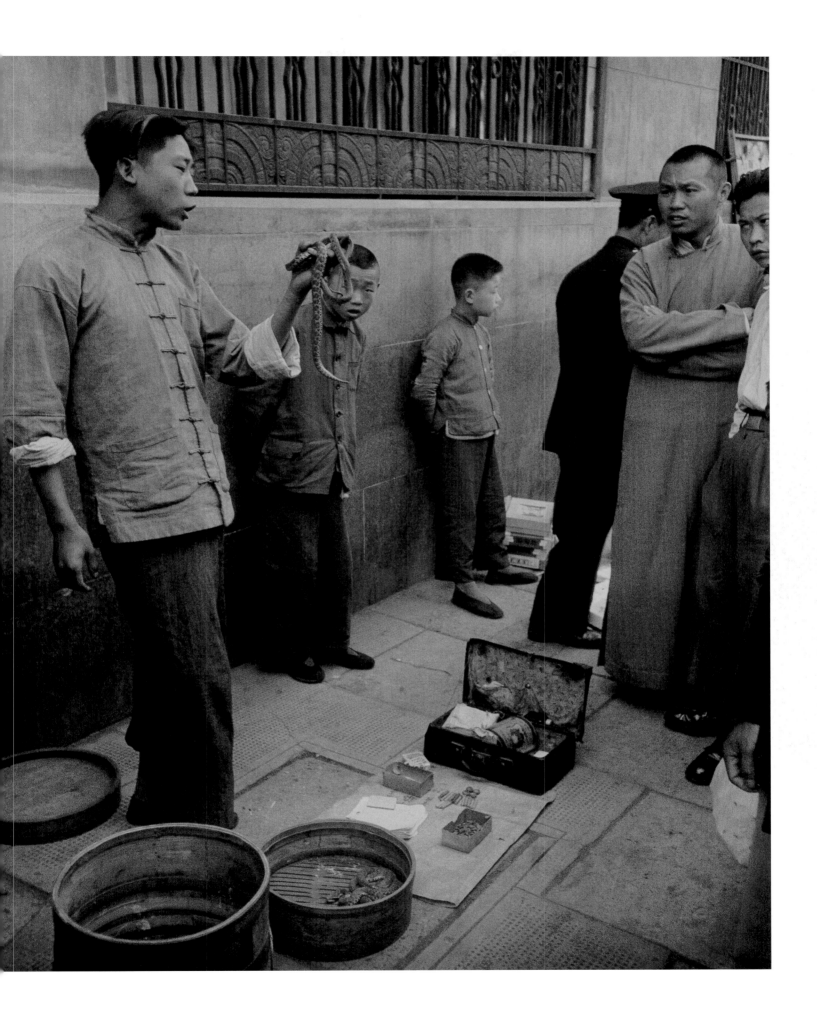

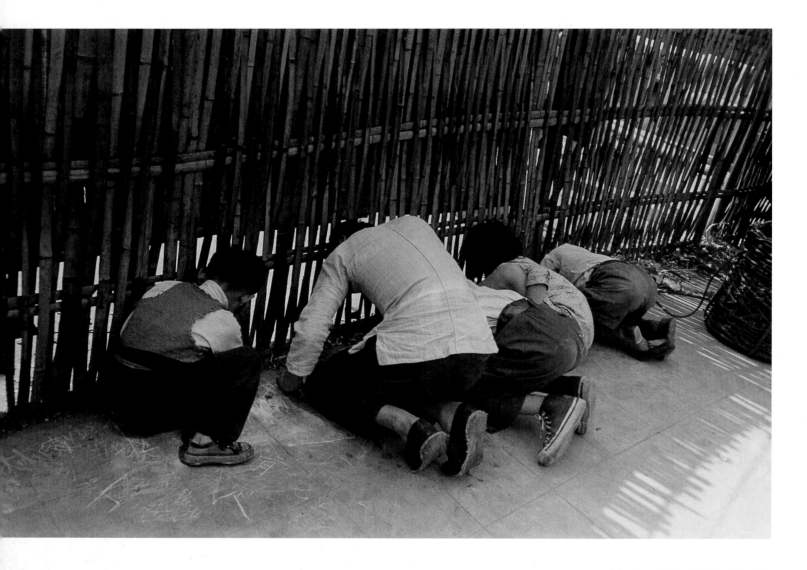

A family peeks through a fence to watch
street acrobats perform. Shanghai, May 1948.

An acrobat balances on a bamboo pole.
Shanghai, May 1948.

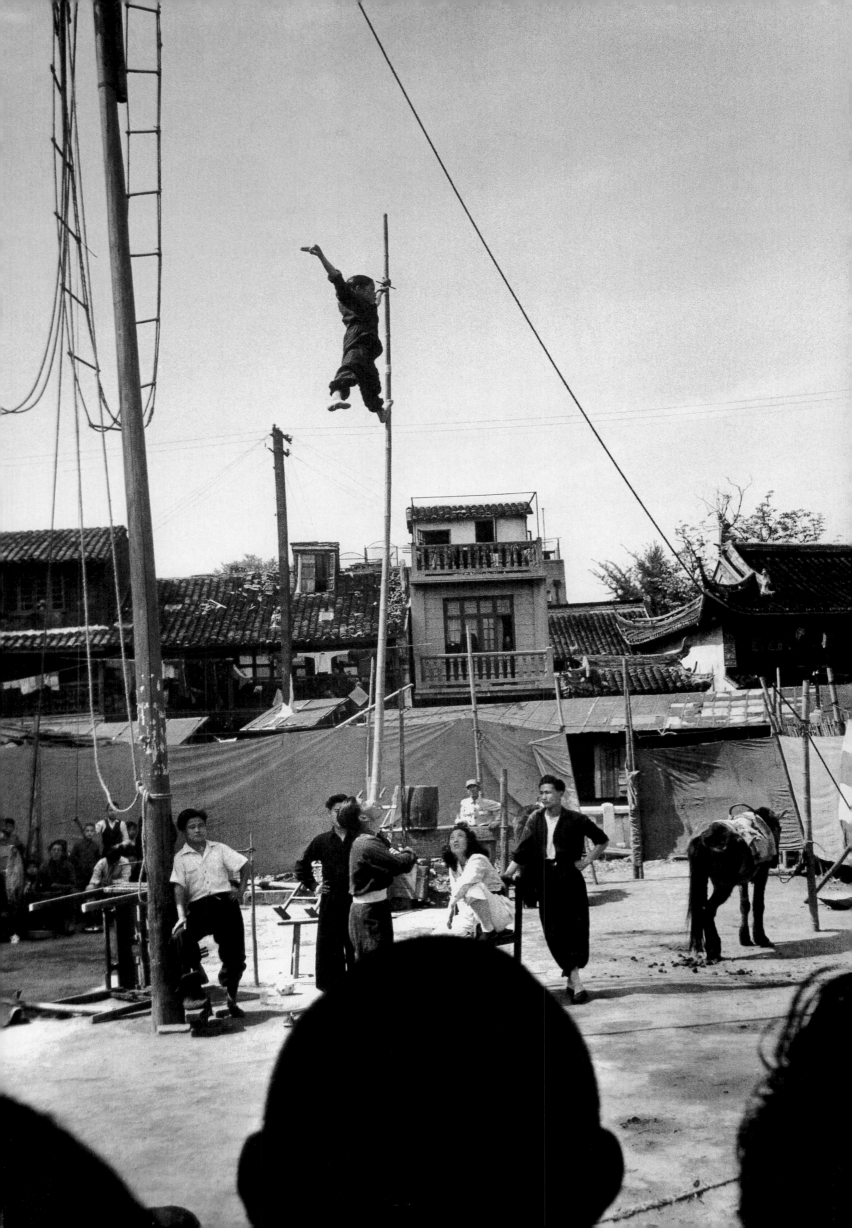

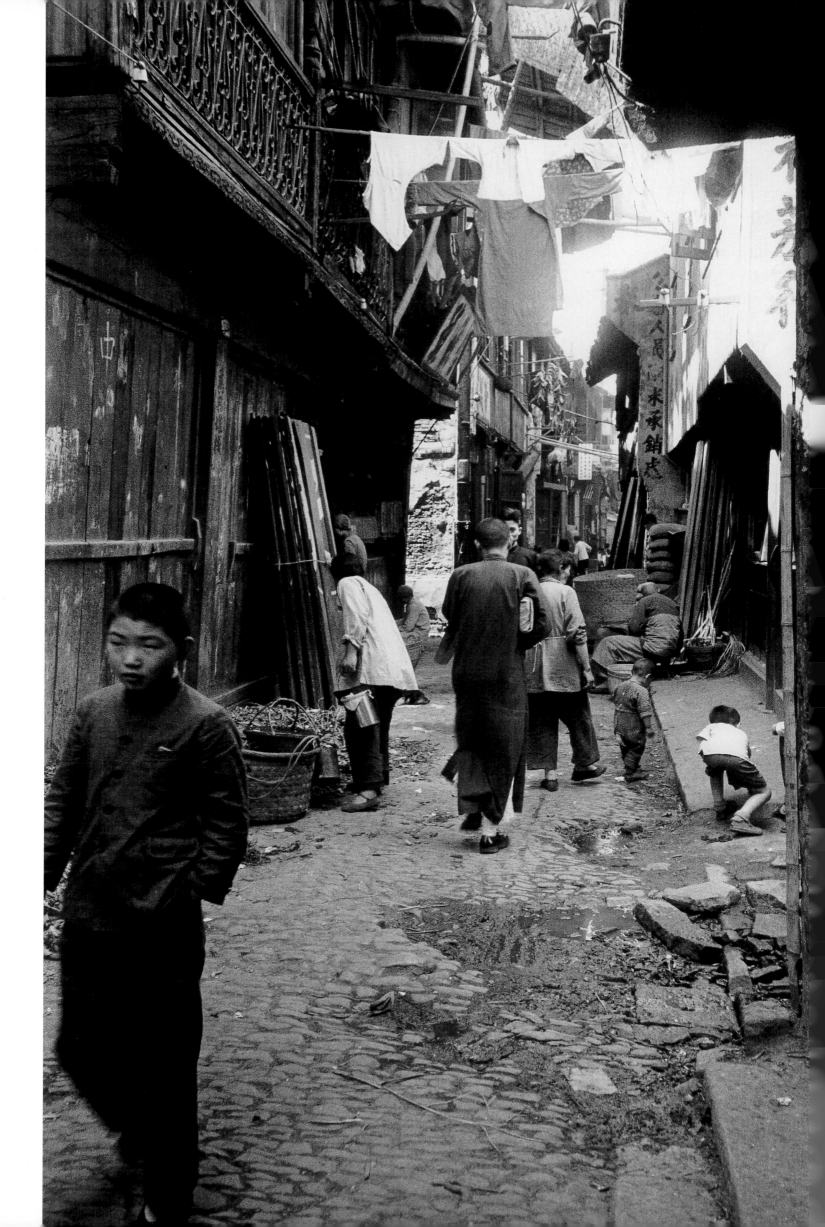

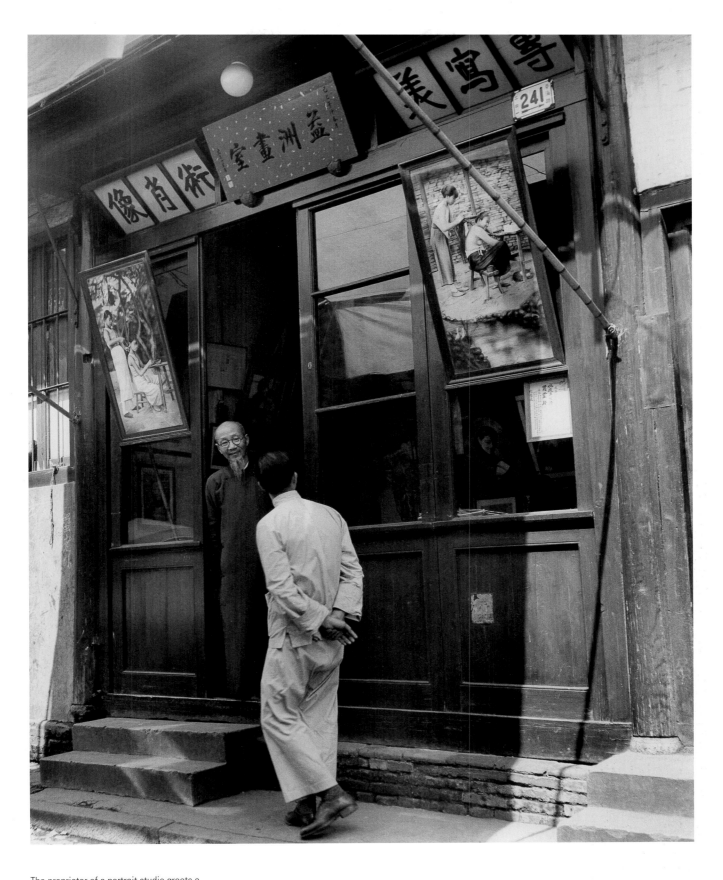

The proprietor of a portrait studio greets a
prospective customer. Shanghai, March 1948.

Children play in a crowded alley on the edge of the
French Concession. Shanghai, March 1948.

Transport workers hoist heavy bales from barges along the waterfront Bund, as migrants from the countryside, risking arrest, grab tufts of raw cotton to sell for pennies to waiting merchants. Guards use clubs to protect loaded trucks, while plainclothes police search the miscreants and pocket the confiscated cotton. The shipment, sent from the U.S. and paid for with United Nations relief funds, is intended for the poverty-stricken interior.

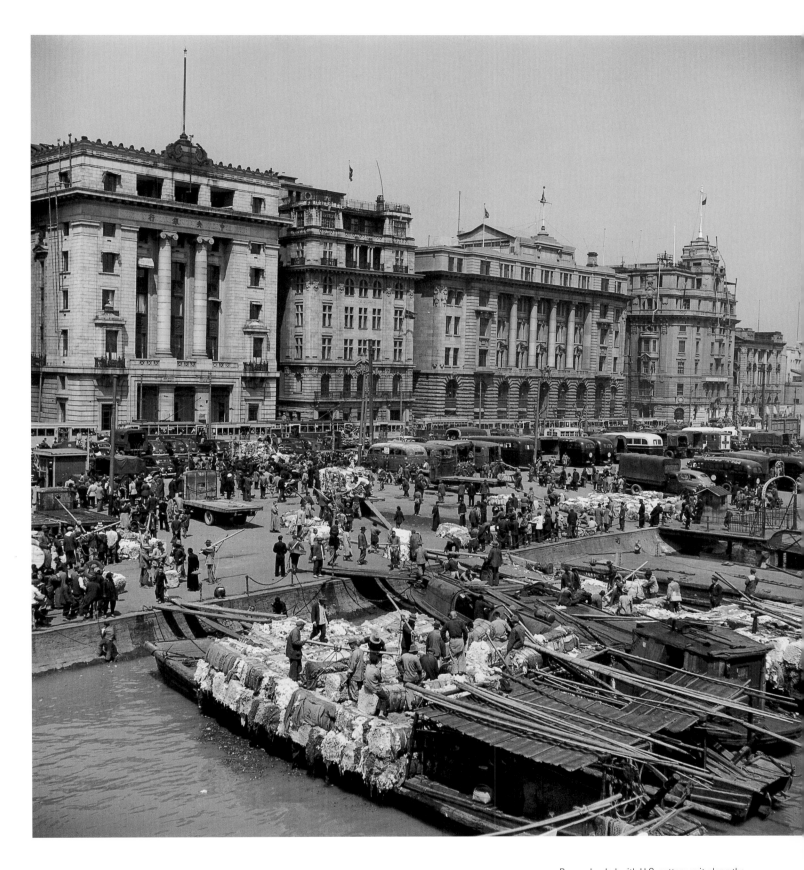

Barges loaded with U.S. cotton wait along the
waterfront Bund. Shanghai, March 1948.

OVERLEAF Dockworkers hoist already vandalized
cotton bales on carrying poles. Shanghai, March 1948.

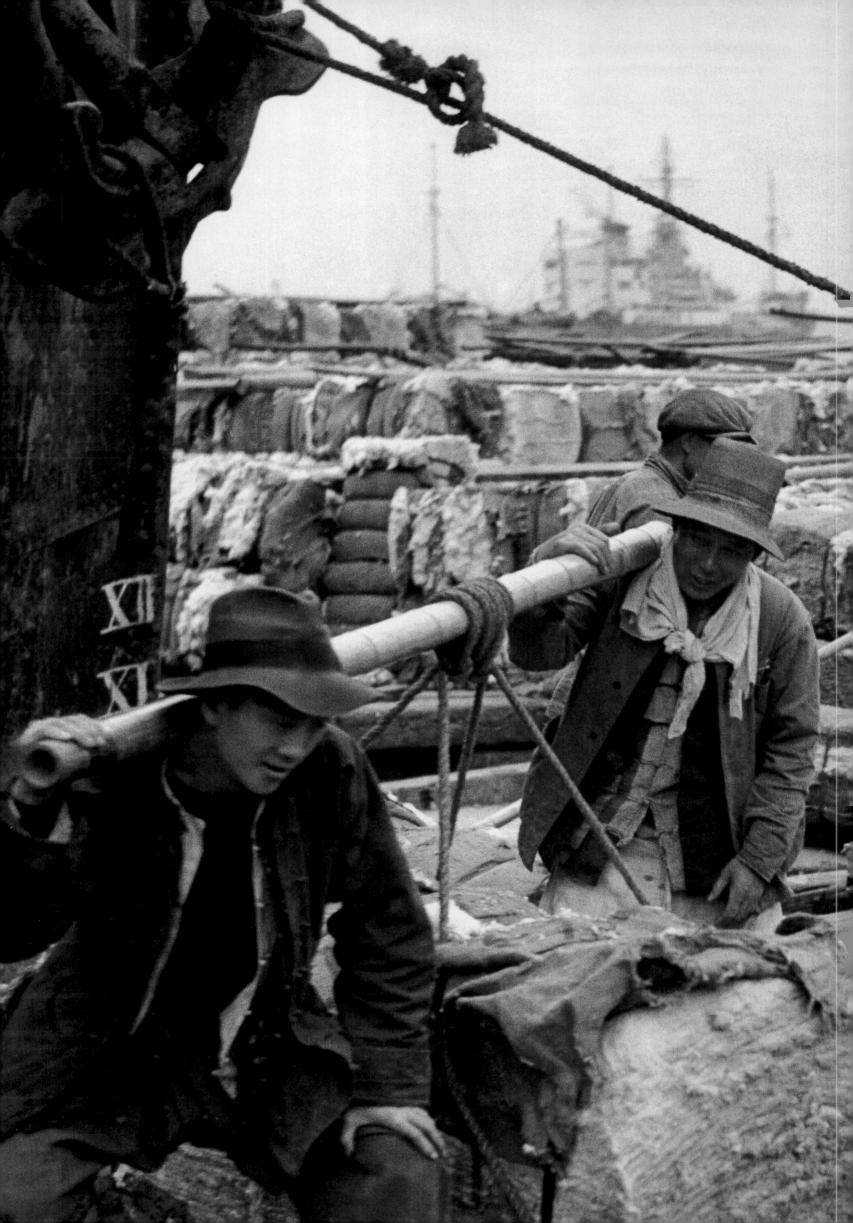

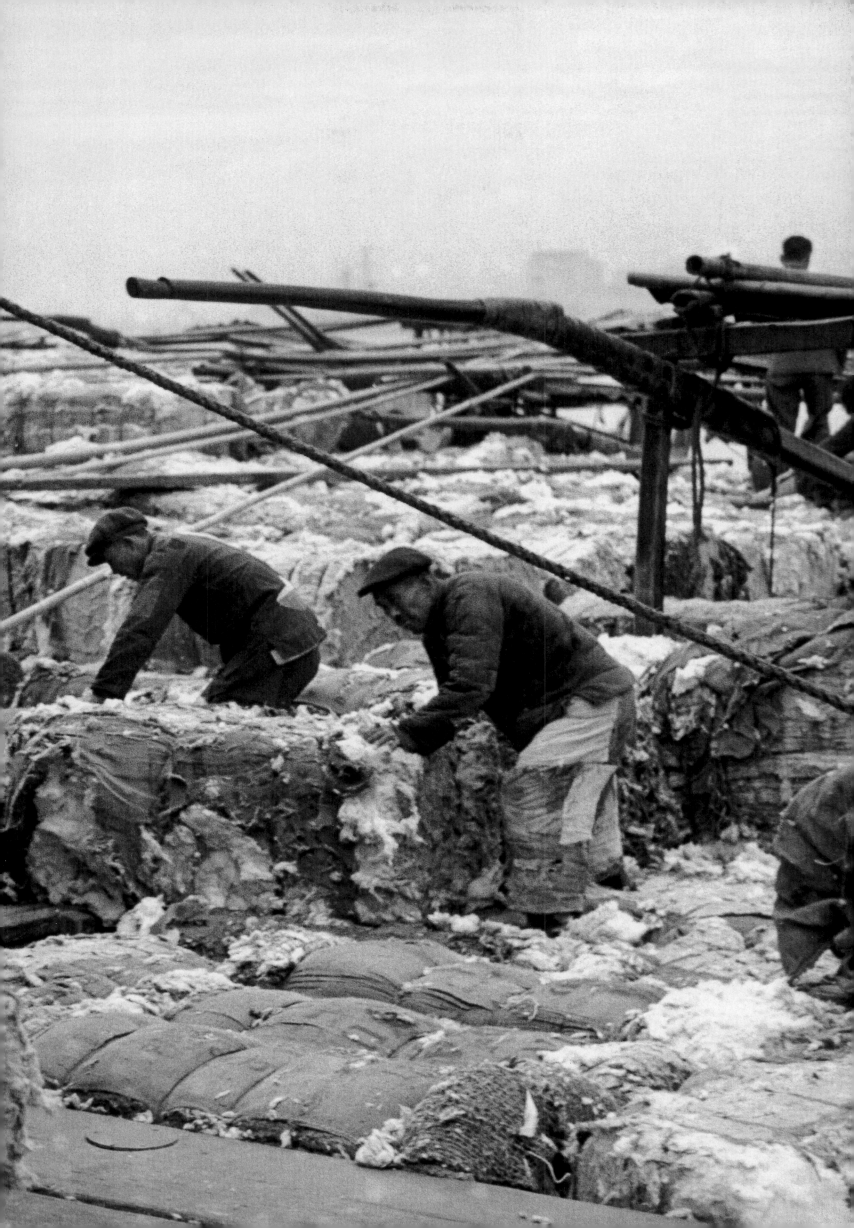

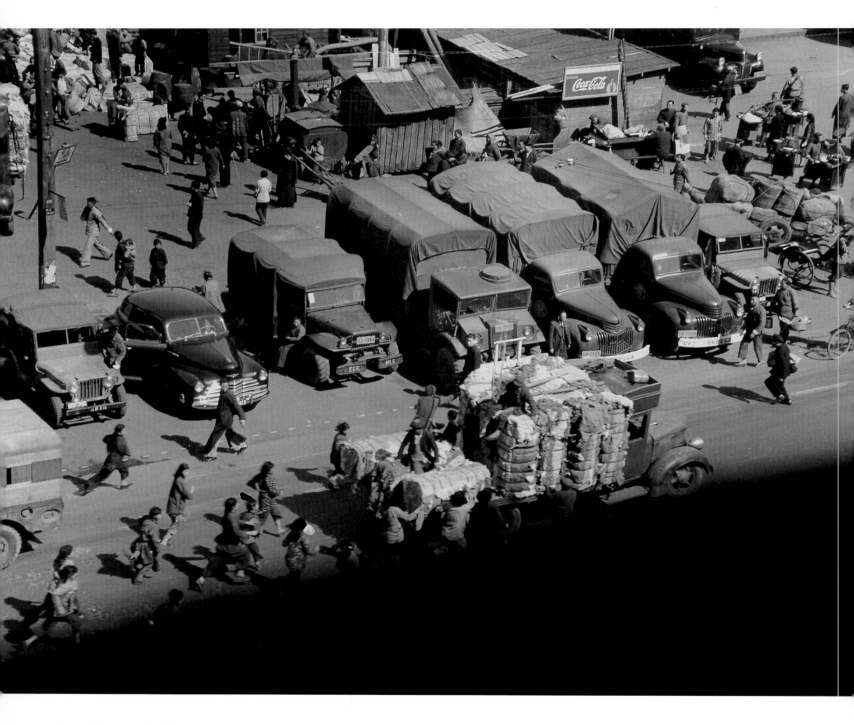

A crowd of women and children pursues a
loaded cotton truck. Shanghai, March 1948.

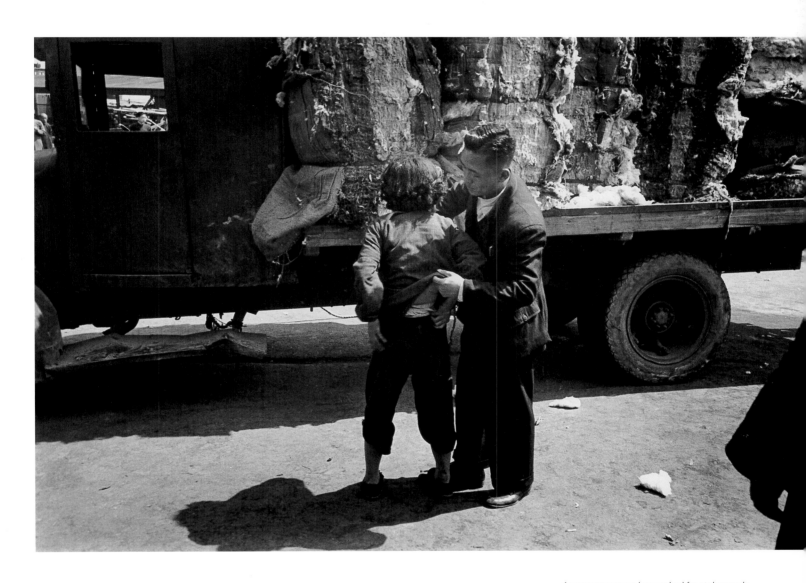

A peasant woman is searched for stolen wads
of cotton. Shanghai, March 1948.

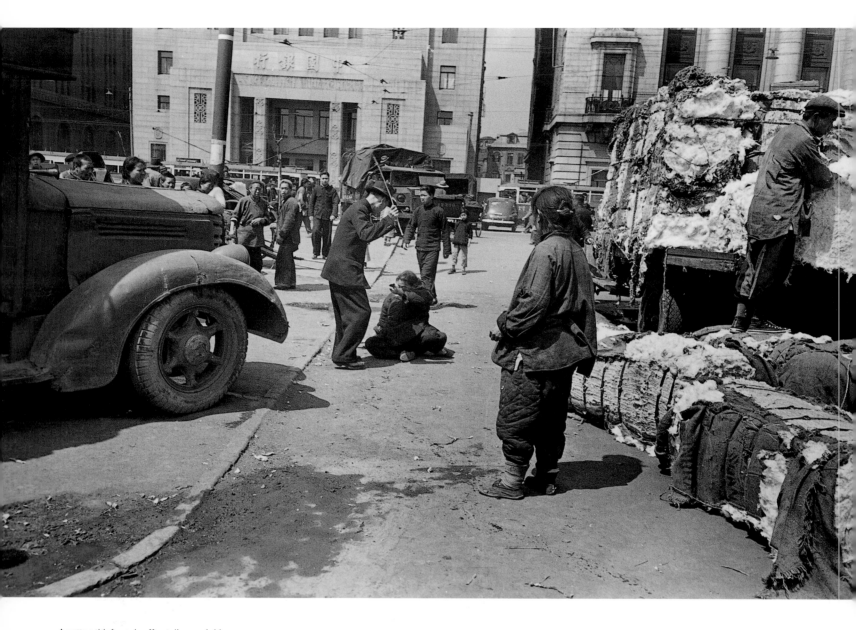

A cotton thief wards off a policeman's blows.
Shanghai, March 1948.

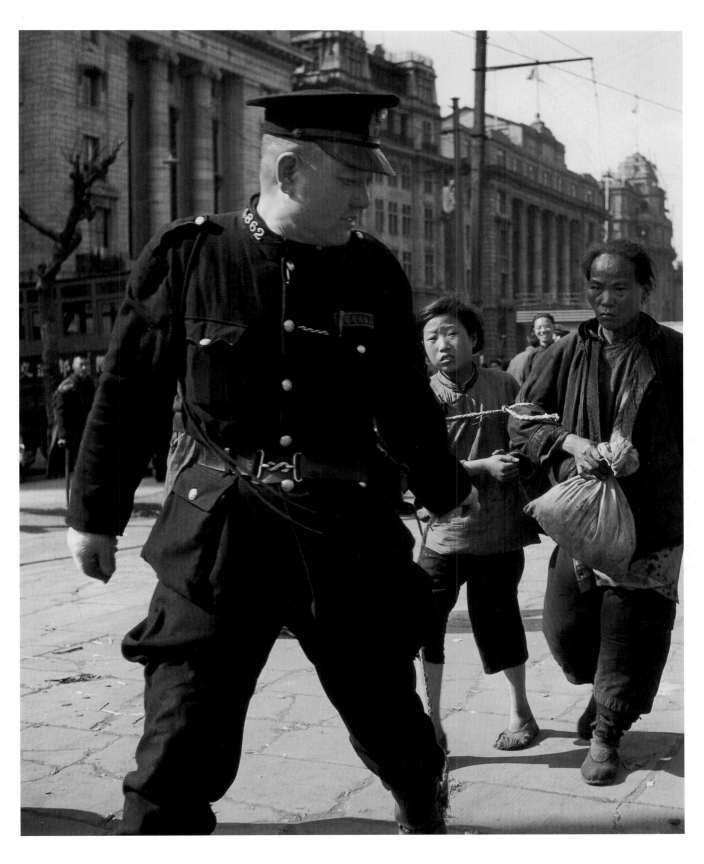

A woman holding a bag of stolen cotton is apprehended with her daughter. Shanghai, March 1948.

Economic pressures in the countryside force desperate refugees to seek subsistence in an over-crowded city. Migrants utilize any available shelter, and a mortuary on the outskirts of Shang-hai provides a crude home for several families. Charity wagons and bicycle carts daily collect the corpses of those who succumb to starvation, illness, and exposure.

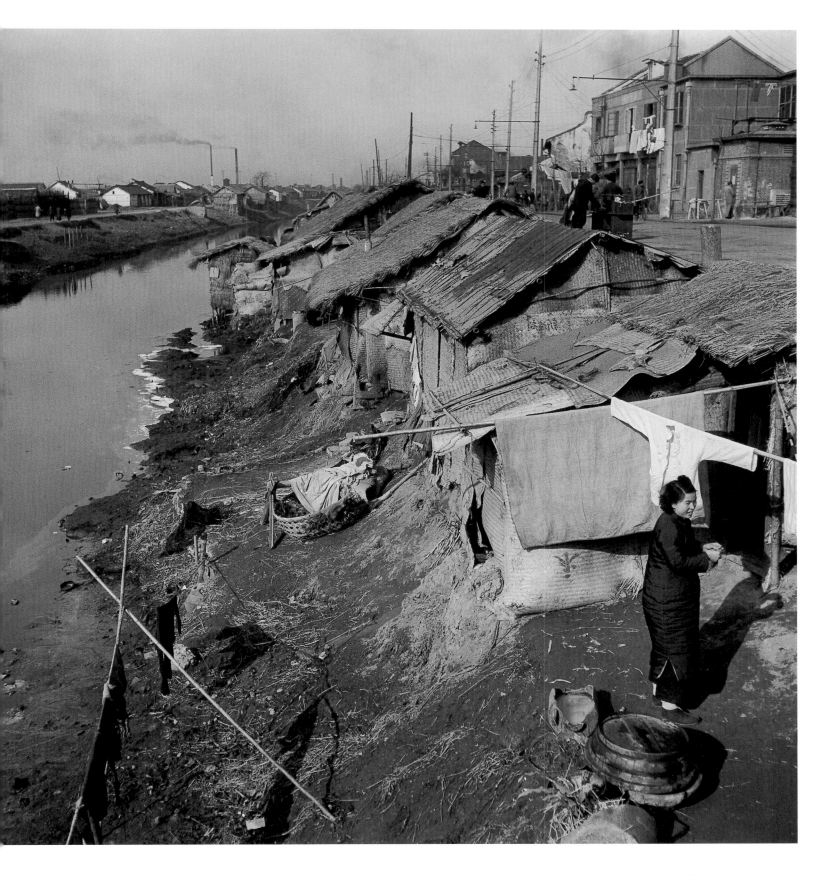

A woman airs bedding outside shanties built along the muddy Huangpu riverbank. Shanghai, December 1947.

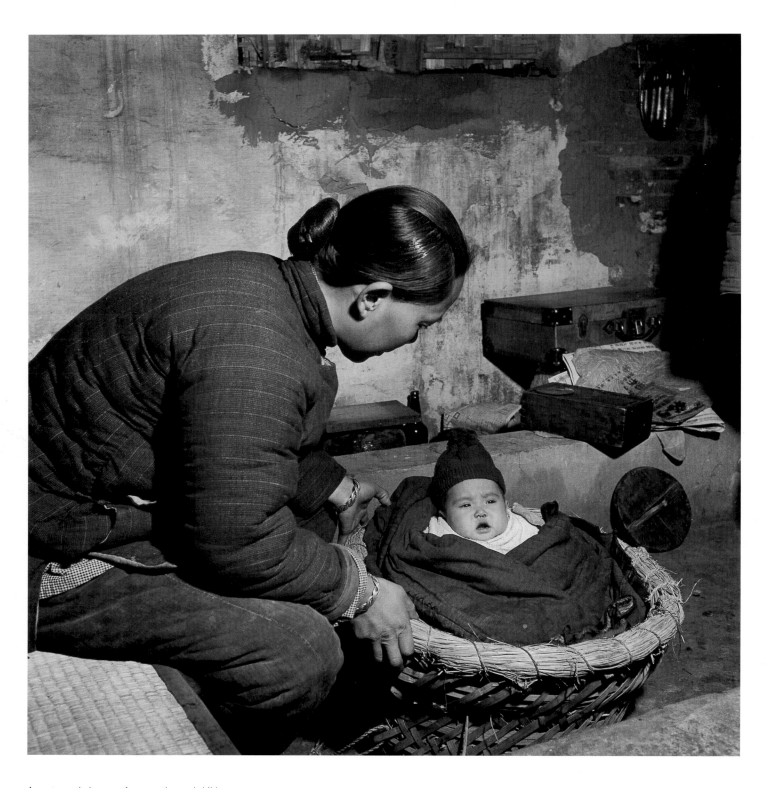

A mortuary shelters a refugee mother and child.
Shanghai, December 1947.

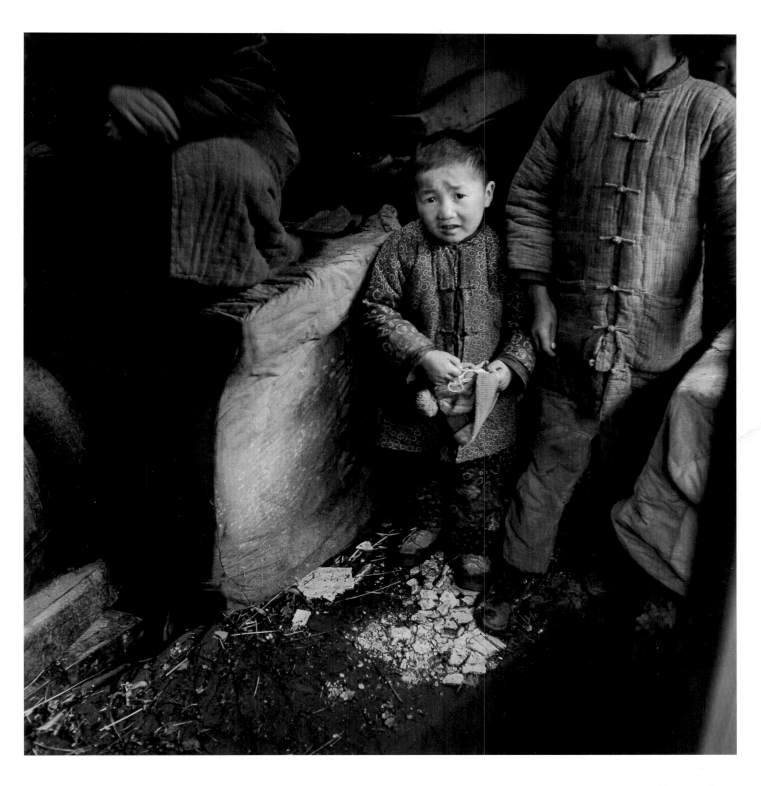

A young boy idles in his mortuary home.
Shanghai, December 1947.

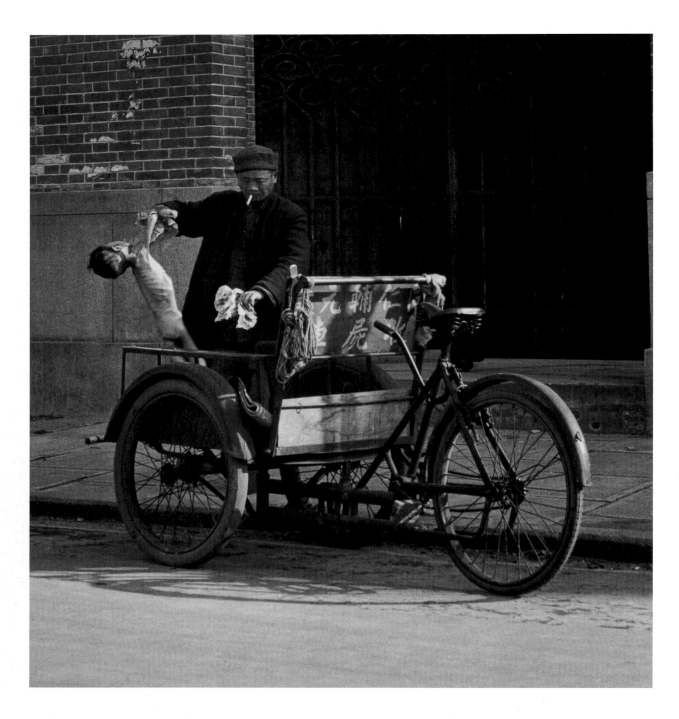

A bicycle cart delivers a child's corpse to a
temporary morgue. Shanghai, December 1947.

Children's corpses in a collective coffin await cremation
on Christmas Eve. Shanghai, December 1947.

OVERLEAF The homeless sleep on the street
in the winter cold. Shanghai, January 1948.

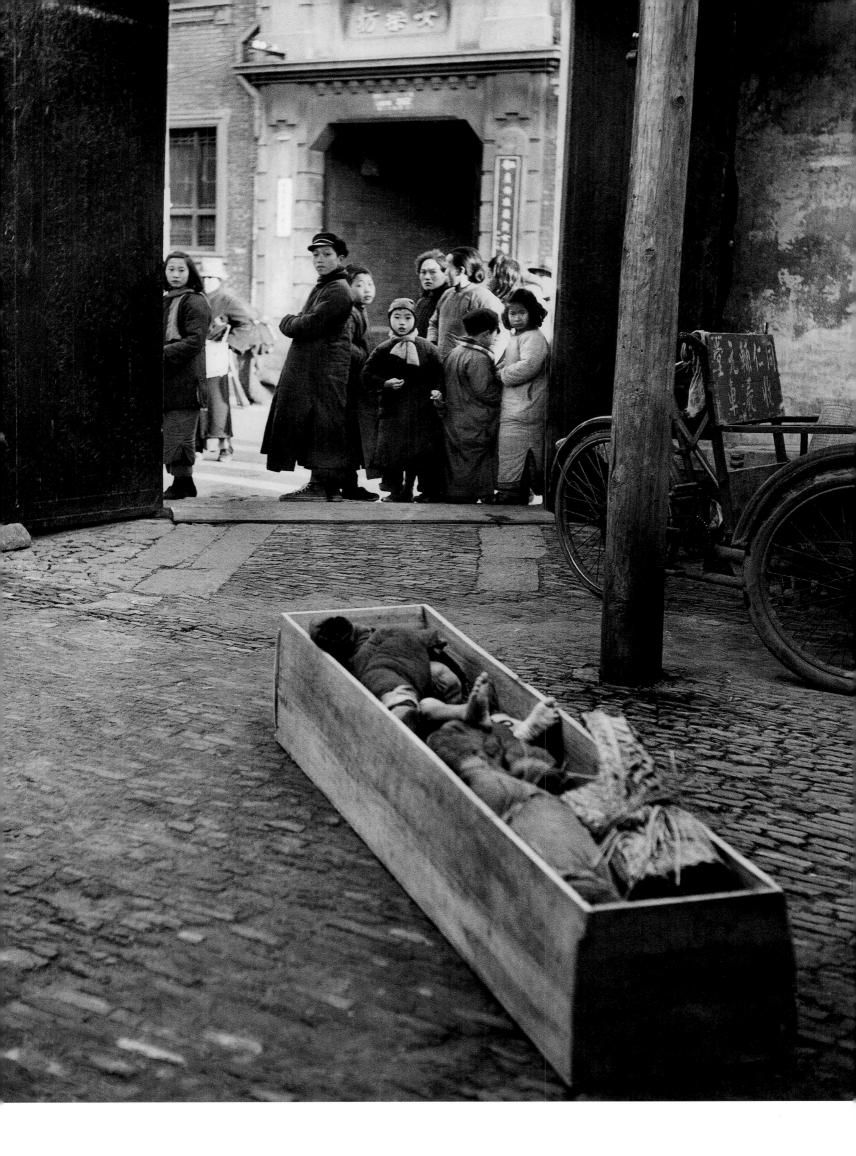

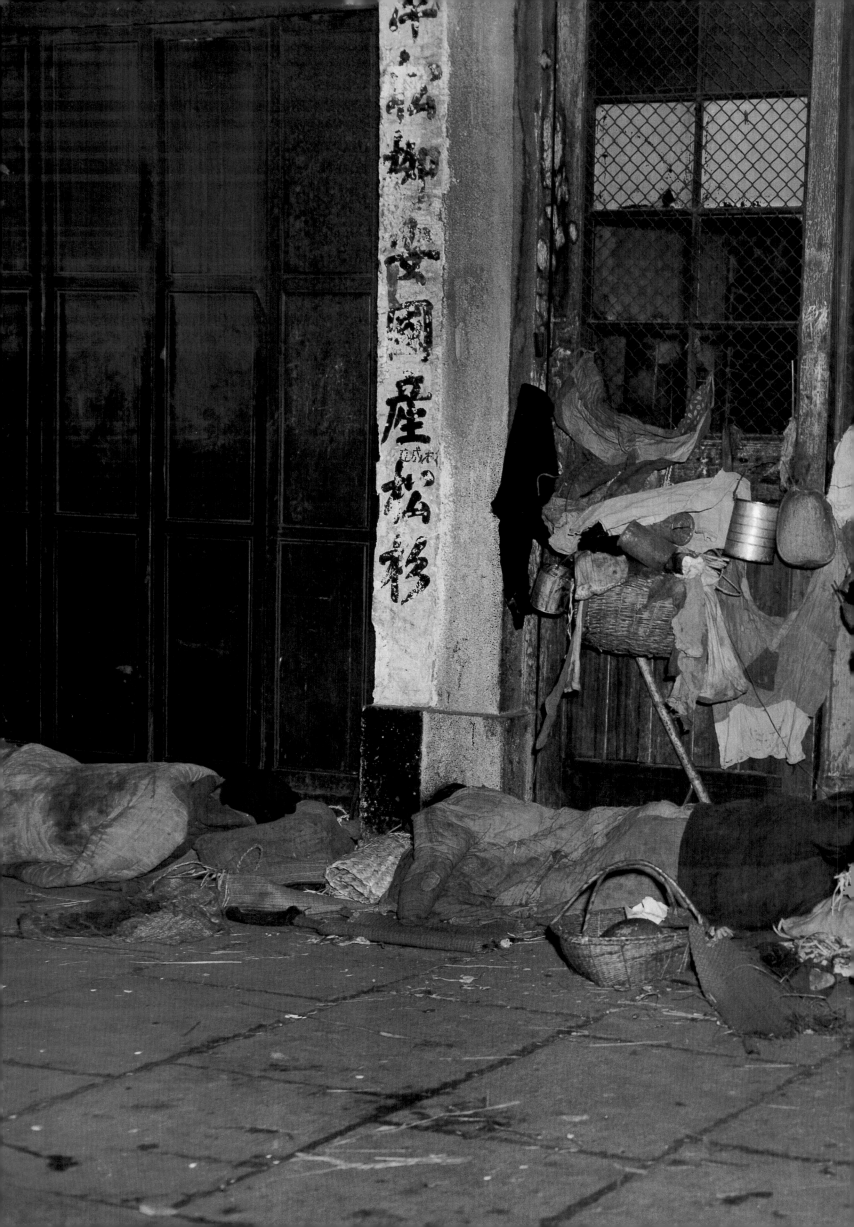

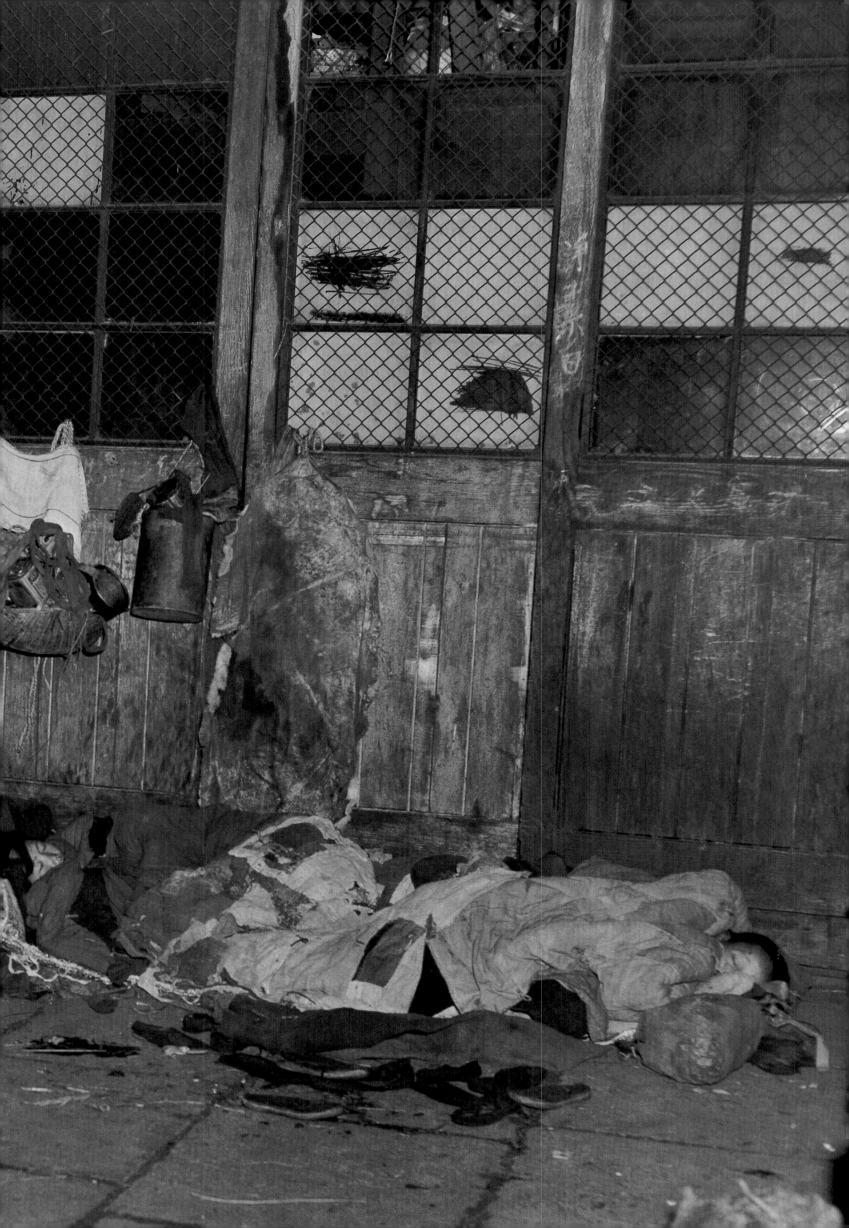

Mukden, an industrial center key to the control of north China, empties of residents as food supplies dwindle. Nationalist soldiers, braving temperatures of −30°F, perform military maneuvers in a display of readiness to defend Manchuria's capital. Ten months later the city falls without a shot fired.

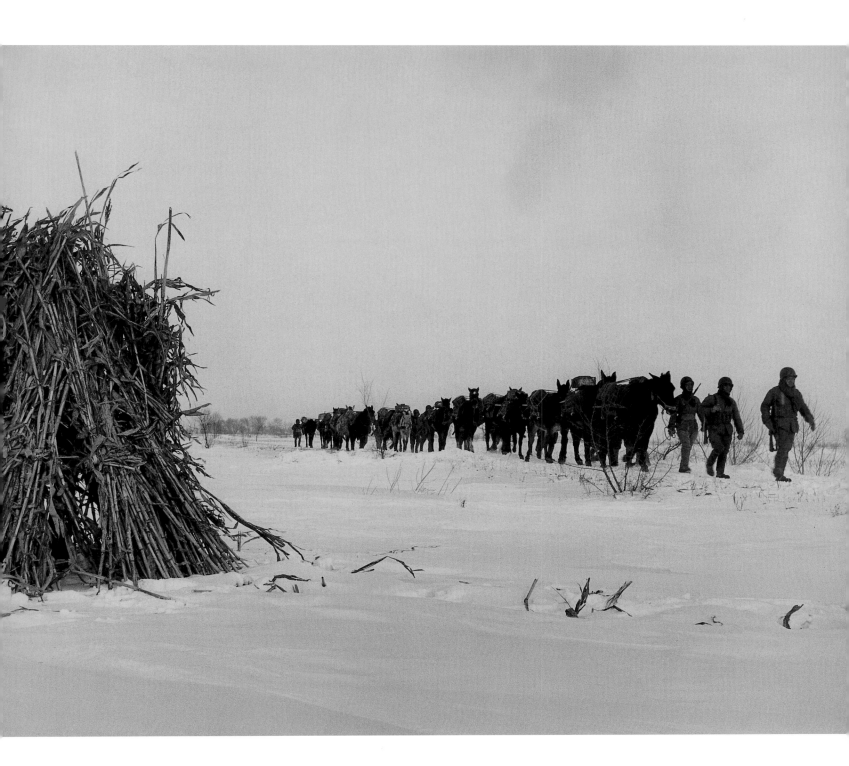

Nationalist infantry on maneuvers marches across
a frozen field. Mukden, January 1948.

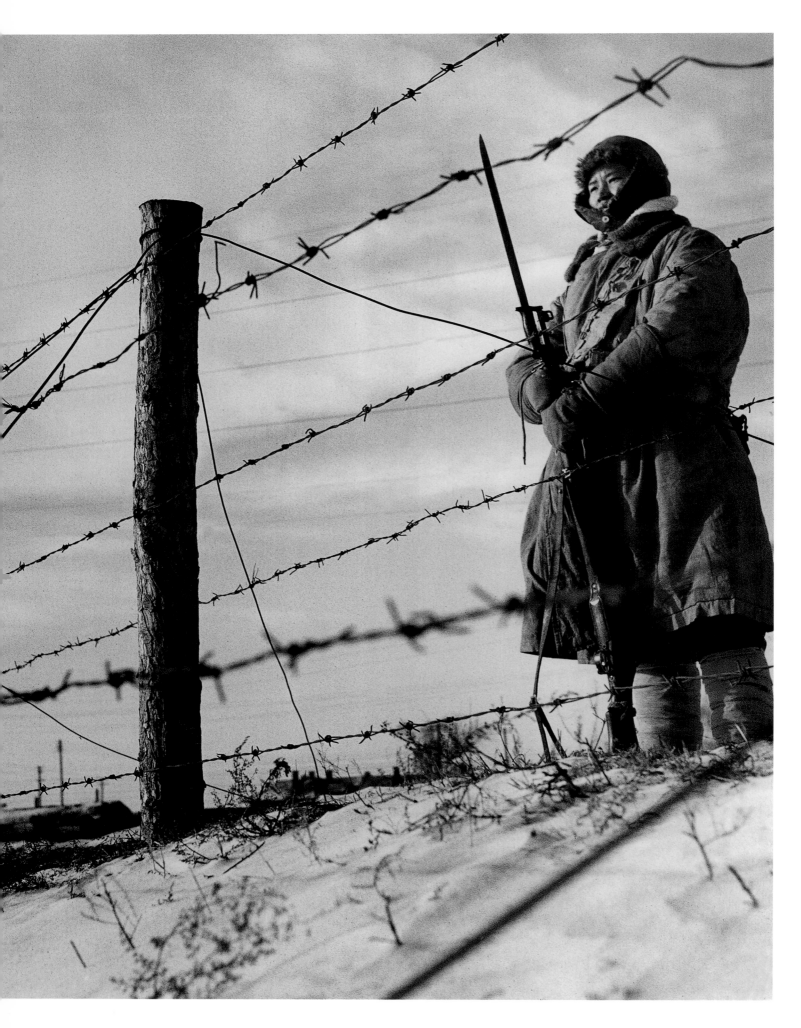

A sentry with fixed bayonet stands guard outside
the city. Mukden, January 1948.

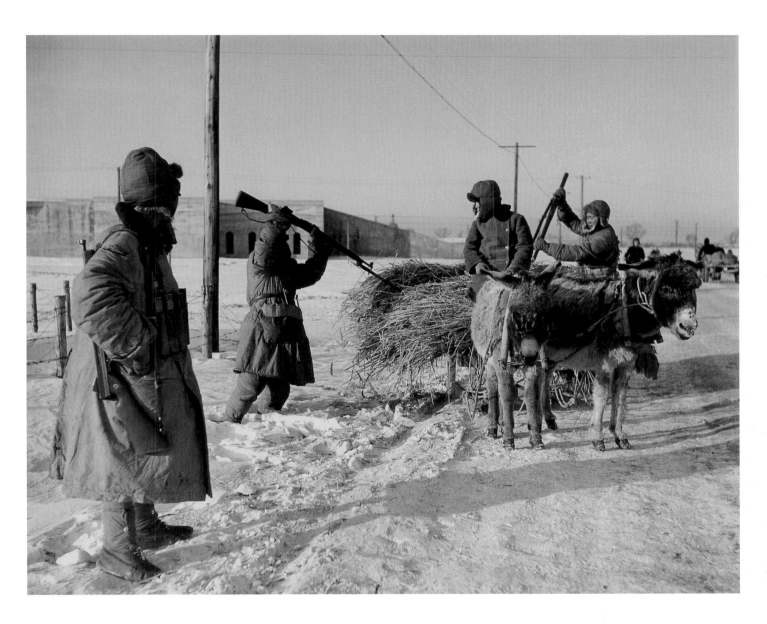

Soldiers probe mule carts in search of
Communist infiltrators. Mukden, January 1948.

OVERLEAF A Nationalist officer guards women
prisoners said to be "comfort girls" used by
the Communists. Mukden, January 1948.

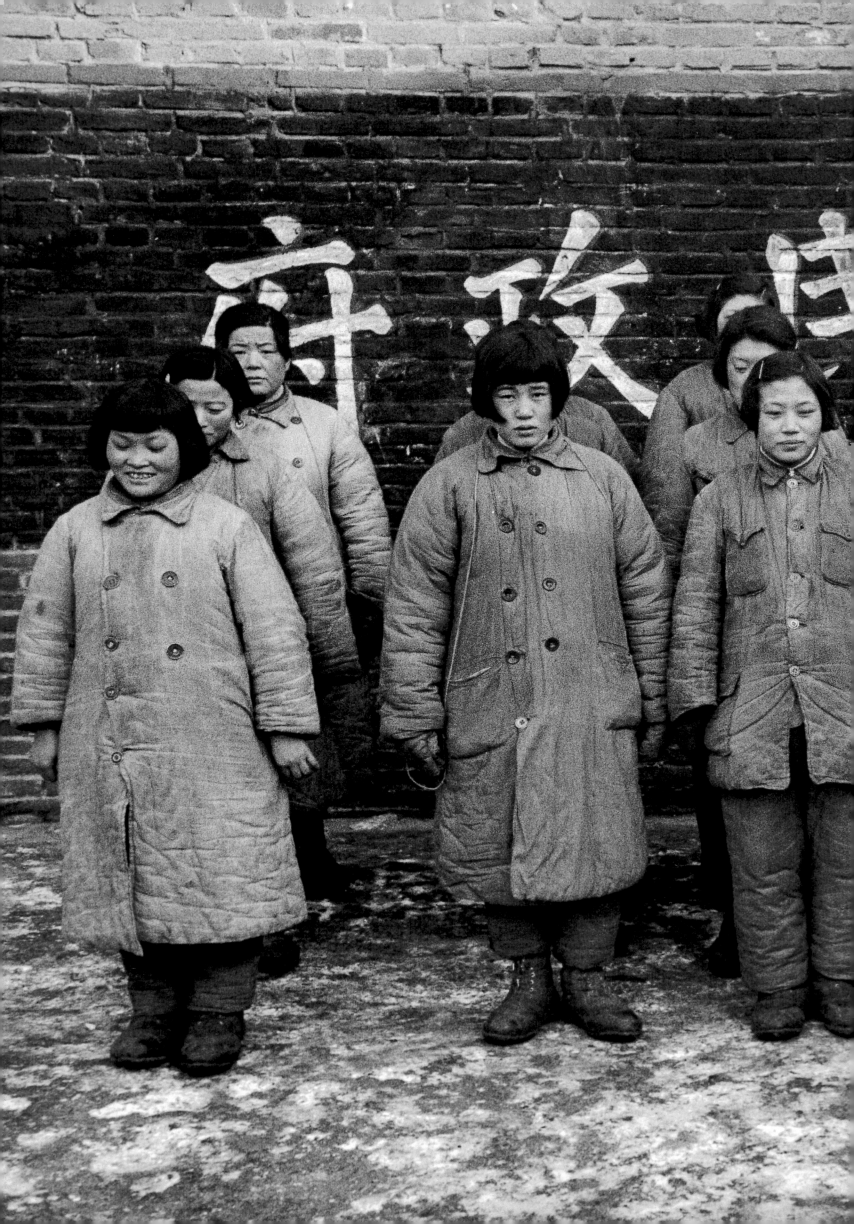

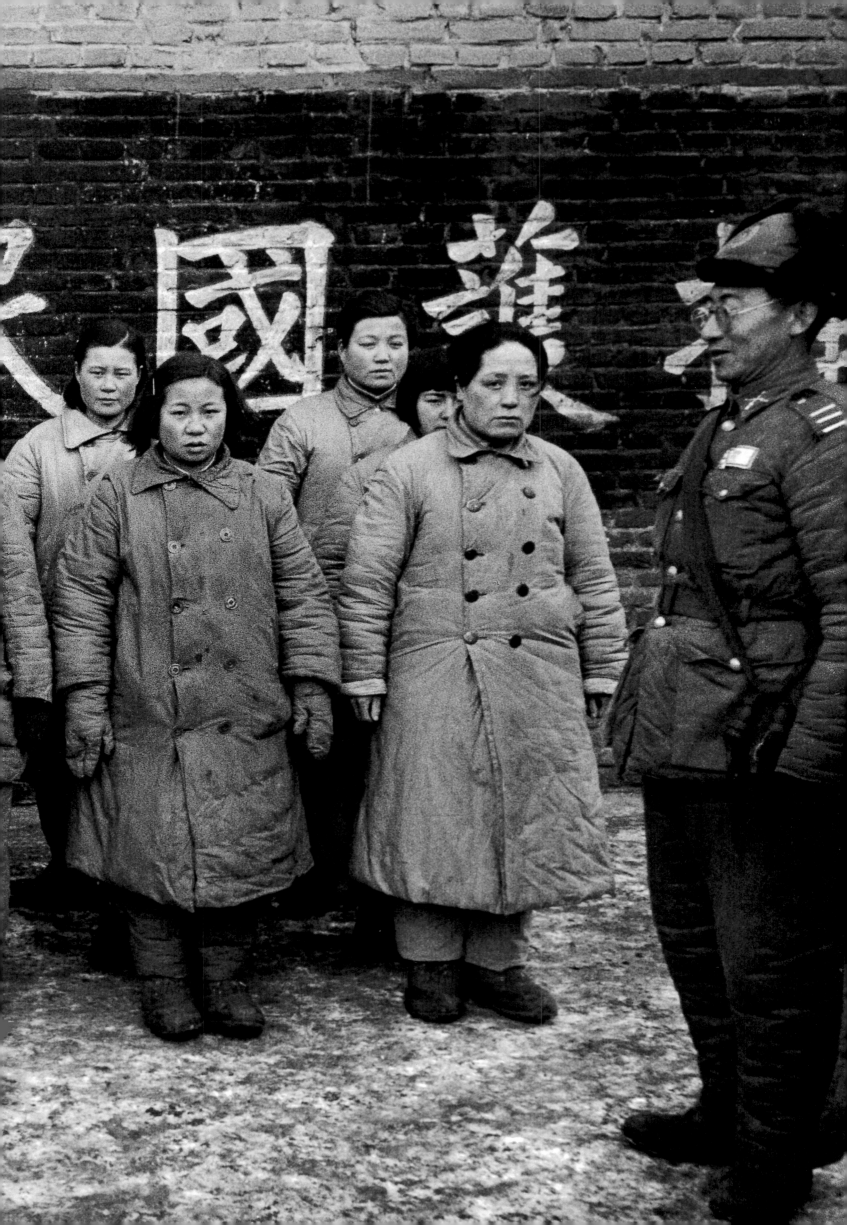

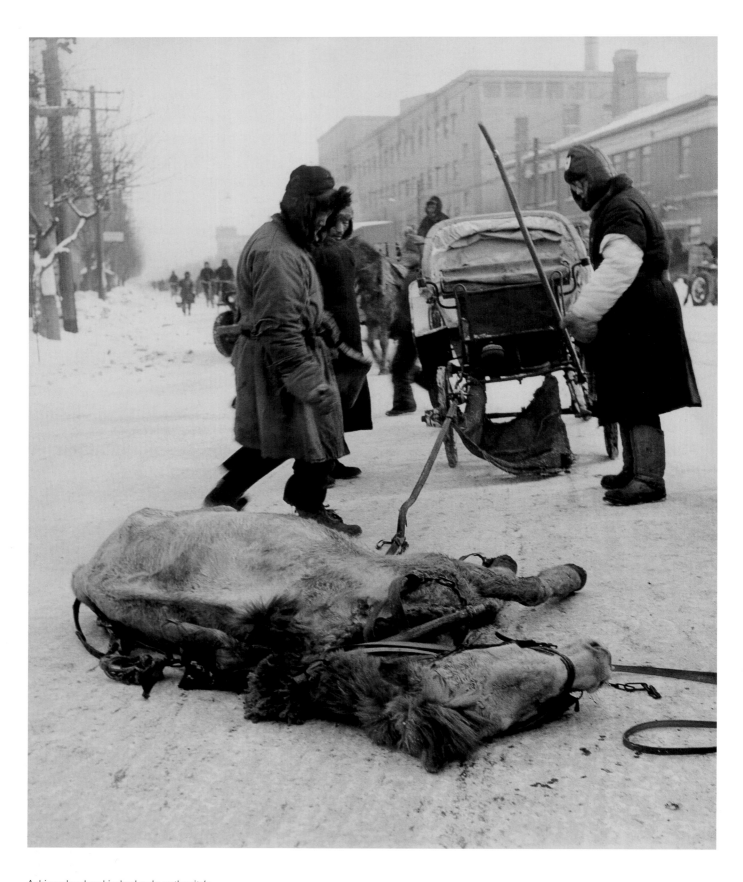

A driver abandons his dead mule on the city's
main street. Mukden, January 1948.

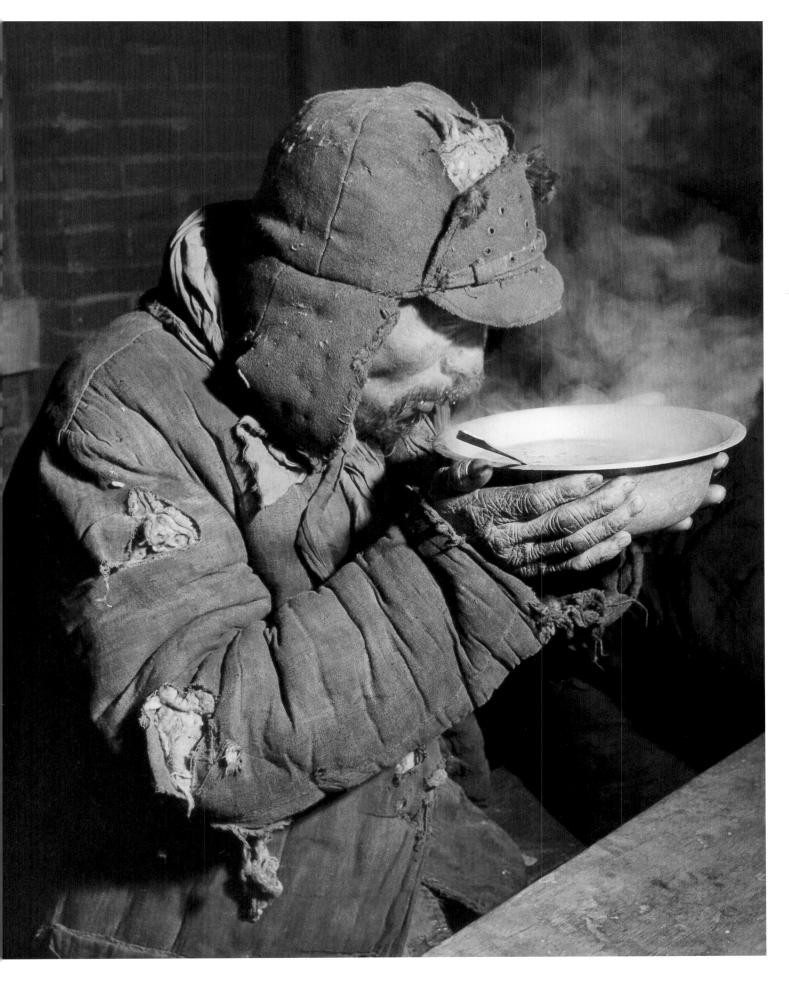

An ex-soldier drinks bean and millet gruel at an aid station
run by American Baptists. Mukden, January 1948.

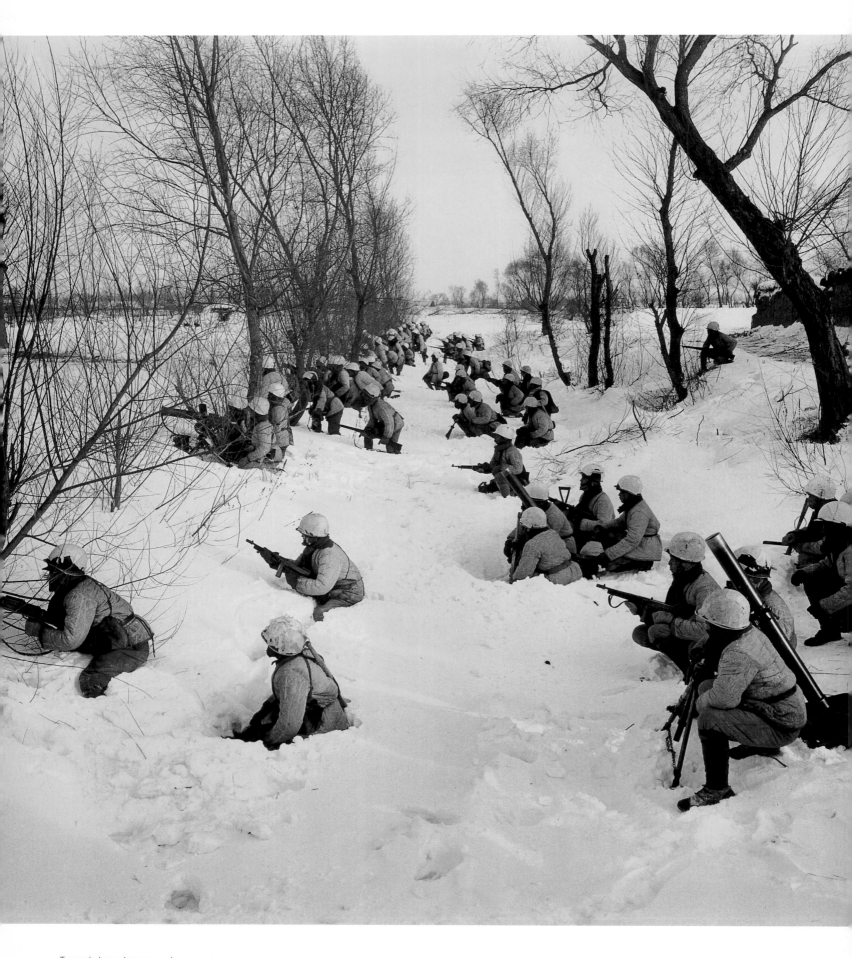

Troops in knee-deep snow demonstrate
defensive positions. Mukden, January 1948.

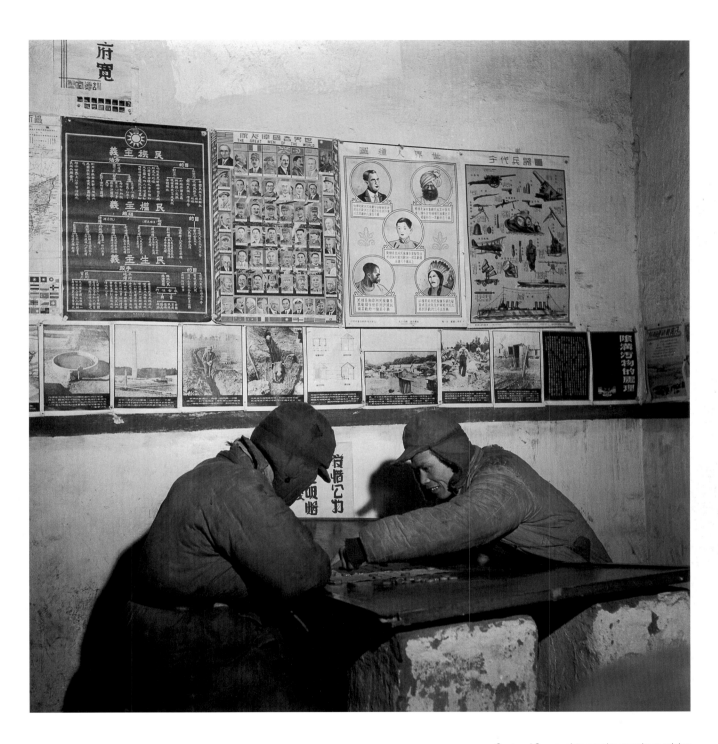

Captured Communists are shown to be receiving
lenient treatment. Mukden, January 1948.

OVERLEAF Nationalist soldiers train with a
cannon dug into the snow. Mukden, January 1948.

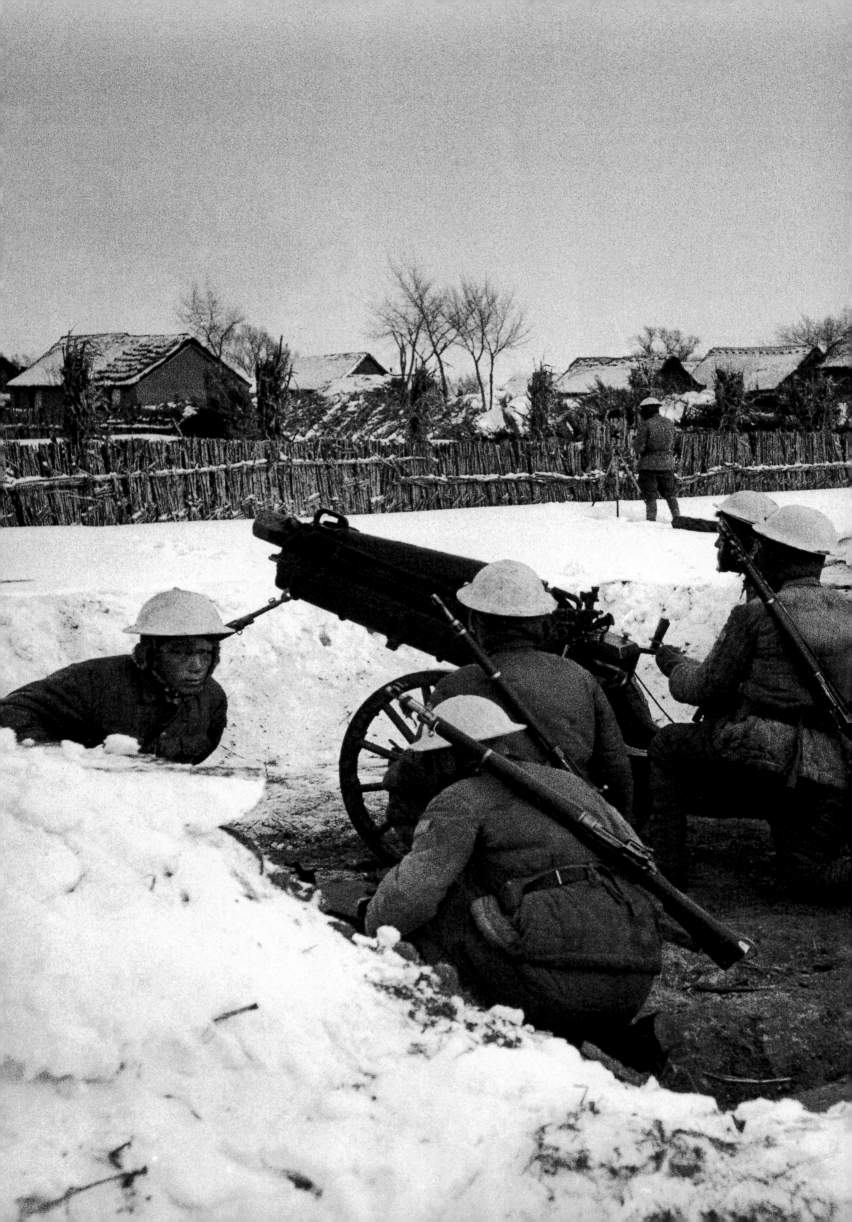

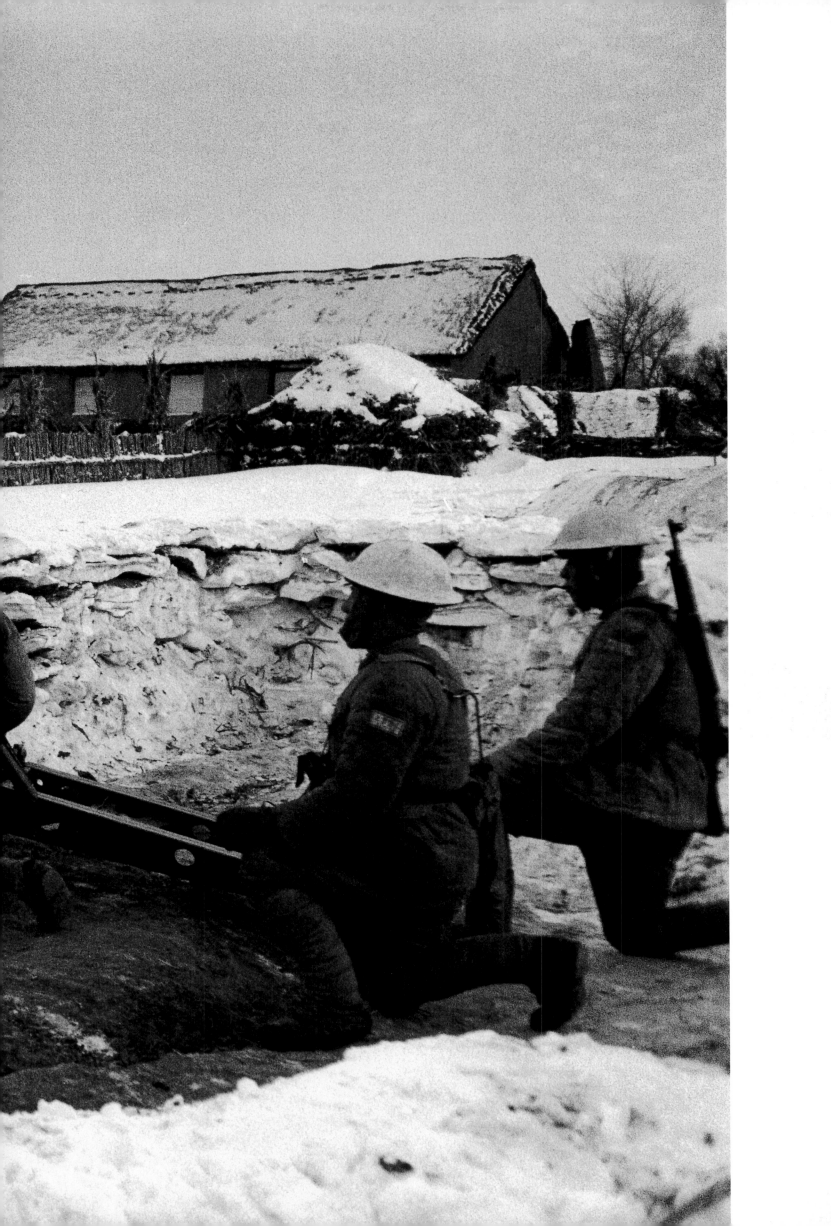

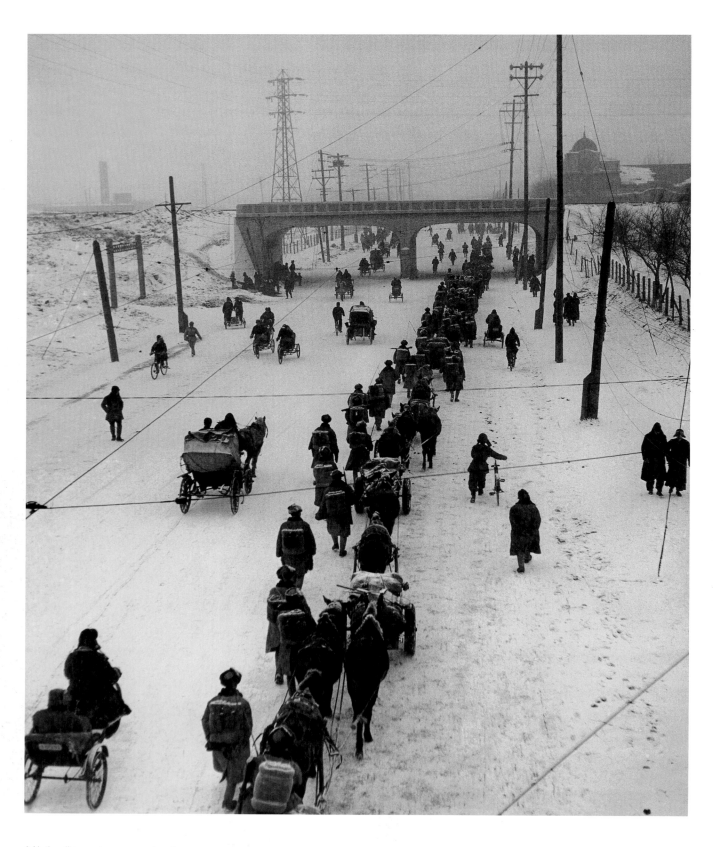

A Nationalist supply caravan enters the
threatened city. Mukden, January 1948.

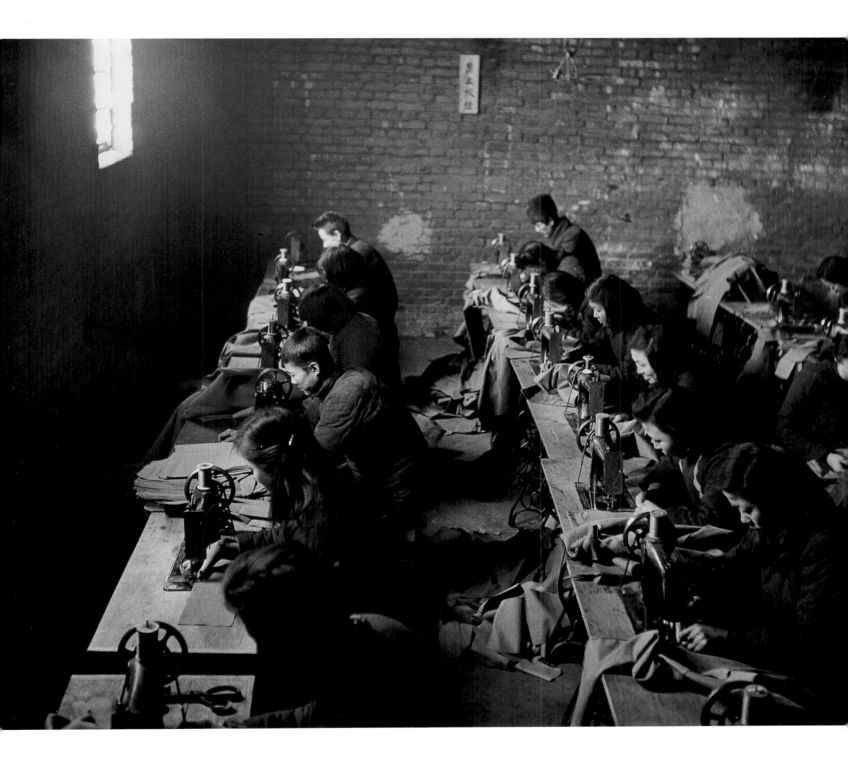

Workers sew uniforms inside a military compound.
Mukden, October 1948.

After the defeat of a Communist raiding party in Songjiang, southwest of Shanghai, the local Nationalist garrison chief shows captured weapons and prisoners, then allows a photographer to venture beyond the village wall. Trussed bodies lie disemboweled on the riverbank, and the head of Communist guerrilla leader Ding Xishan hangs from a spike. *Life* publisher Henry R. Luce refused to run the photographs.

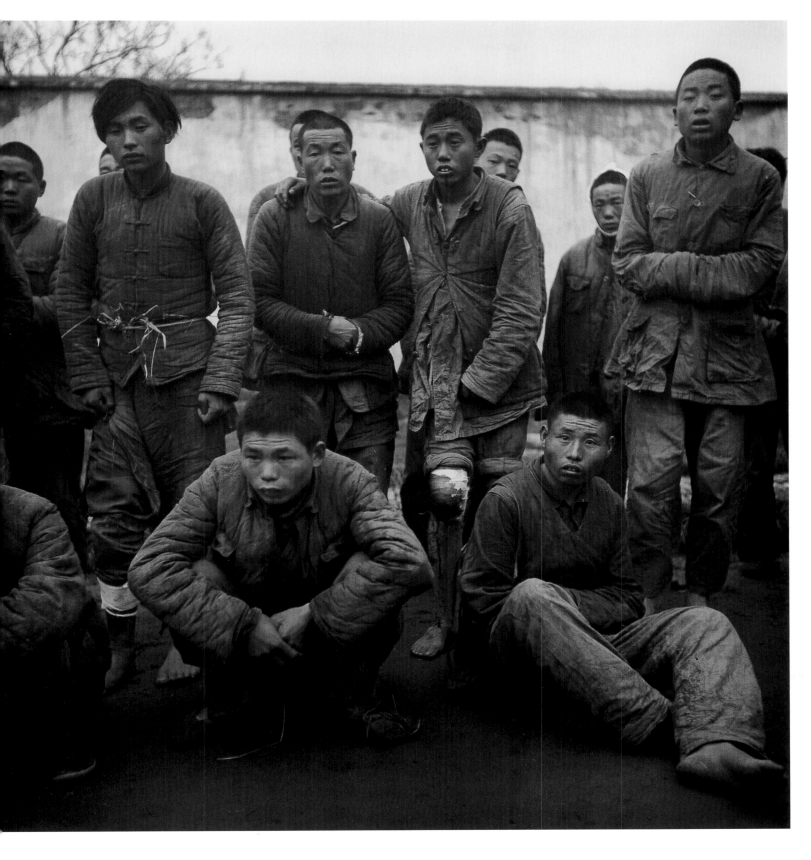

Captives are displayed after a Nationalist victory.
Songjiang, February 1948.

OVERLEAF Communist prisoners, trussed
and disemboweled, line the riverbank.
Songjiang, February 1948.

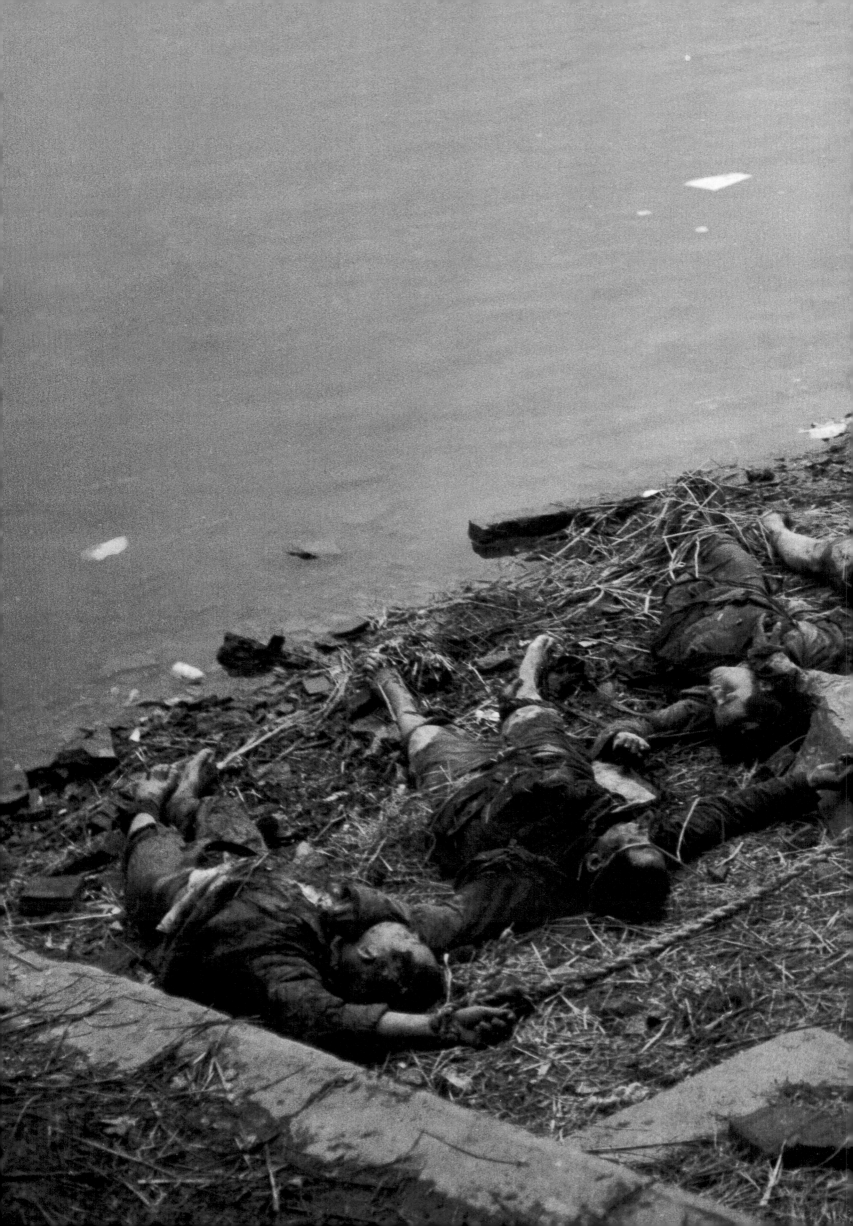

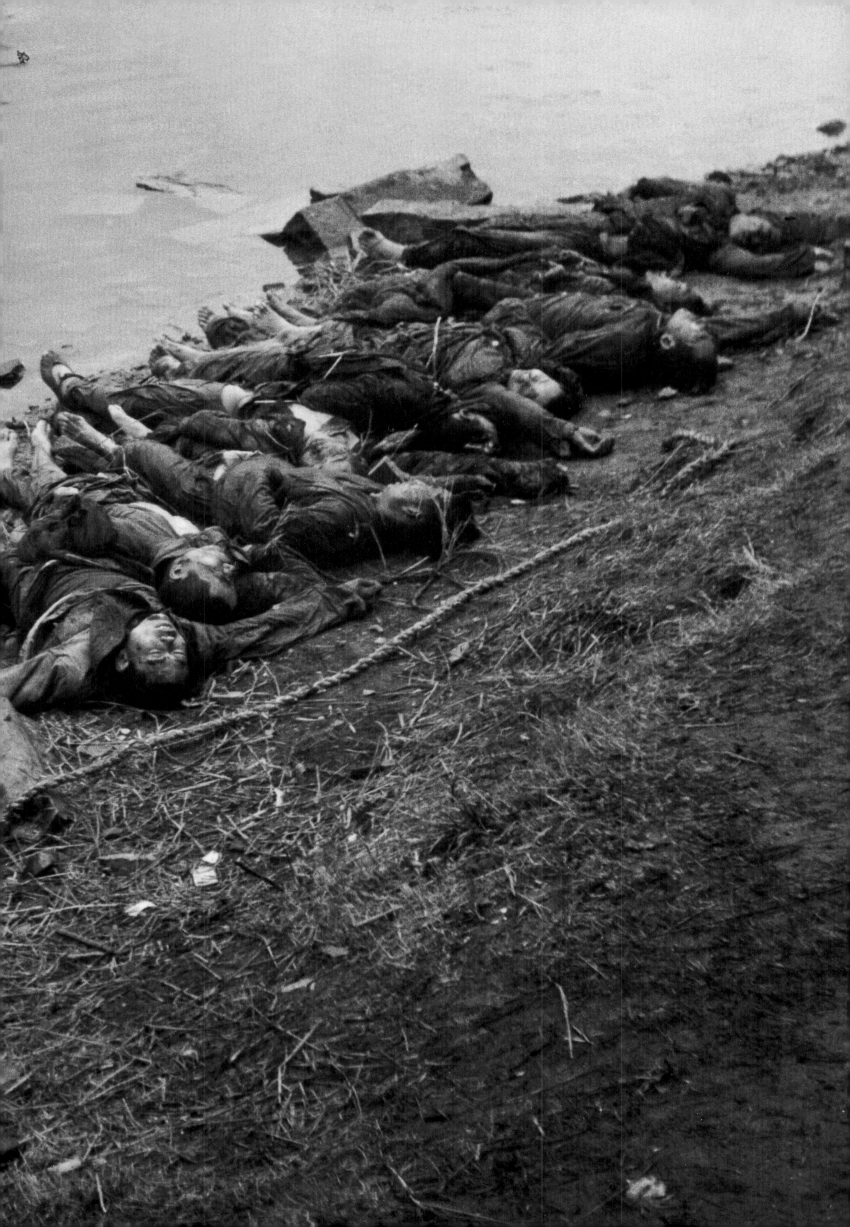

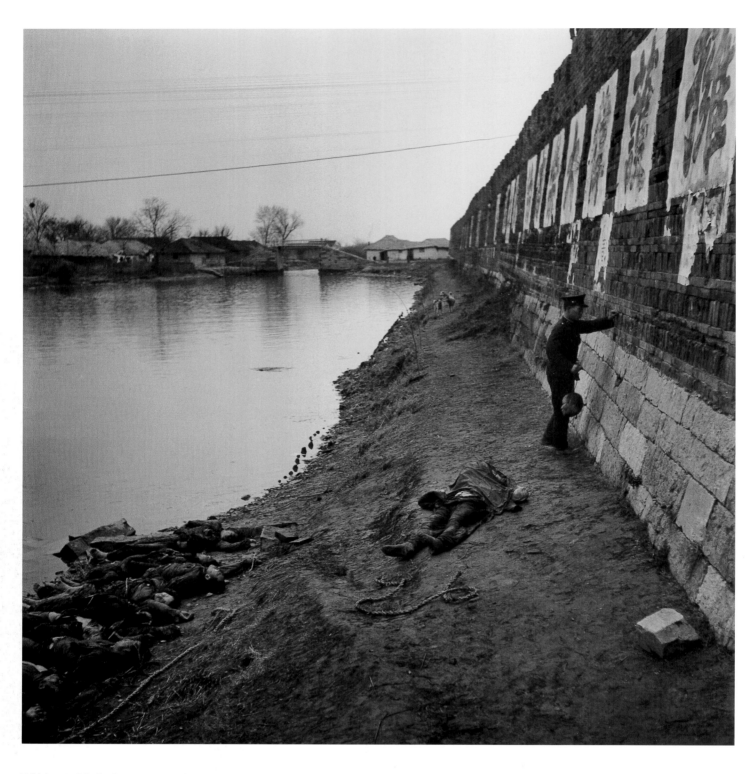

Wild dogs wait in the distance as a garrison soldier
mounts the Communist guerrilla leader's severed
head on a wall. Songjiang, February 1948.

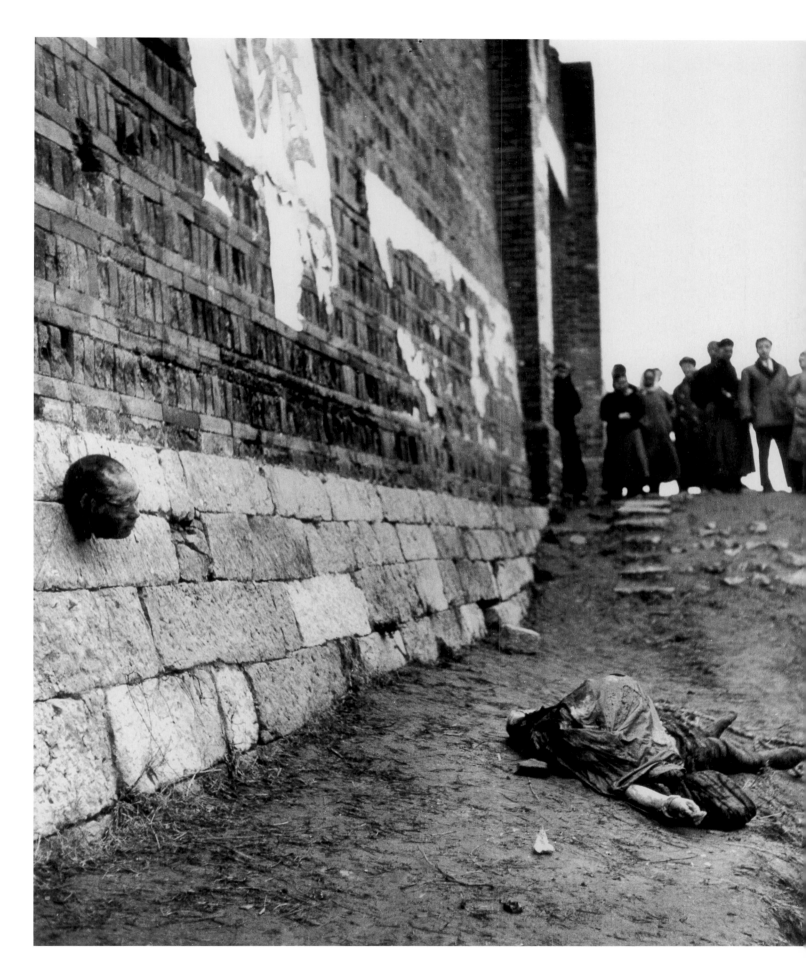

A sullen crowd views the blood-soaked corpse.
Songjiang, February 1948.

Extremes collide in Shanghai's streets, as shopkeepers, laborers, vendors, and beggars struggle to subsist in a deteriorating economy. Inflation strikes hard at workers, who receive stacks of devalued paper currency as weekly wages.

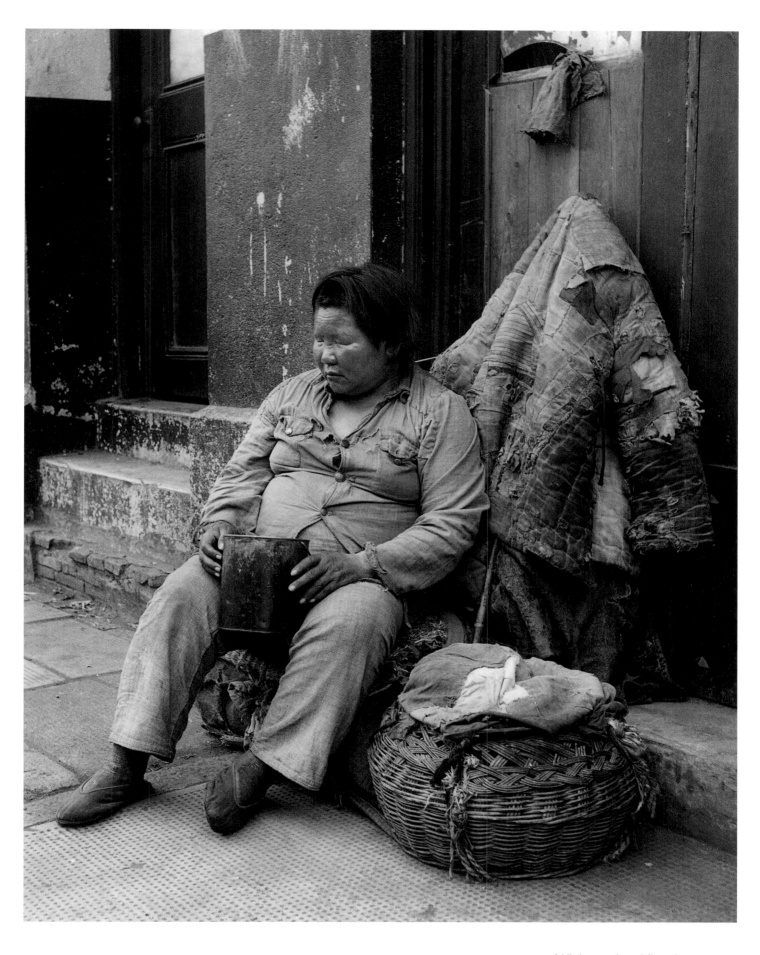

A blind woman begs daily on the same stoop.
Shanghai, April 1948.

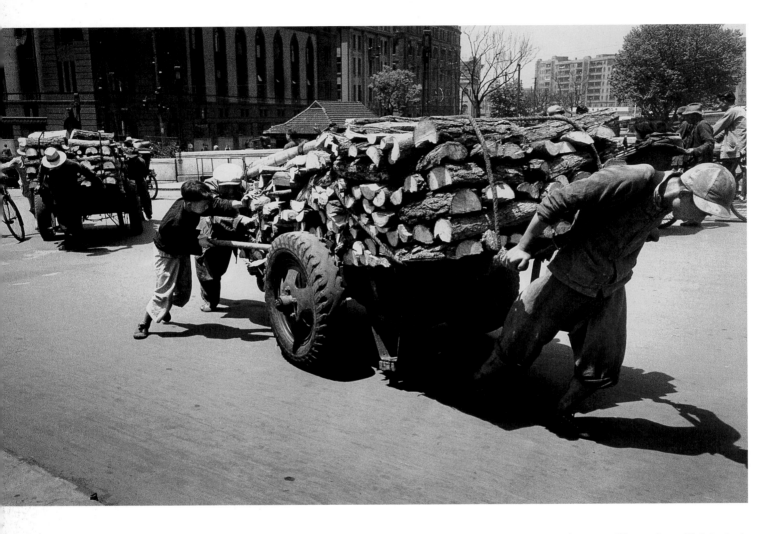

A ten-year-old boy pushes as his father hauls
a load of firewood. Shanghai, April 1948.

A housewares shop sells brushes and twine.
Shanghai, March 1948.

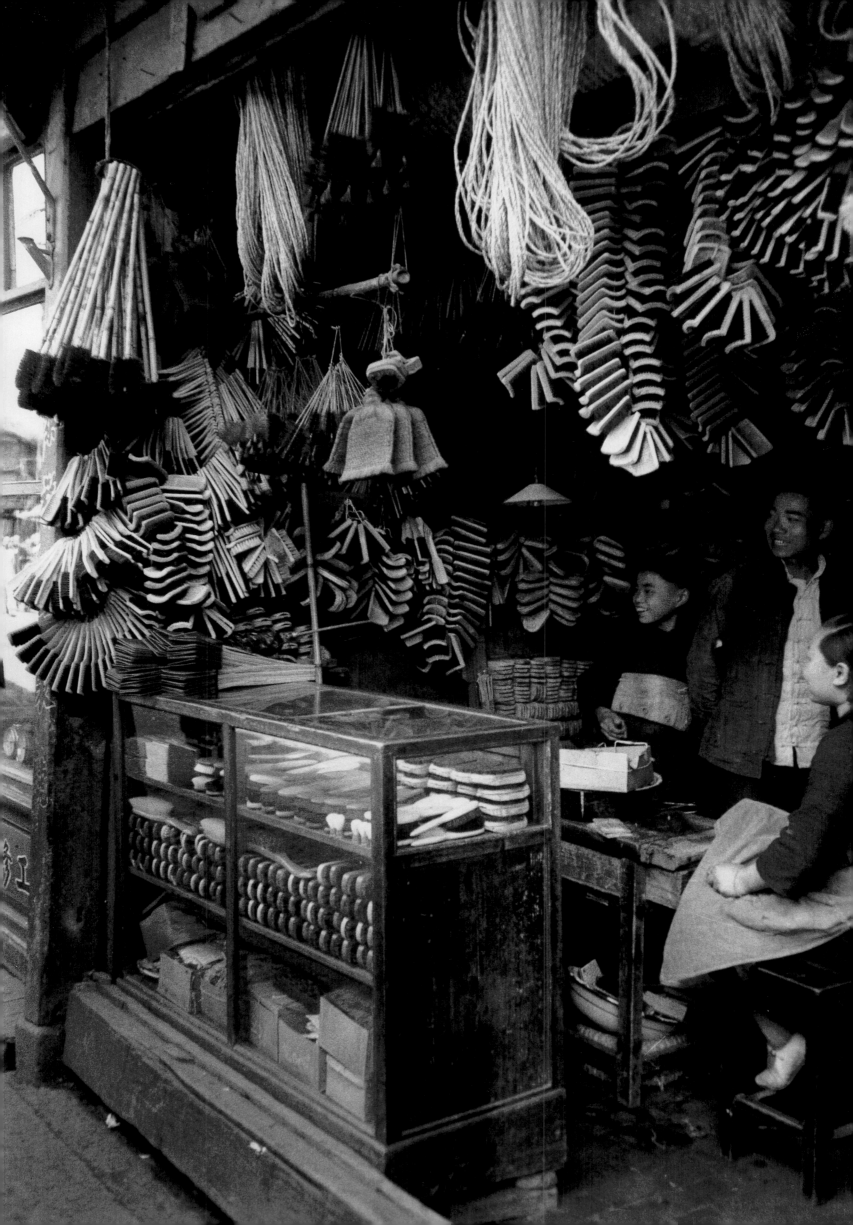

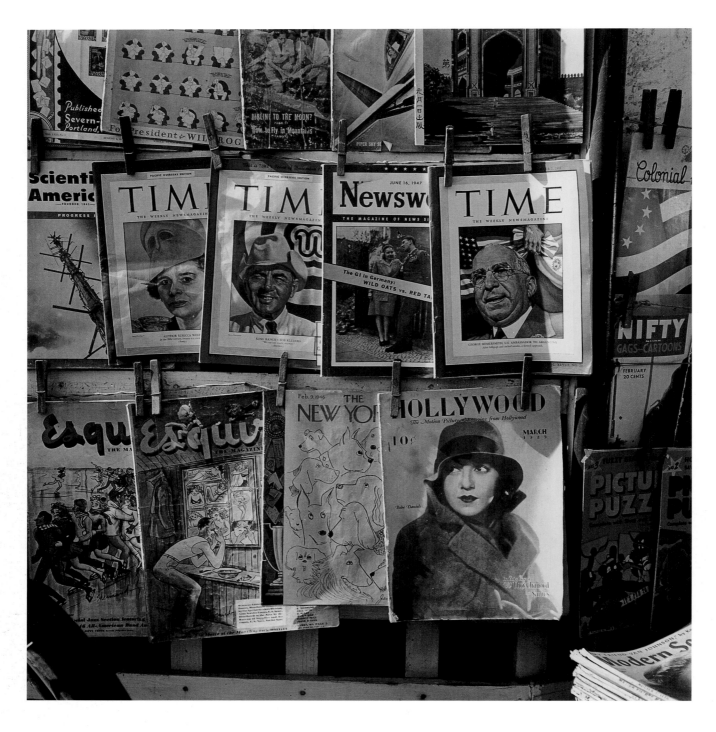

A sidewalk stand displays recent American
magazines. Shanghai, January 1948.

A boy tests his skill at an improvised
shooting gallery. Shanghai, February 1948.

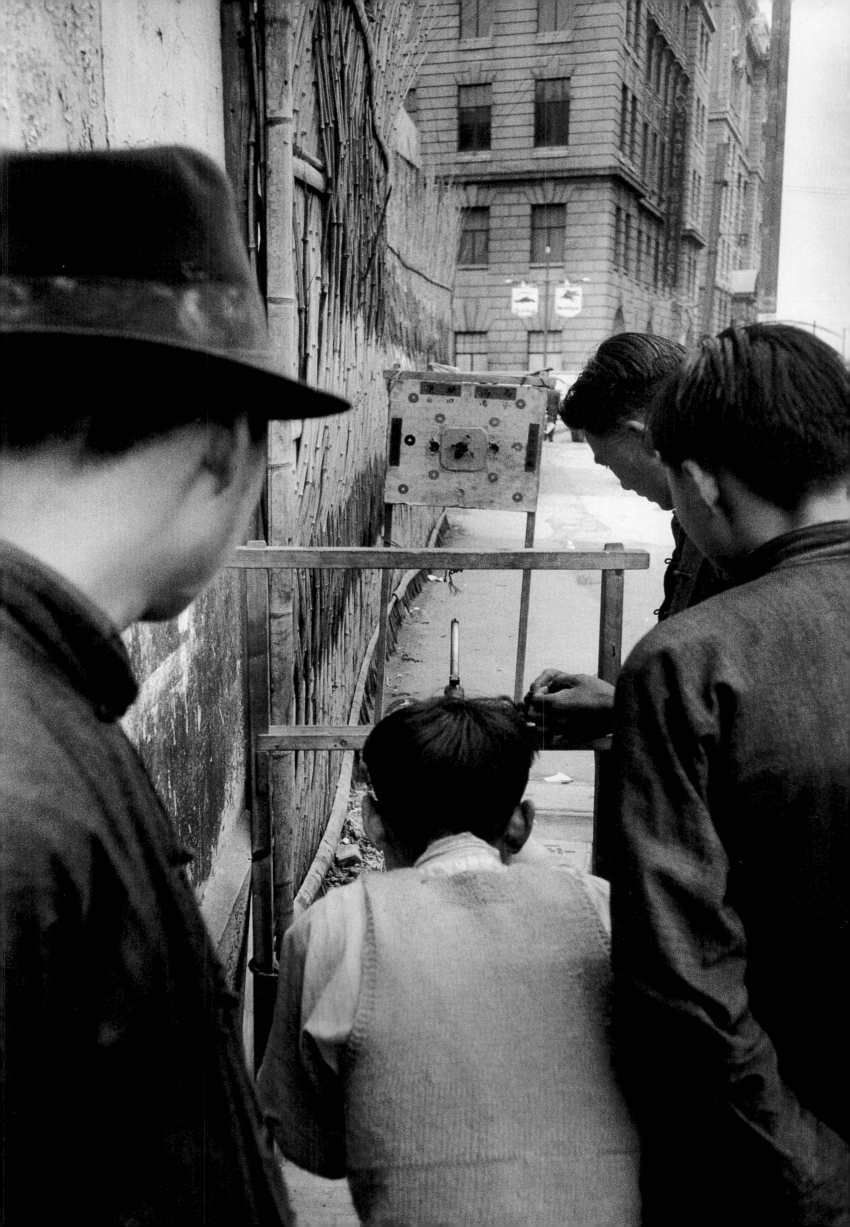

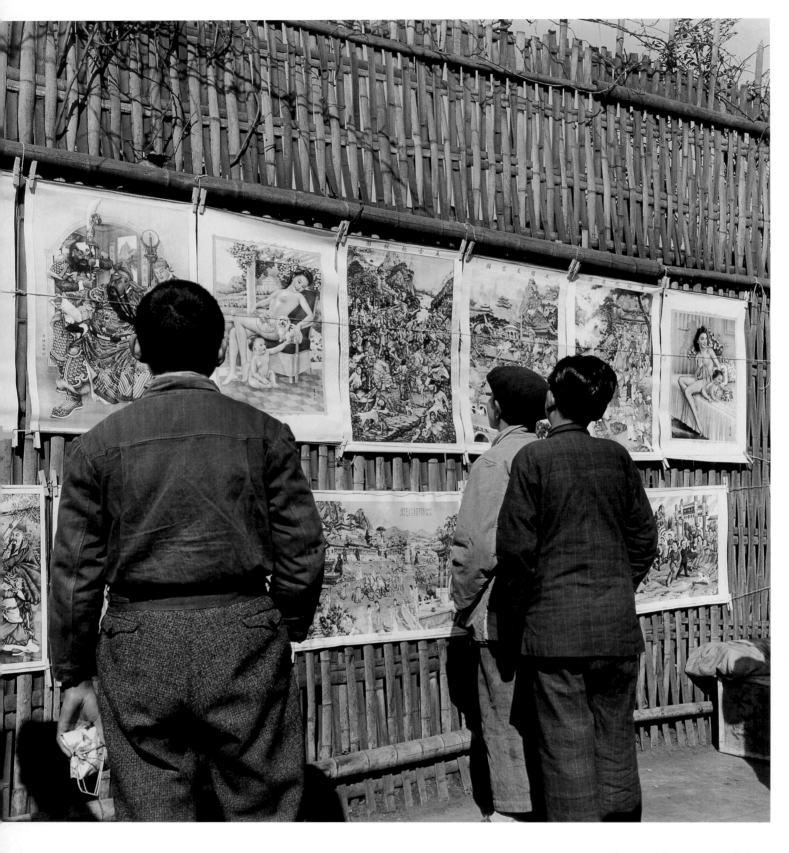

Prints for sale hang on a sidewalk fence.
Shanghai, January 1948.

A woman drying fish secures the family's sampan
on Suzhou Creek. Shanghai, March 1948.

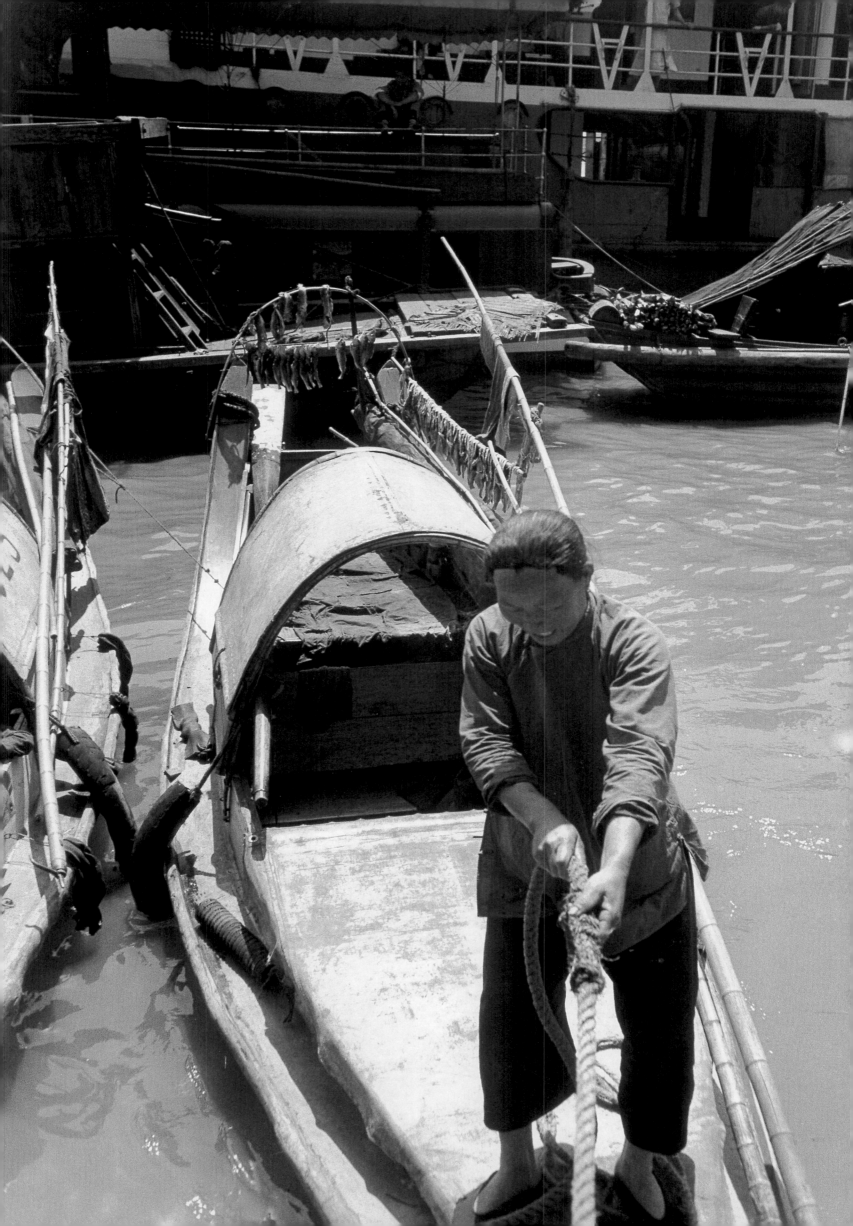

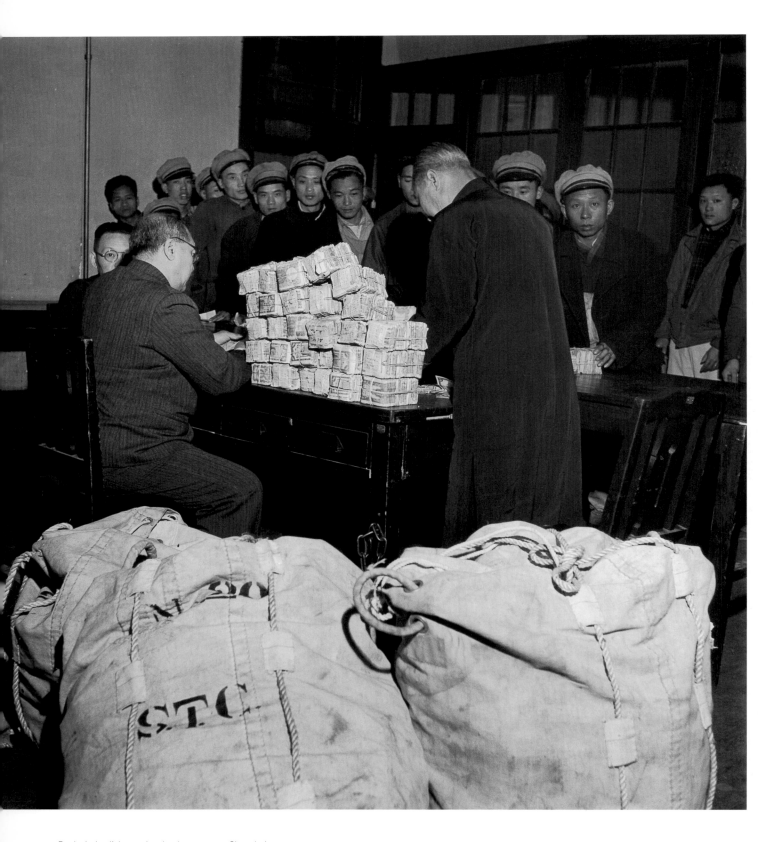

Bank clerks disburse devalued currency to Shanghai
Telephone Company workers. Shanghai, March 1948.

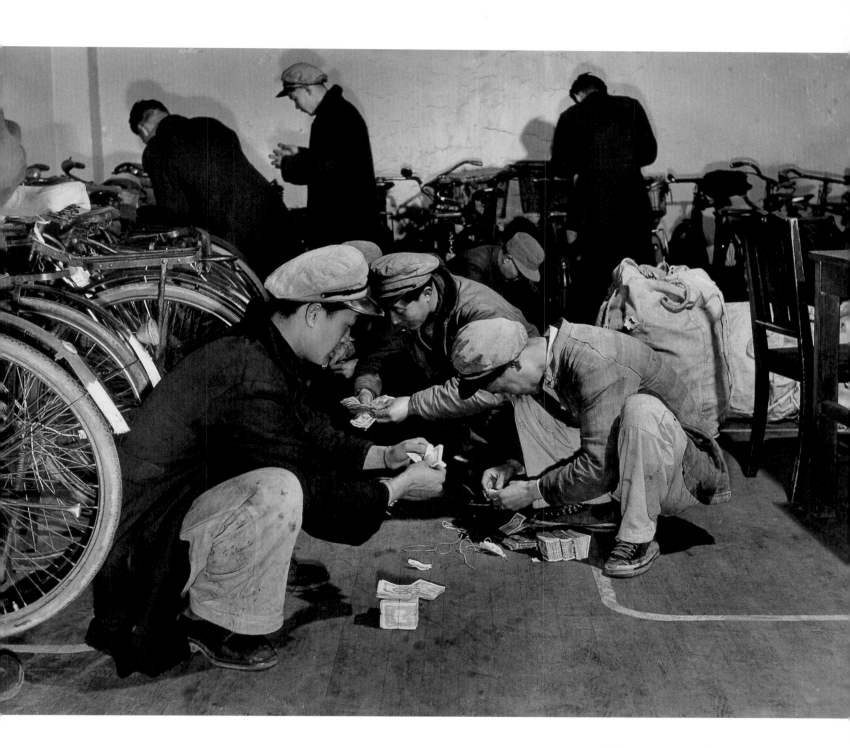

Workers count their pay. Shanghai, March 1948.

Cabaret dancers and textile workers, encouraged by underground Communists, organize marches and strikes to protest rising fees, soaring prices, and harsh labor conditions. The U.S. decision to provide economic aid to Japan just three years after China's wartime occupation sends thousands of university student demonstrators into the streets.

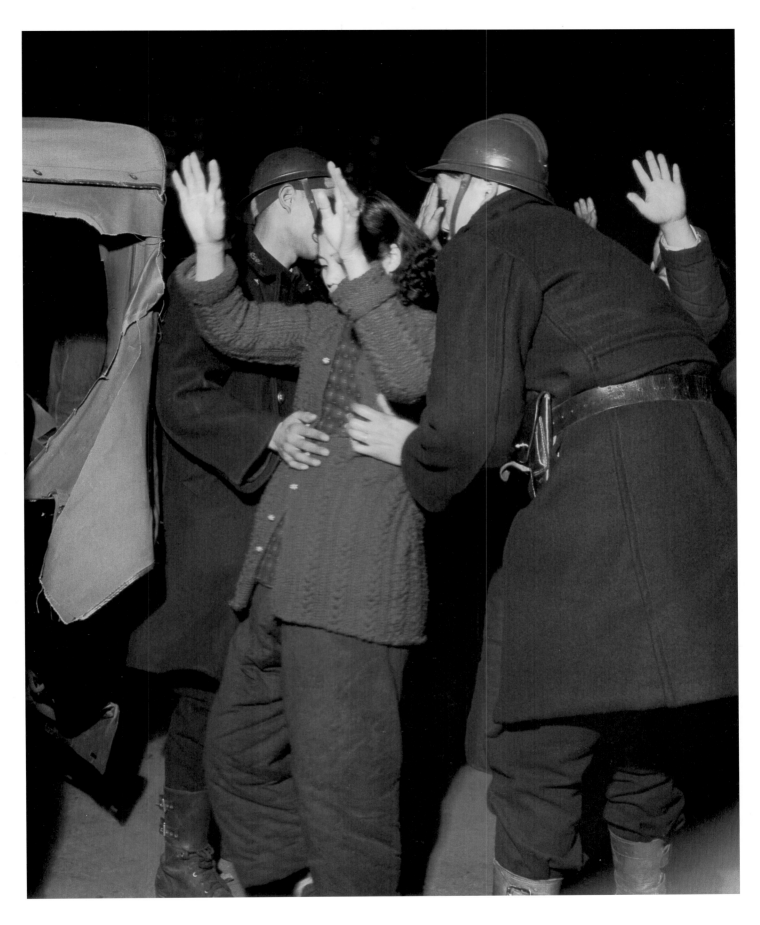

Police frisk a lineup of striking women workers after
a textile mill riot. Shanghai, February 1948.

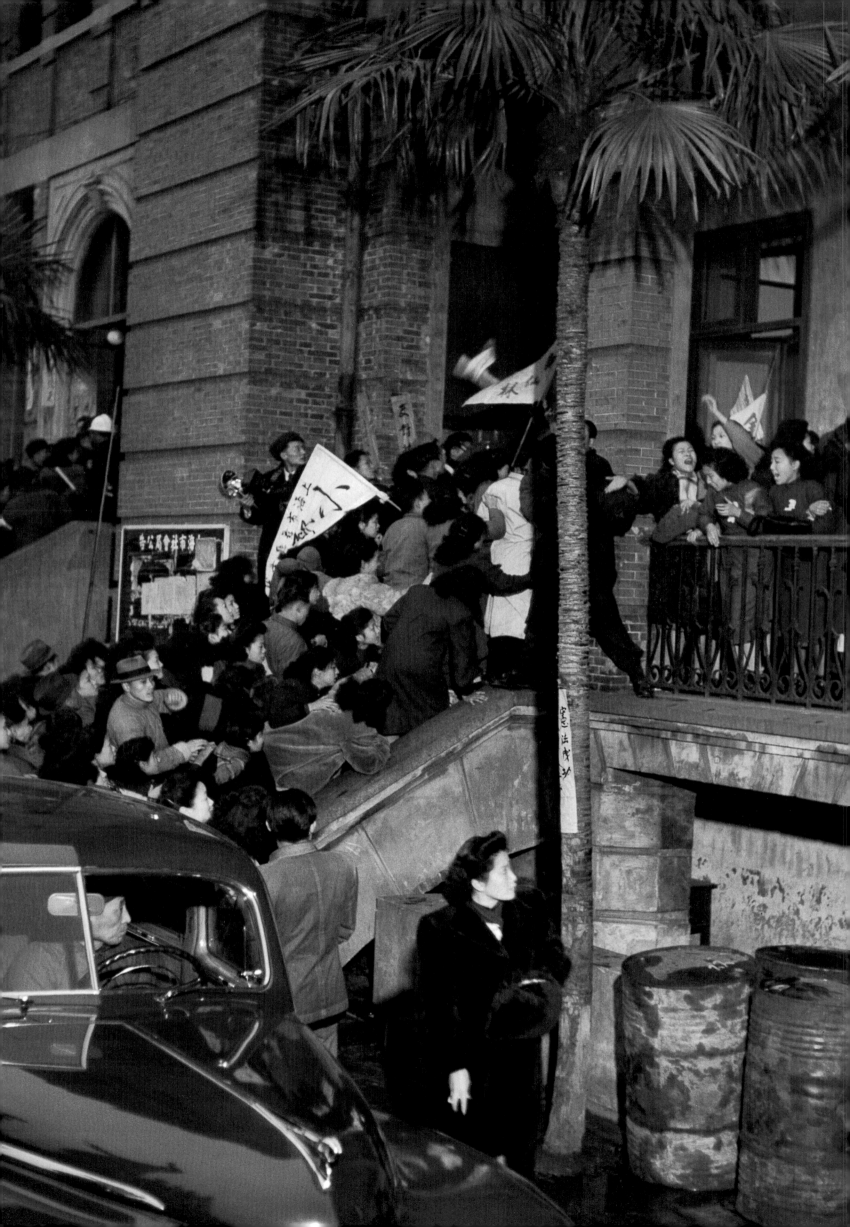

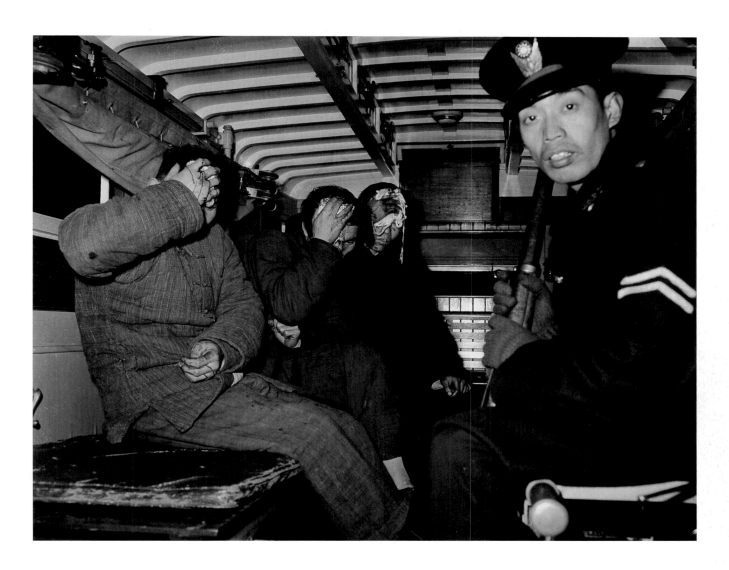

A police officer guards bloodied cotton mill strikers.
Shanghai, February 1948.

Dance hall hostesses mob the Bureau of Social
Affairs to protest an increase in license fees.
Shanghai, January 1948.

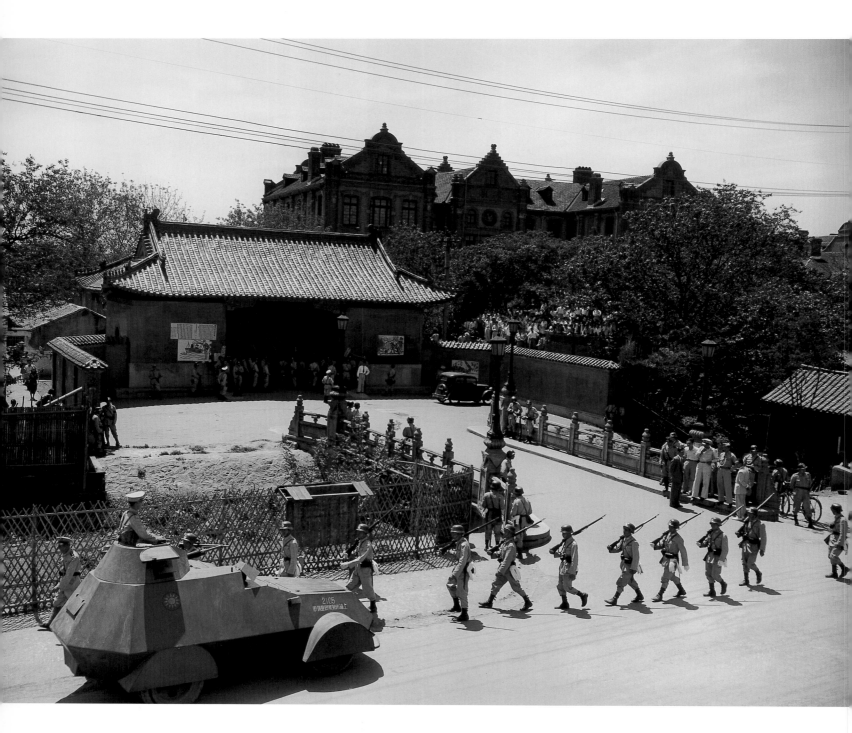

Soldiers and an armored car prevent
Jiaotong University students from joining a
mass demonstration. Shanghai, June 1948.

A poster outside the university gate
denounces the U.S. decision to fund Japan's
postwar recovery. Shanghai, June 1948.

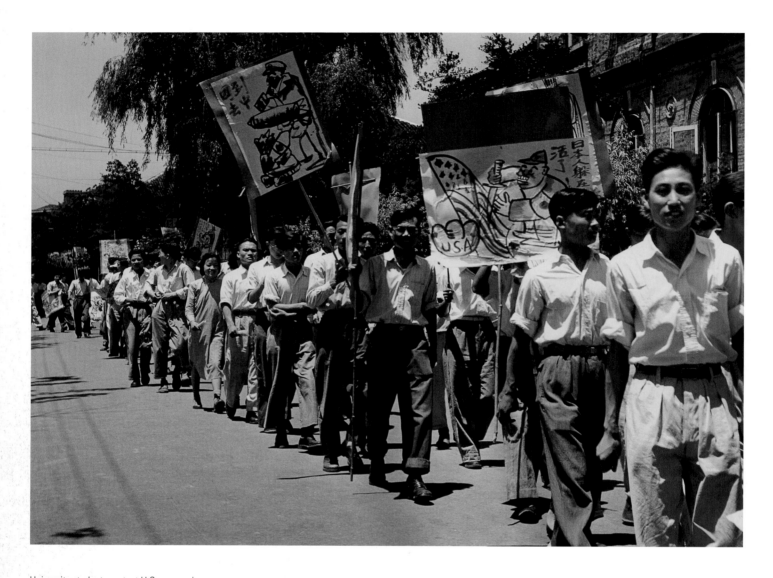

University students protest U.S. economic
aid to Japan. Shanghai, June 1948.

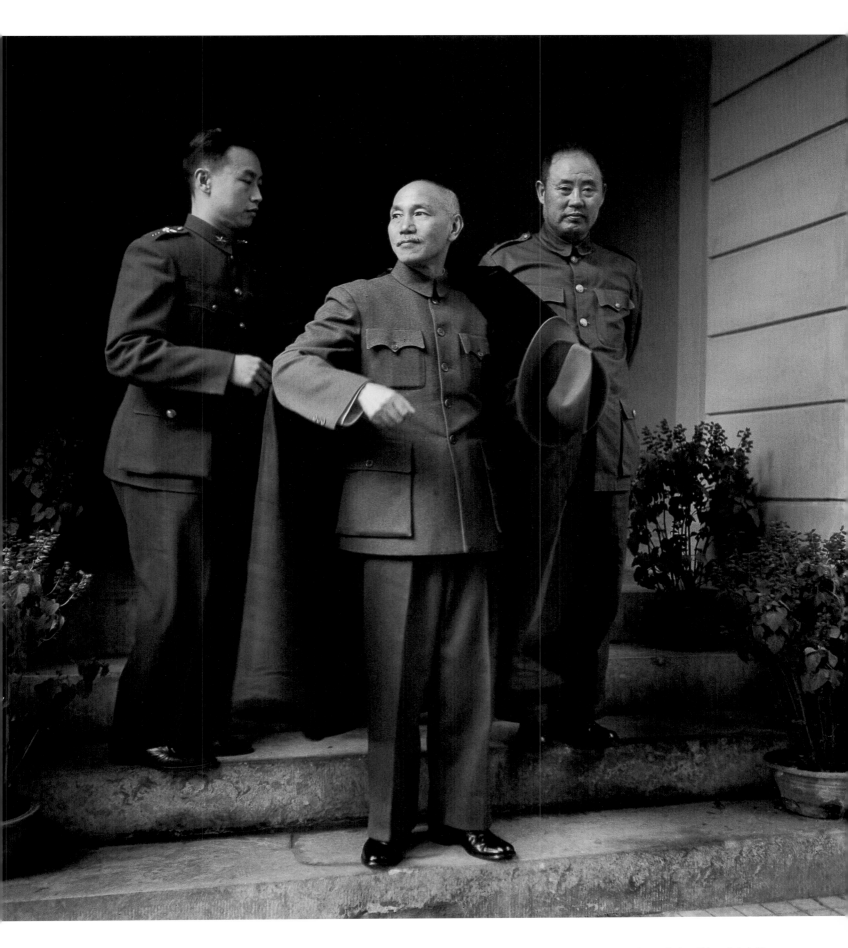

An aide holds Generalissimo Chiang Kai-shek's coat after a conference with General Fu Zuoyi to plan the defense of Beijing. Beijing, October 1948.

Nationalist troops retreat and regroup after Communist forces, victorious in Manchuria, press south to win a decisive battle at Xuzhou, threatening Chiang Kai-shek's capital at Nanjing. Demoralized soldiers wait along the rail line for orders and transport, while anxious civilians seek passage south to escape fighting and food shortages.

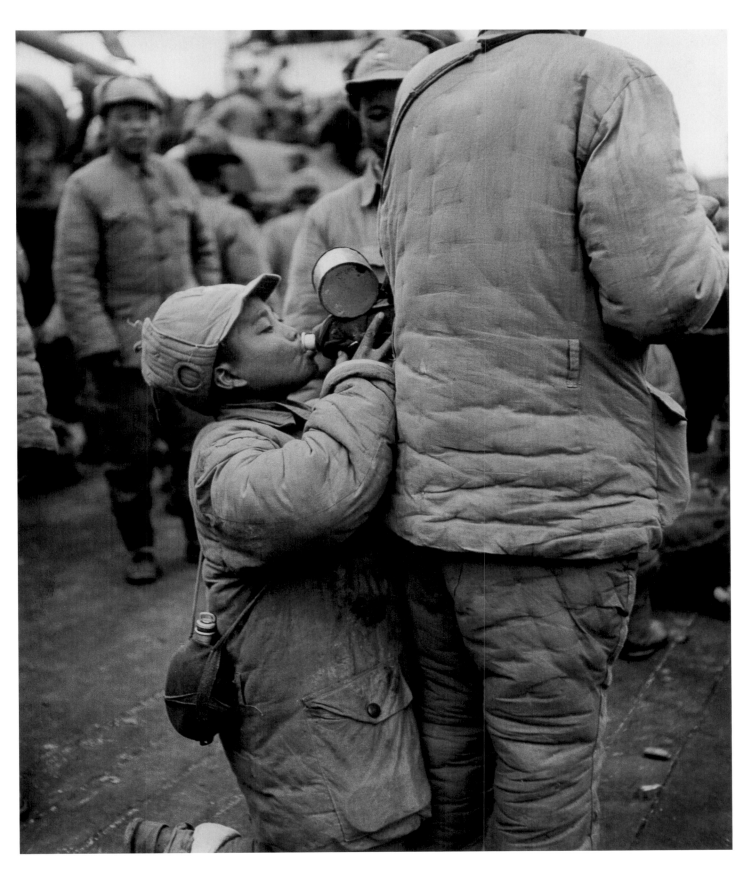

A soldier's helper, evacuated with troops from the
northern front, drinks from a friend's canteen.
Shanghai, November 1948.

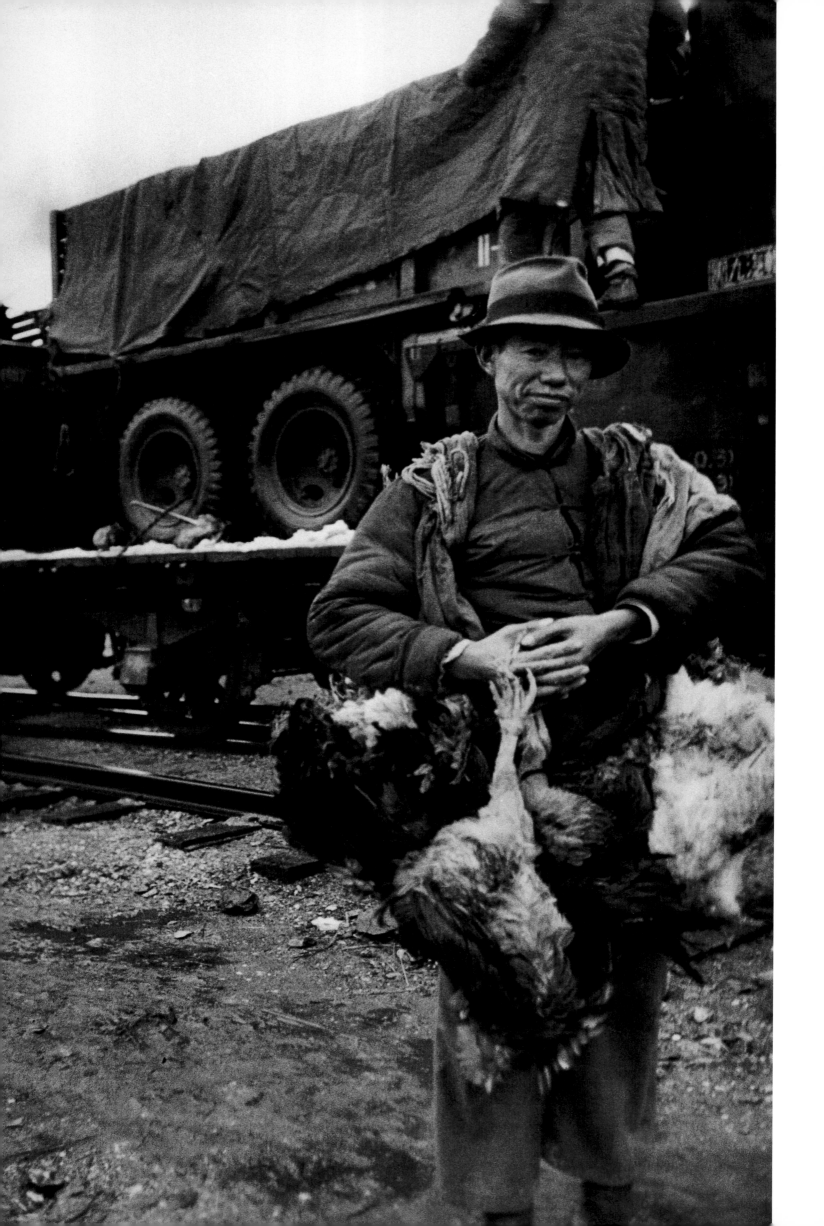

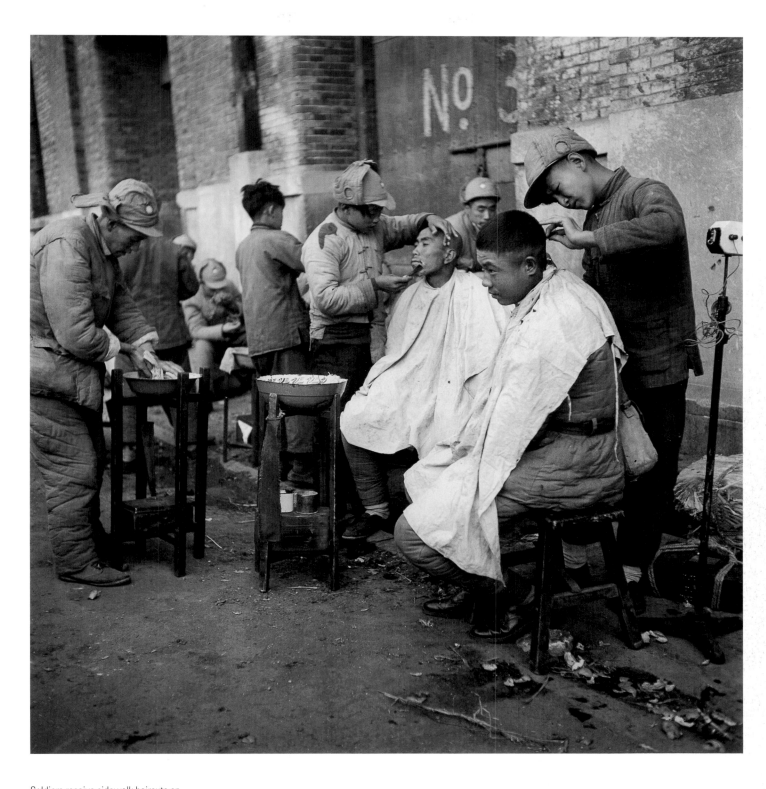

Soldiers receive sidewalk haircuts on
Huangpu Road after their retreat from
Manchuria. Shanghai, October 1948.

A farmer unsuccessfully peddles chickens to
troops in transit. Pukou, November 1948.

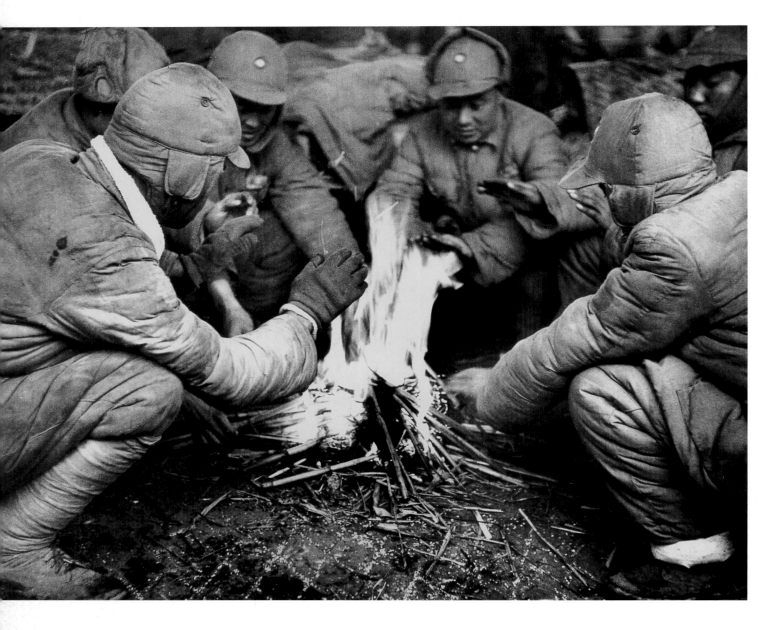

Troops warm their hands while waiting for
transport. Pukou, November 1948.

A young woman wearing a donated uniform holds
her baby in an open boxcar. Pukou, November 1948.

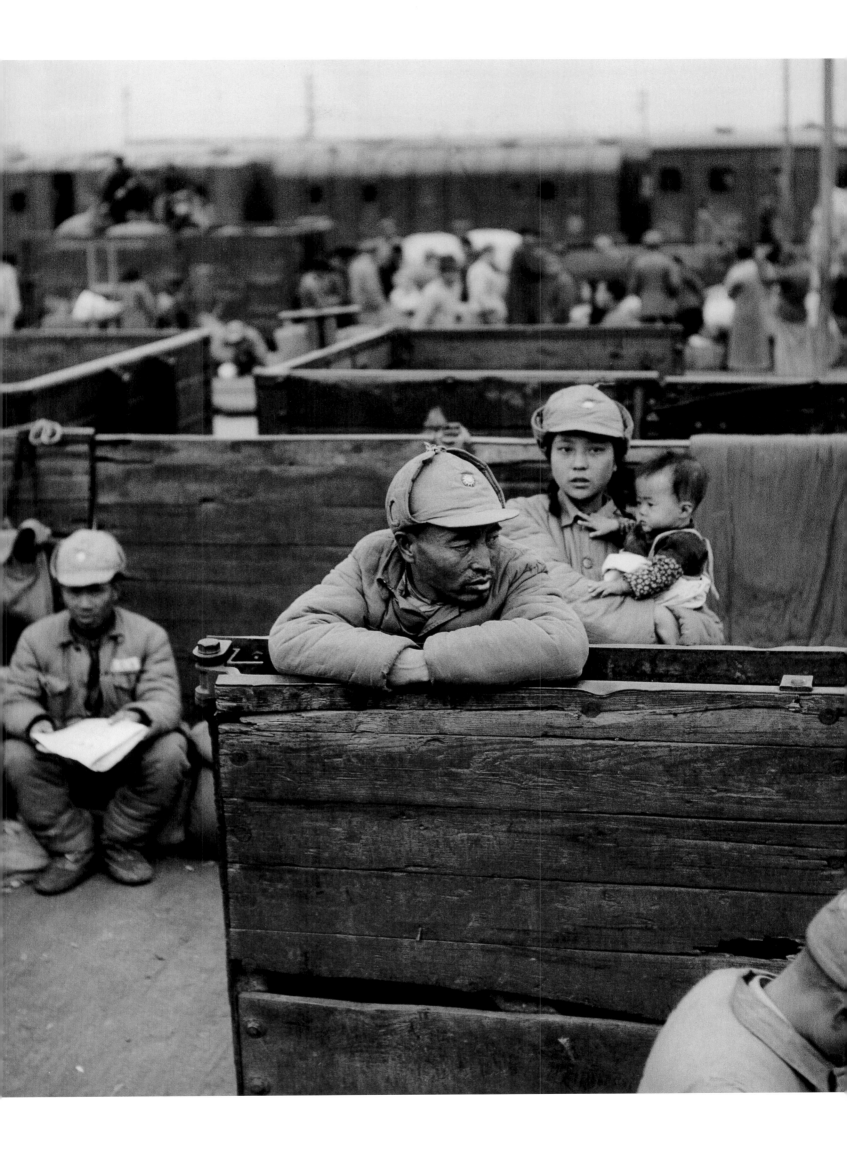

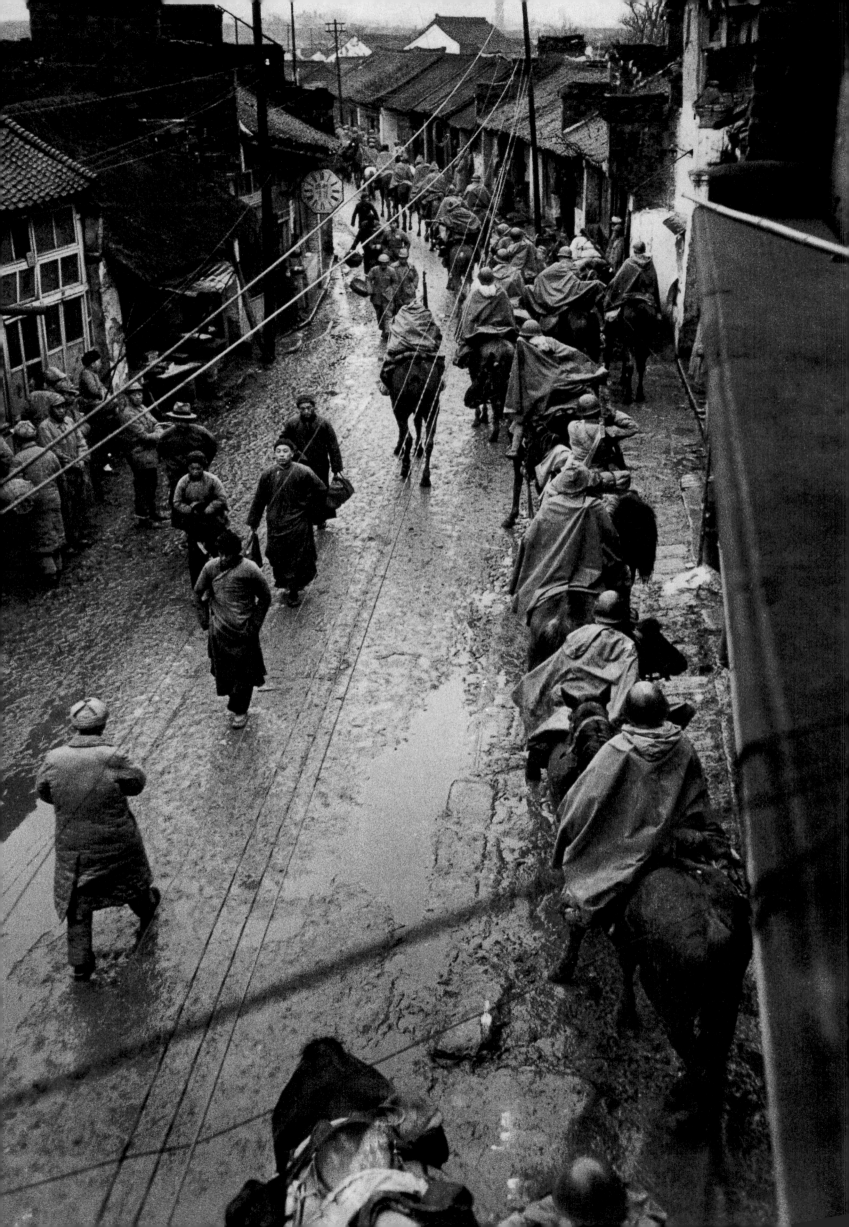

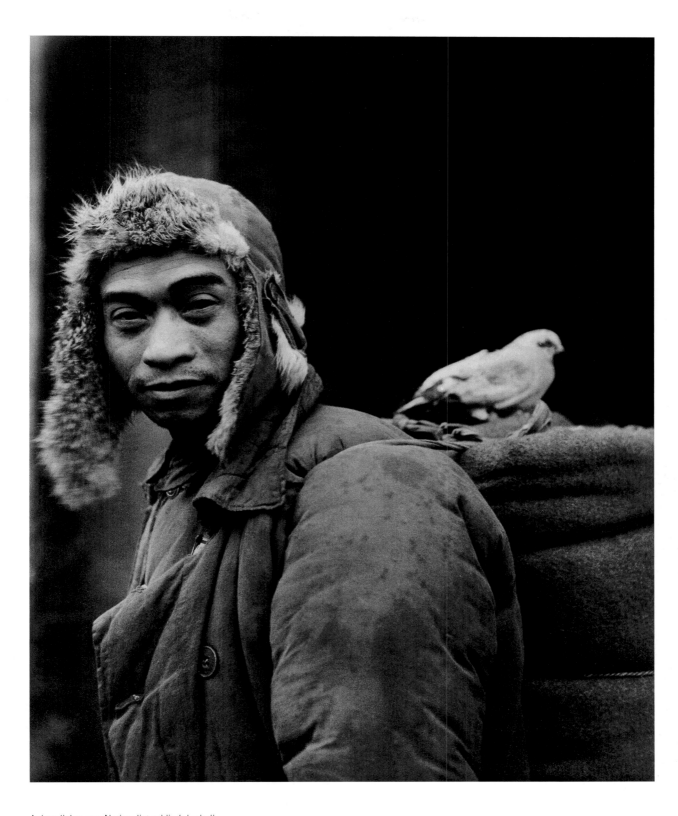

A dove lights on a Nationalist soldier's bedroll.
Bengbu, November 1948.

A cavalry company heads south in chilling rain along
the town's main street. Bengbu, November 1948.

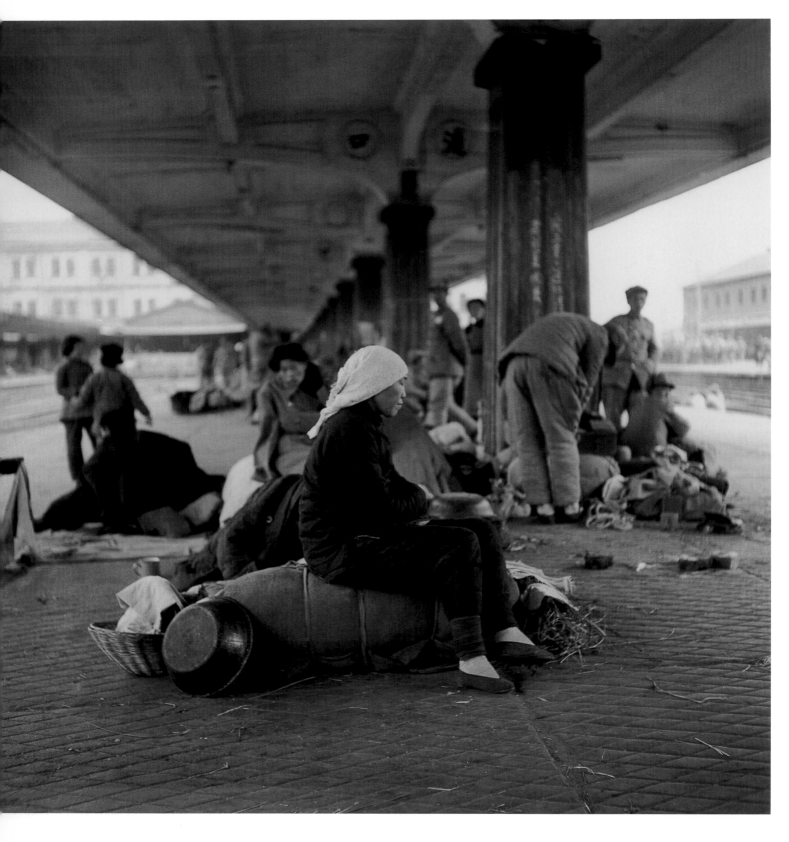

A woman with bound feet waits for a train.
Nanjing, November 1948.

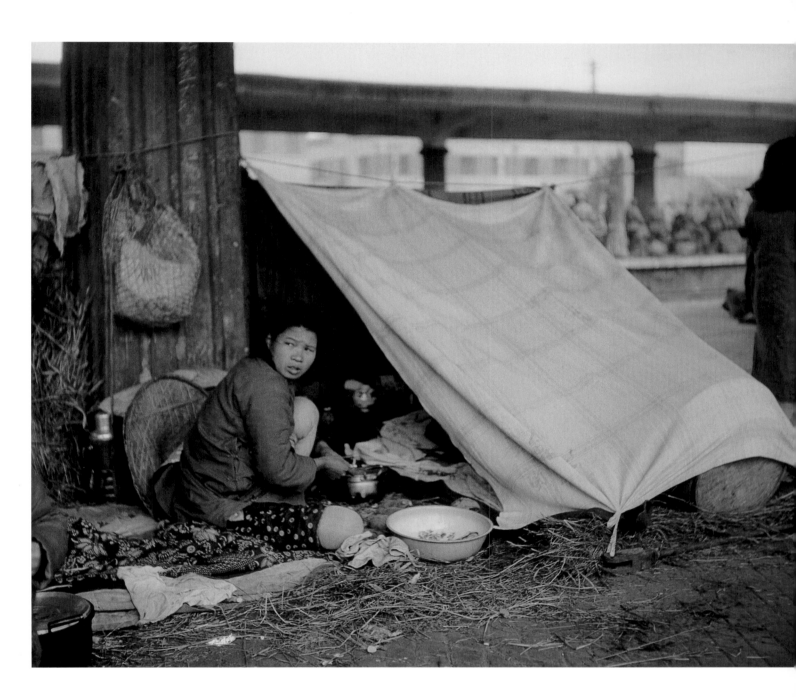

A family hoping for rail tickets camps for days under
a makeshift shelter. Nanjing, November 1948.

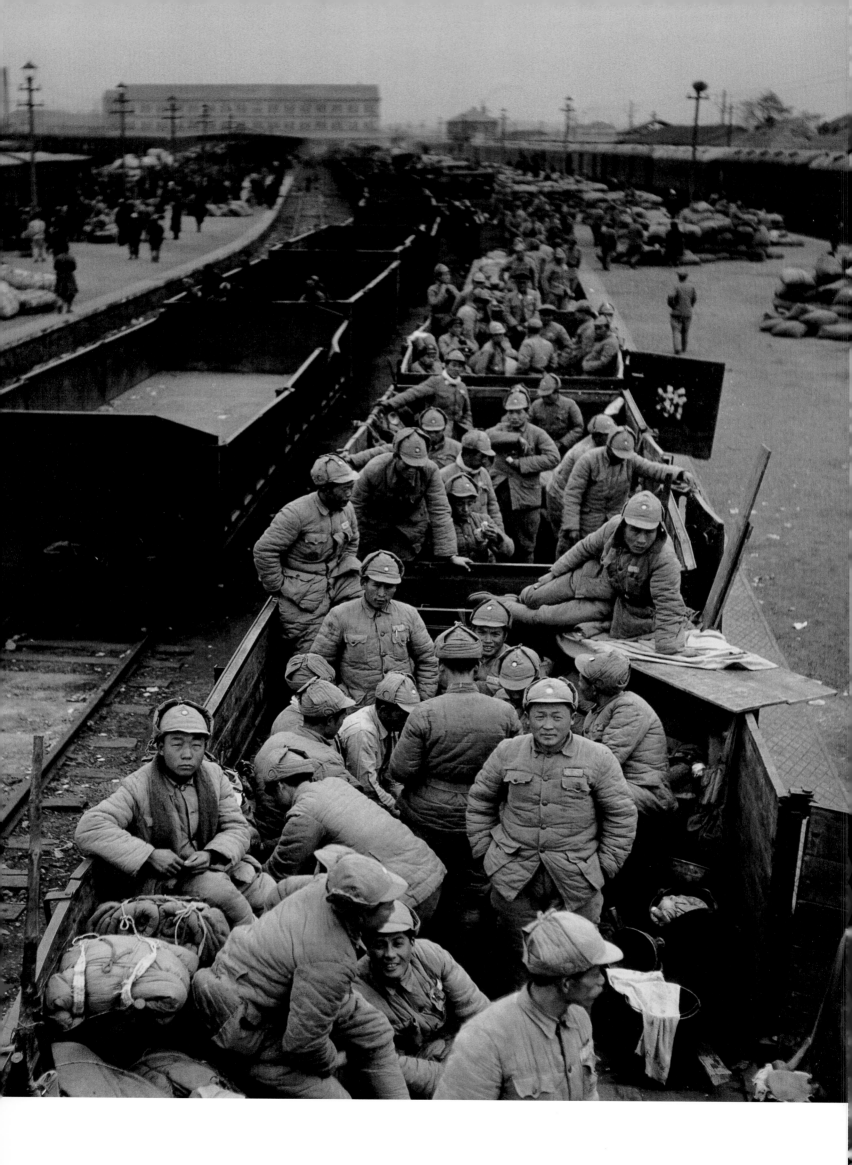

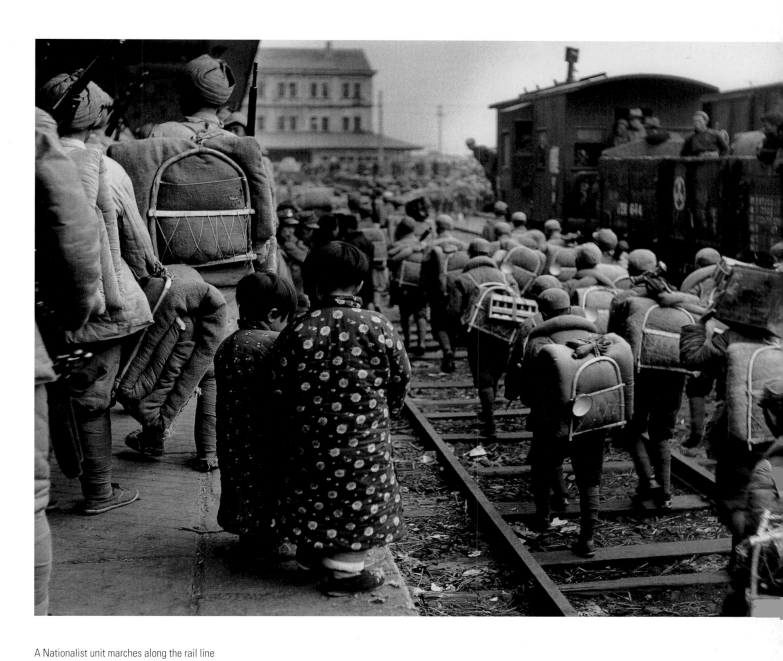

A Nationalist unit marches along the rail line
toward Shanghai. Nanjing, November 1948.

Soldiers in open troop cars await redeployment;
sacks of rice line the platform. Pukou, November 1948.

Business lags at the steamy bars near the Shanghai riverfront as the Communists draw closer to the city. The supply of foreign sailors on shore leave dwindles, and a ten o'clock shoot-to-kill curfew inhibits the city's once raucous nightlife.

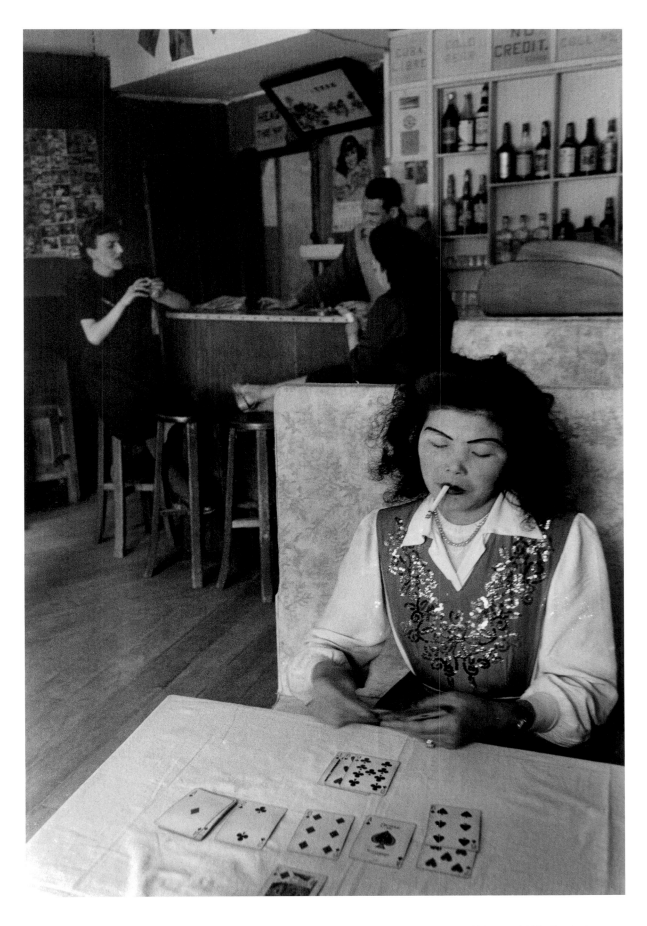

Chinese and White Russian hostesses
at the American Bar find few customers as
war approaches. Shanghai, April 1949.

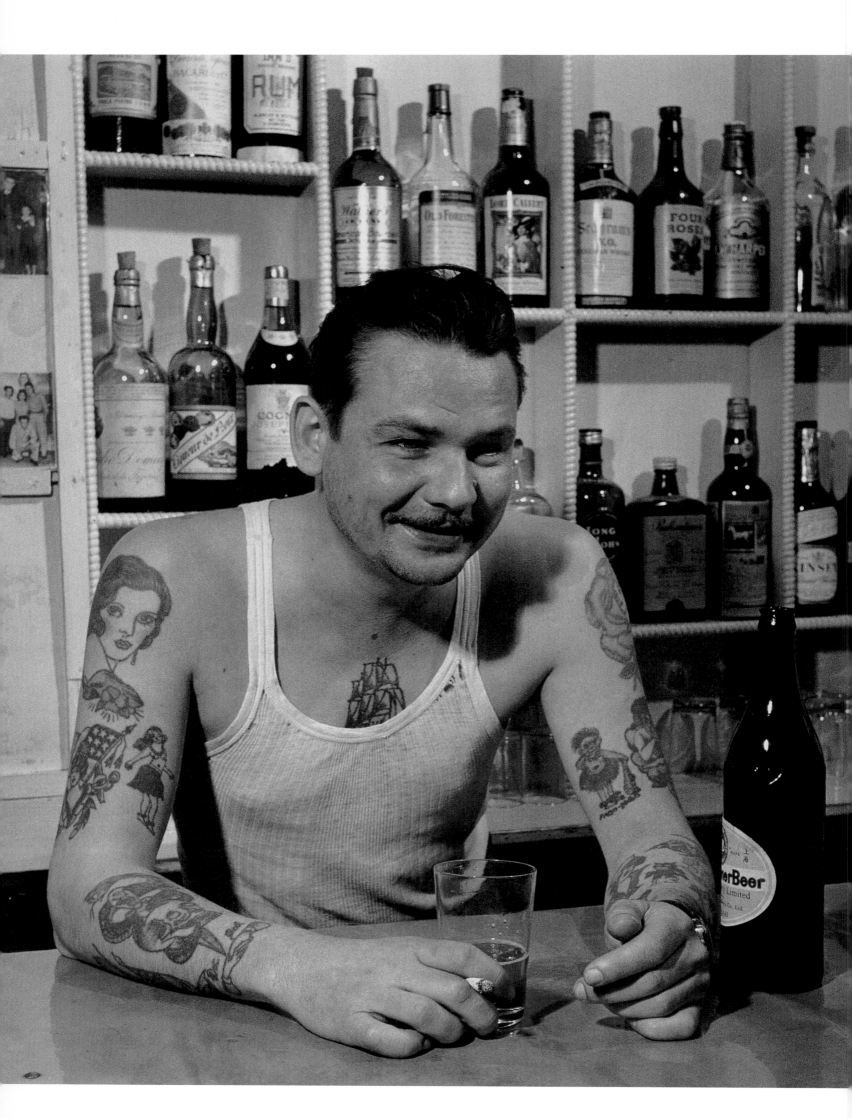

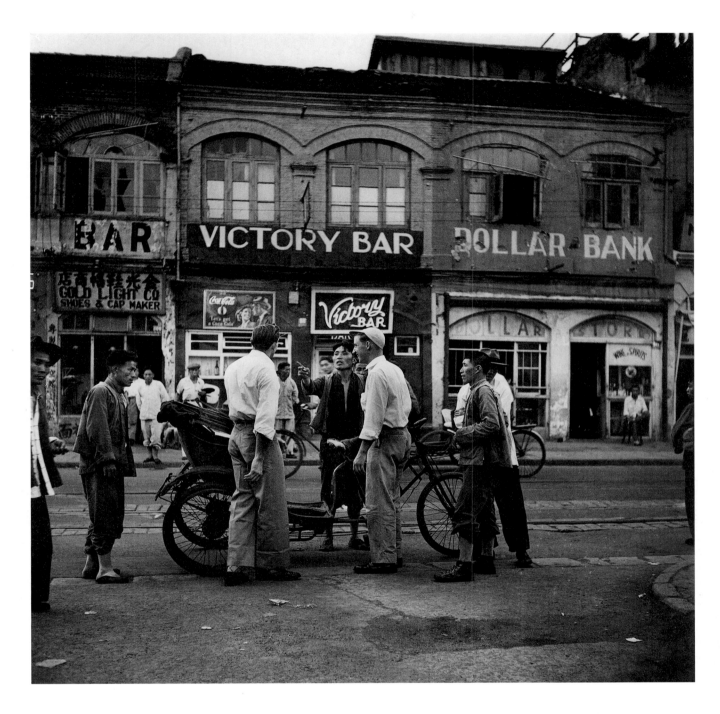

Sailors on shore leave haggle with a
pedicab driver. Shanghai, April 1949.

A former merchant seaman from Chicago
owns and operates the Diamond Bar.
Shanghai, April 1949.

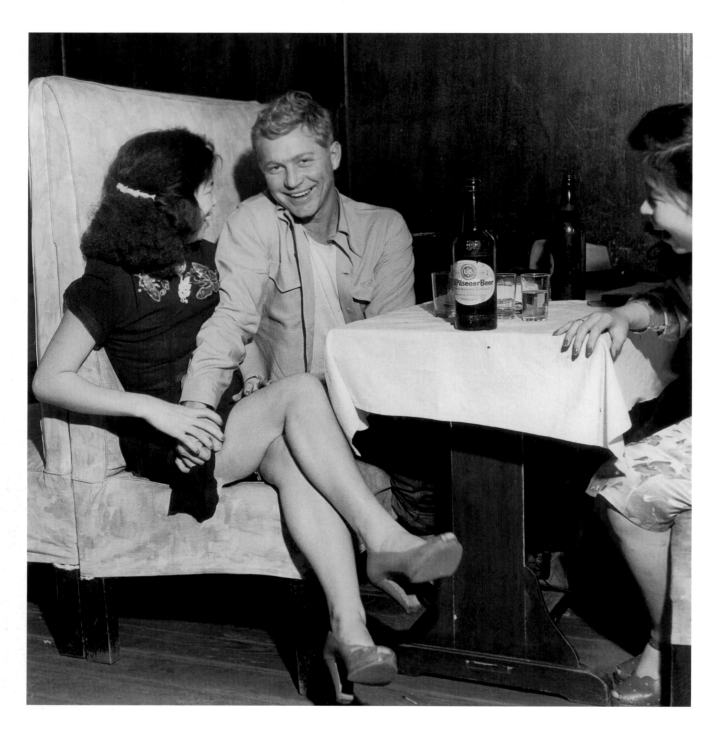

An American sailor enjoys women and beer at
the Victory Bar. Shanghai, April 1949.

Business slows at the Lear Bar. Shanghai, April 1949.

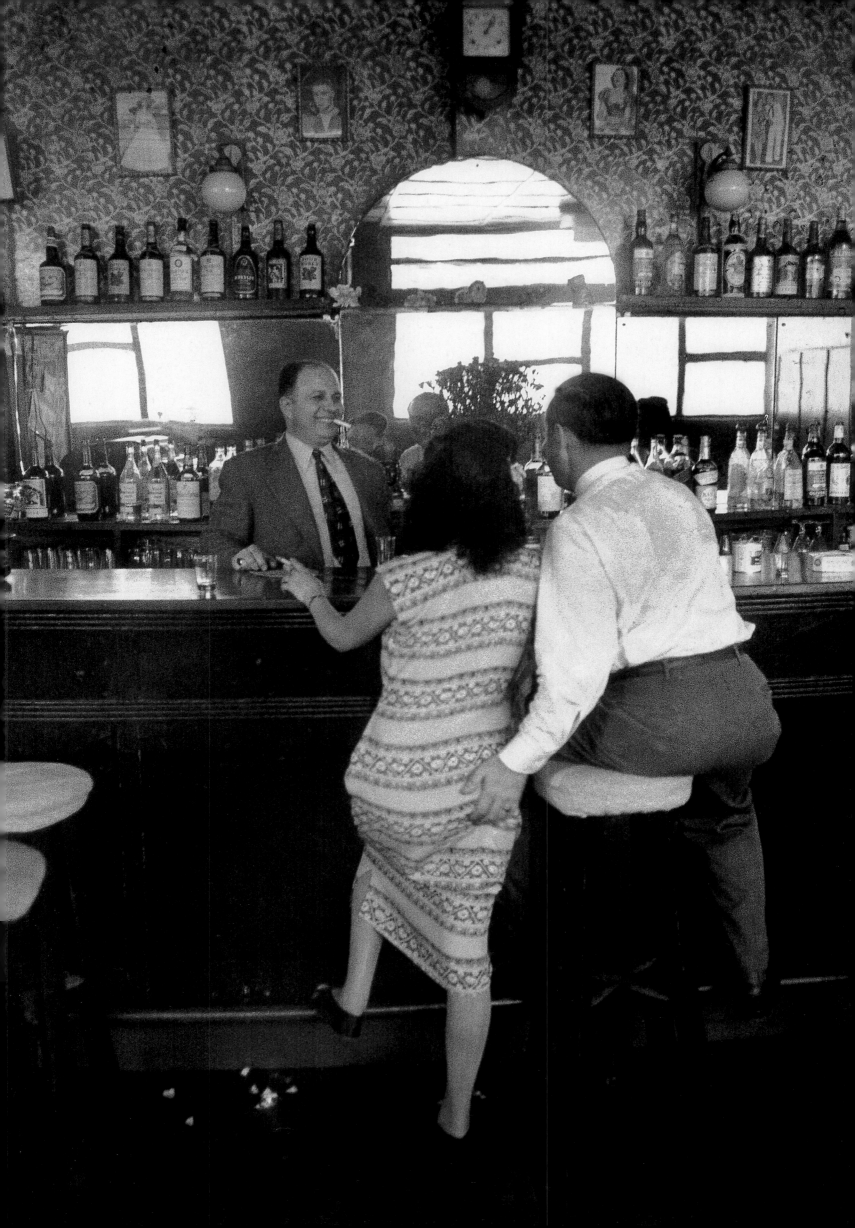

A curfew empties the street outside the Broadway
Mansions Hotel, used as headquarters by the
U.S. Military Aid Group in China (MAGIC).
Shanghai, April 1949.

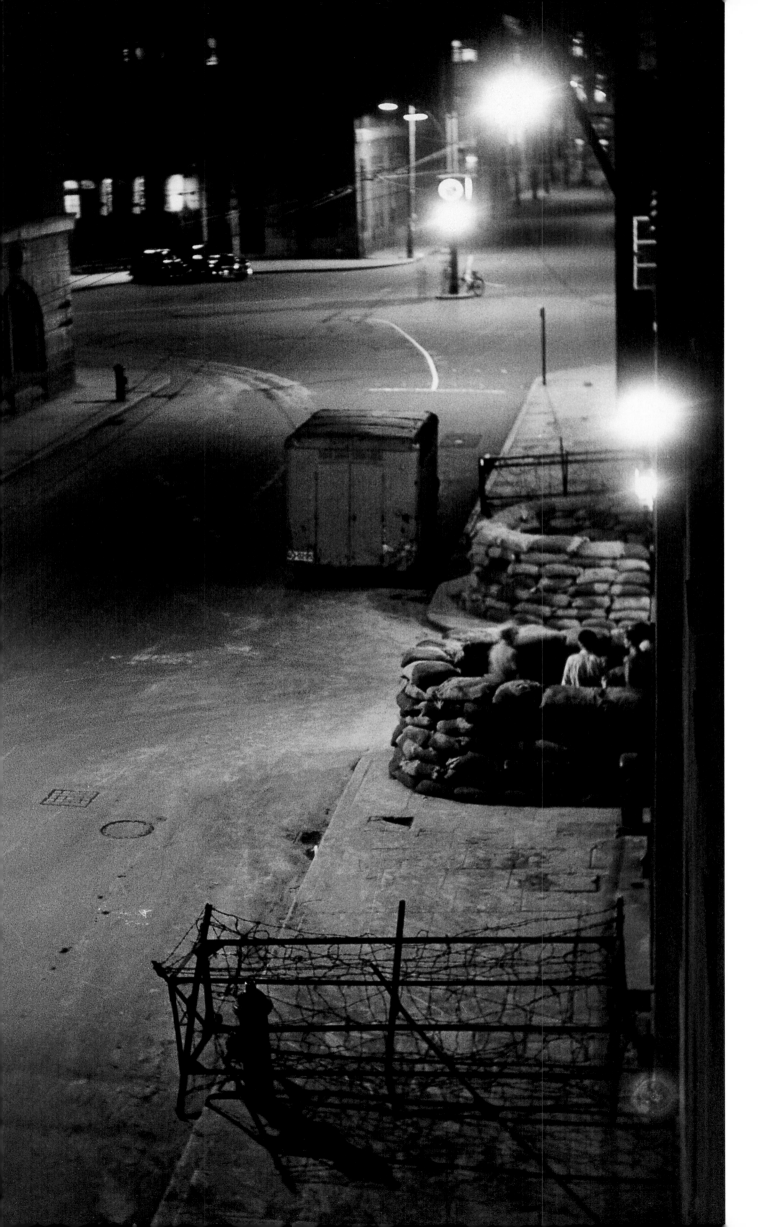

STREET JUSTICE

After mock trials at the central police station on Fuzhou Road, black marketeers and accused Communists are paraded in open trucks to Zhabei Park, behind the railway station, for public execution. Crude punishment fails to deter economic crime or political opposition.

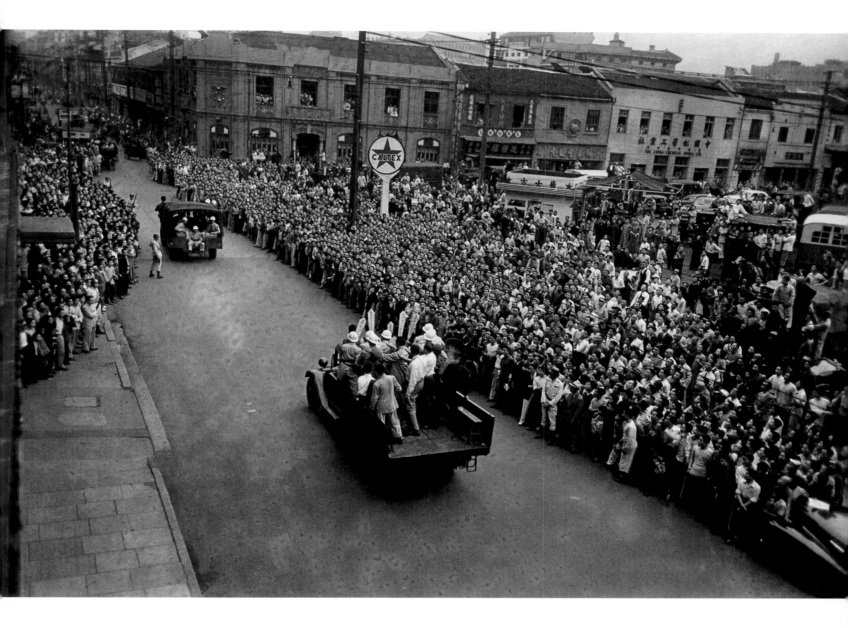

Crowds watch prisoners paraded in an open truck.
Shanghai, May 1949.

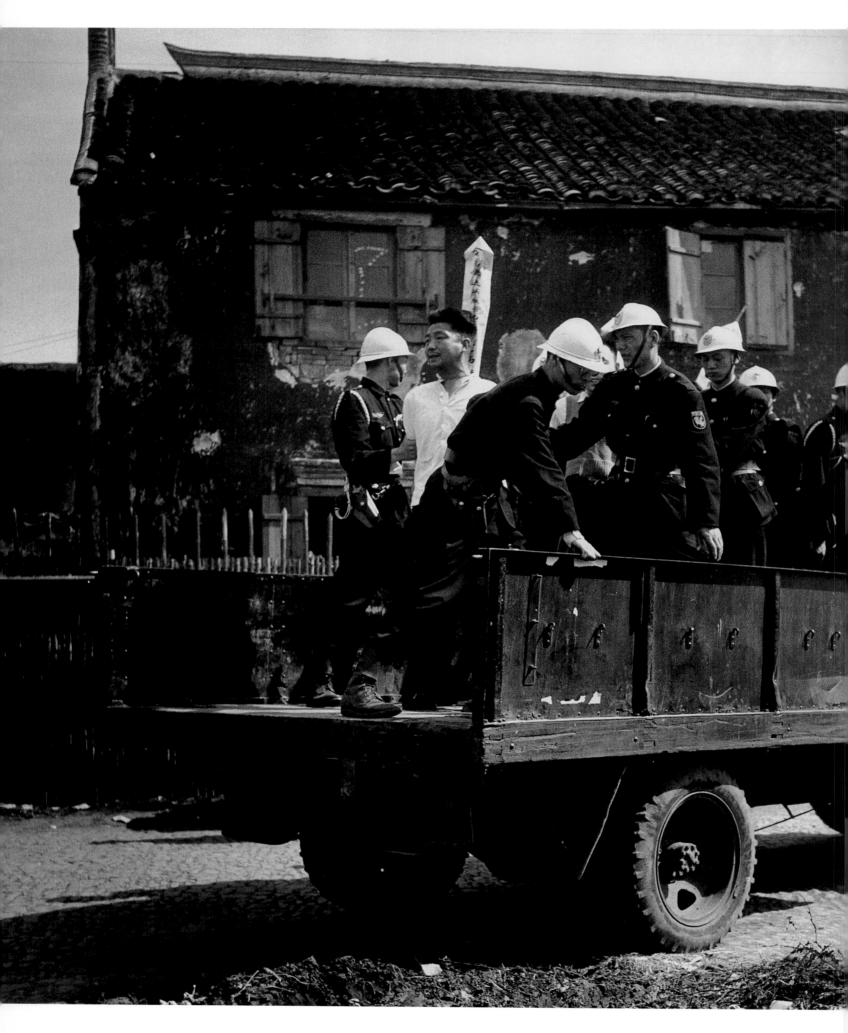

A suspected Communist awaits execution with his
hands lashed behind a paddle listing his crimes.
Shanghai, May 1949.

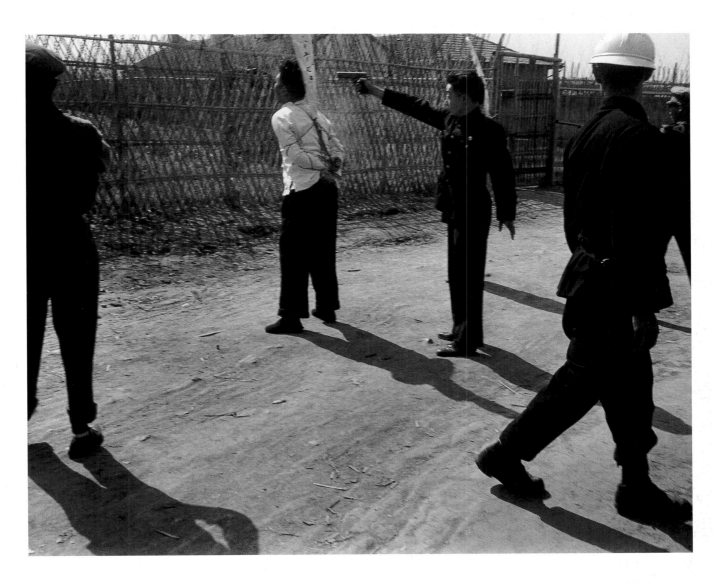

A prisoner is executed with a Colt automatic
in Zhabei Park. Shanghai, May 1949.

A second executioner steps forward with a machine
gun to dispatch another accused Communist.
Shanghai, May 1949.

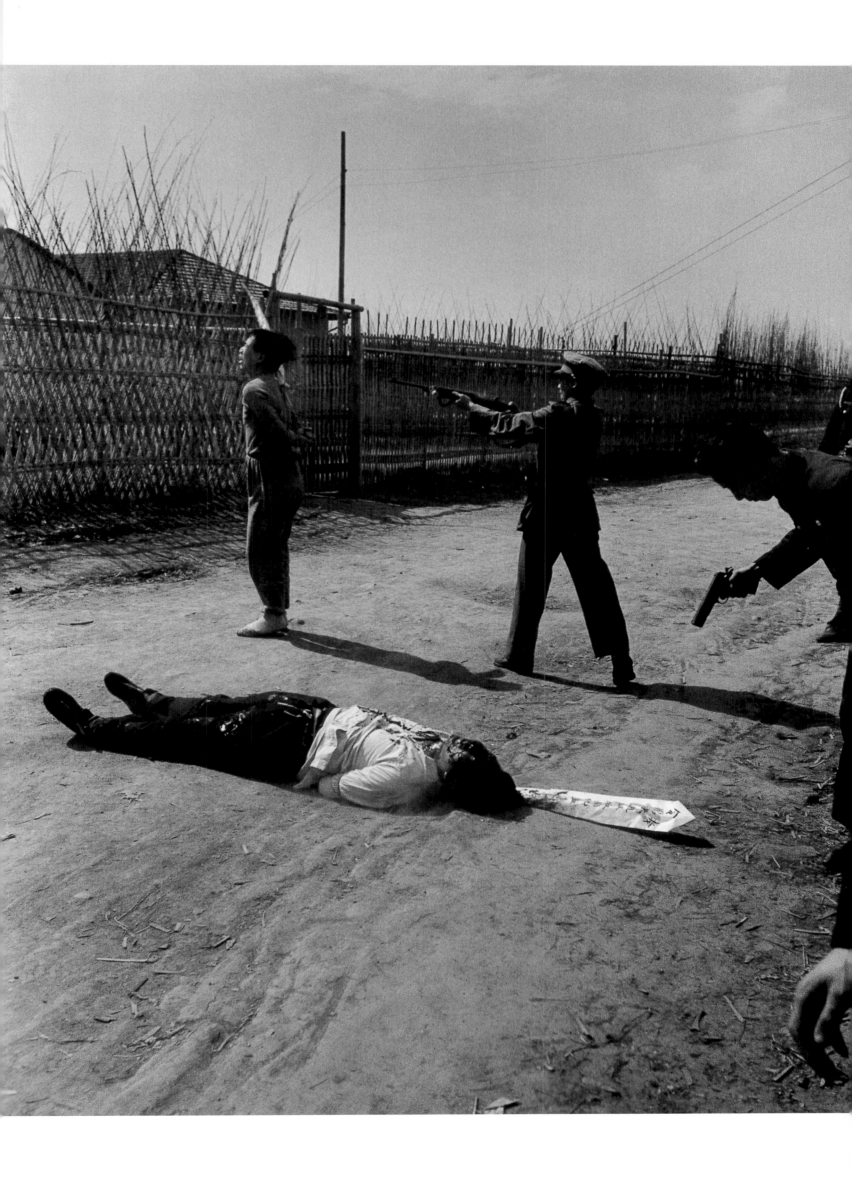

AN ERA ENDING

In a chaotic exodus city dwellers seek refuge in rural areas, even as villagers flock to the city. Amid fears that Shanghai will become a battleground or fall prey to looting and lawlessness, those with cash or connections squeeze onto overloaded trains and coastal steamers, hoping to reach Hong Kong or Taiwan. The Nationalist government calls for the city to be defended to the last drop of blood, and the garrison command razes homes in the prosperous Hongqiao suburb to create an unobstructed field of fire. The People's Liberation Army, unresisted, enters Shanghai near midnight on May 24, 1949.

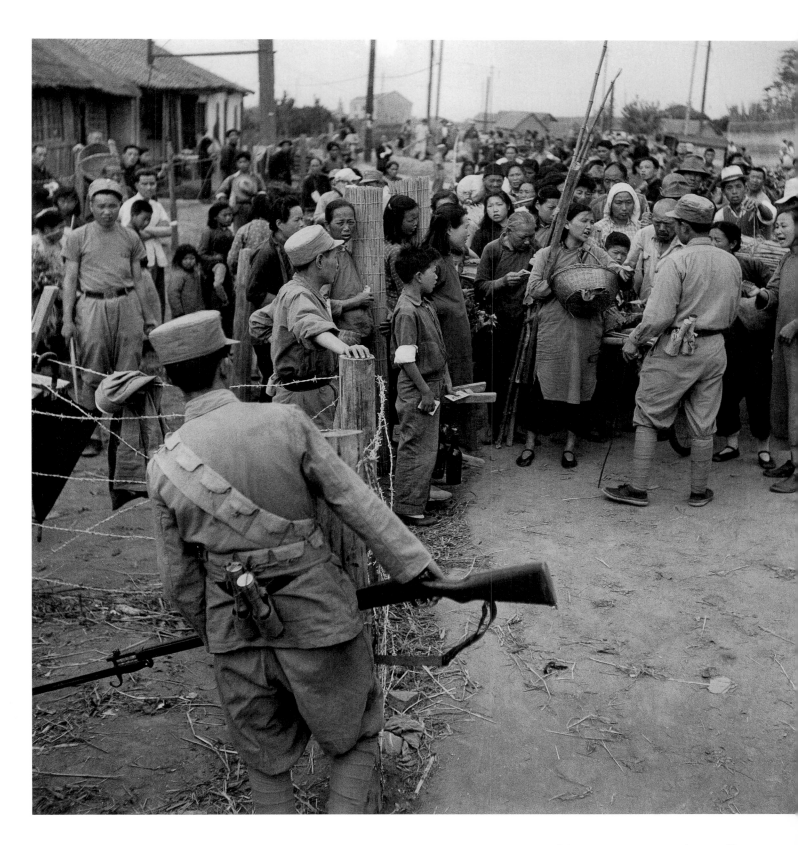

Soldiers with bayonets prevent farmers selling
produce from entering the city. Shanghai, May 1949.

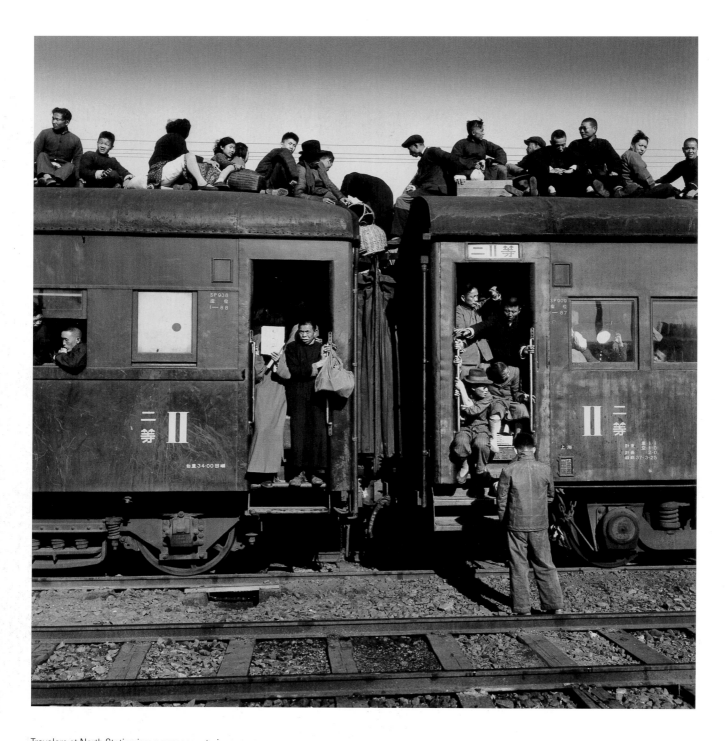

Travelers at North Station jam a passenger train.
Shanghai, March 1949.

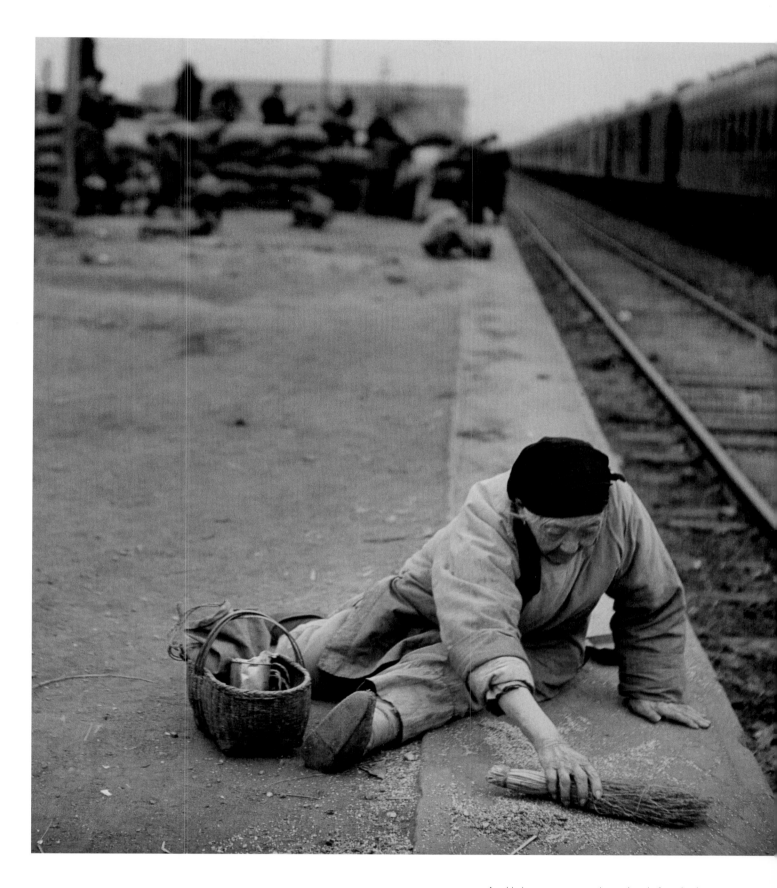

An elderly woman sweeps the station platform, hoping to find grains of rice or bits of coal. Pukou, November 1948.

OVERLEAF Passengers find a precarious foothold on the locomotive of a southbound train. Shanghai, March 1949.

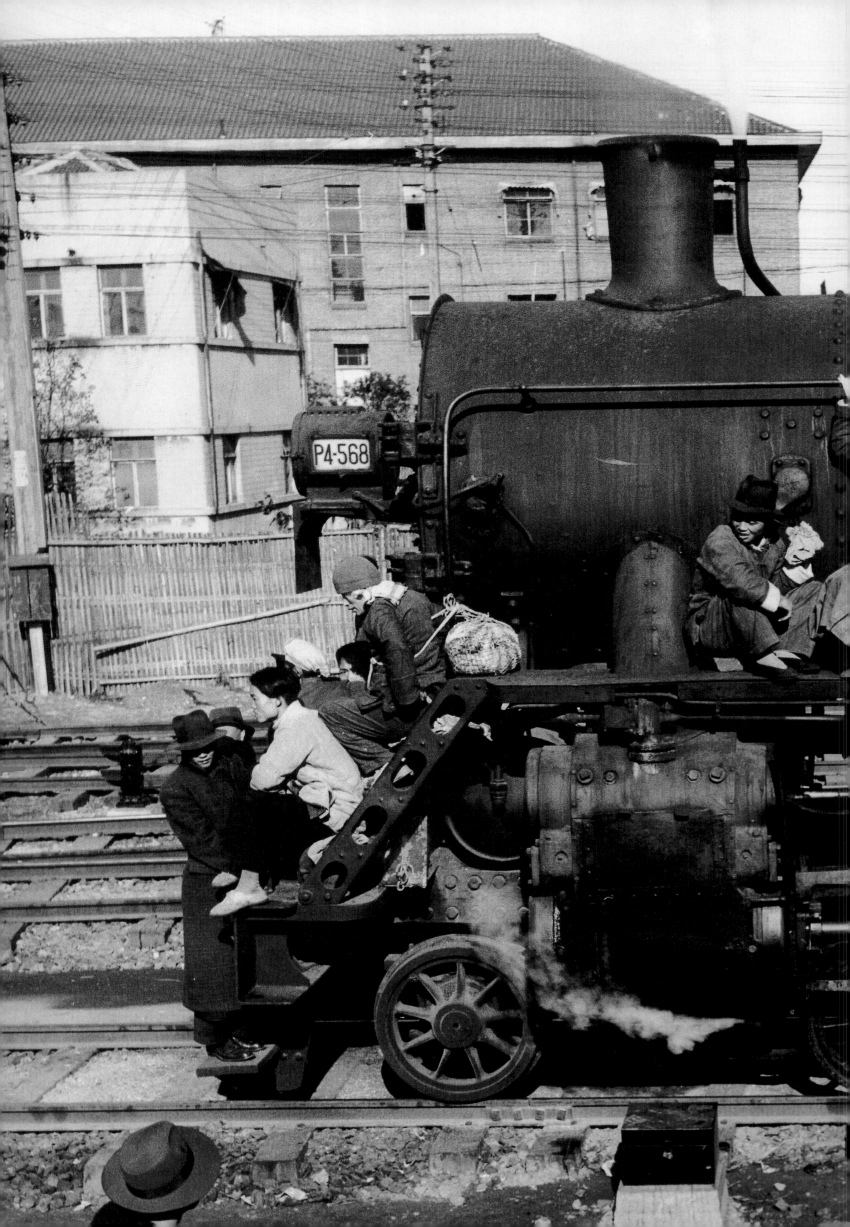

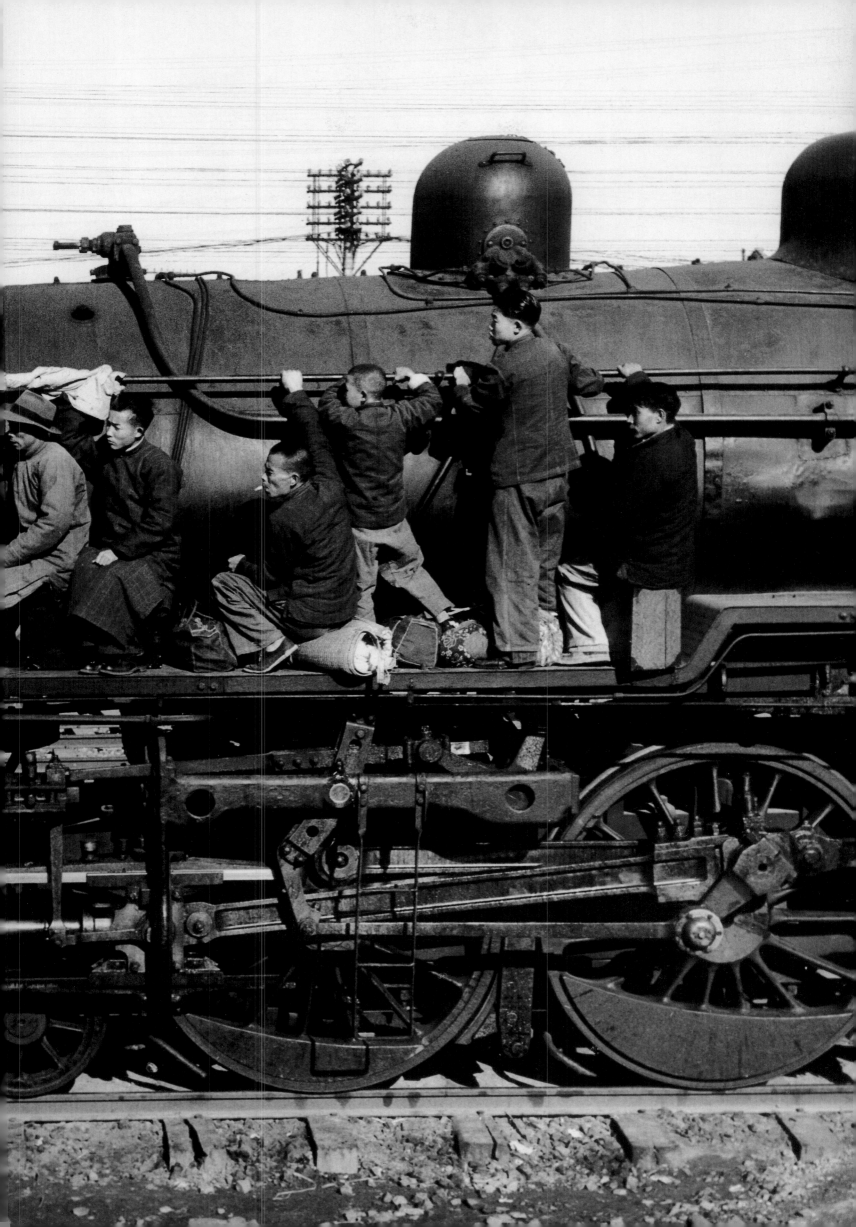

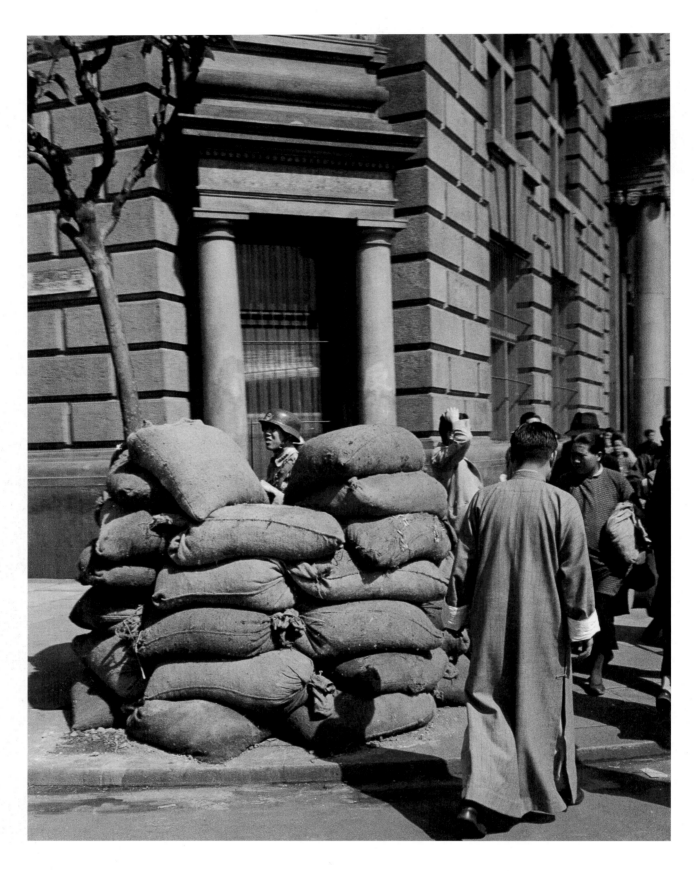

Pedestrians eye the sandbags protecting
commercial buildings. Shanghai, May 1949.

Workers secure shop windows against expected
looting and siege. Shanghai, May 1949.

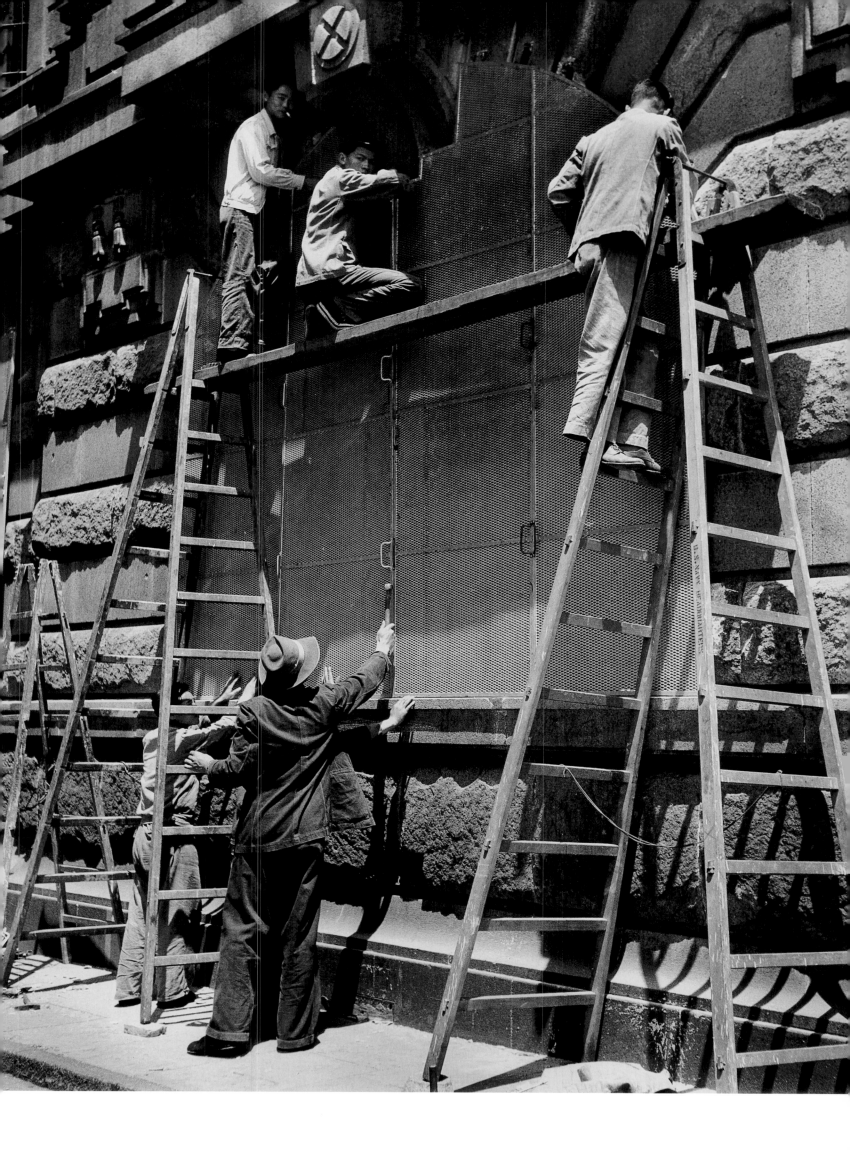

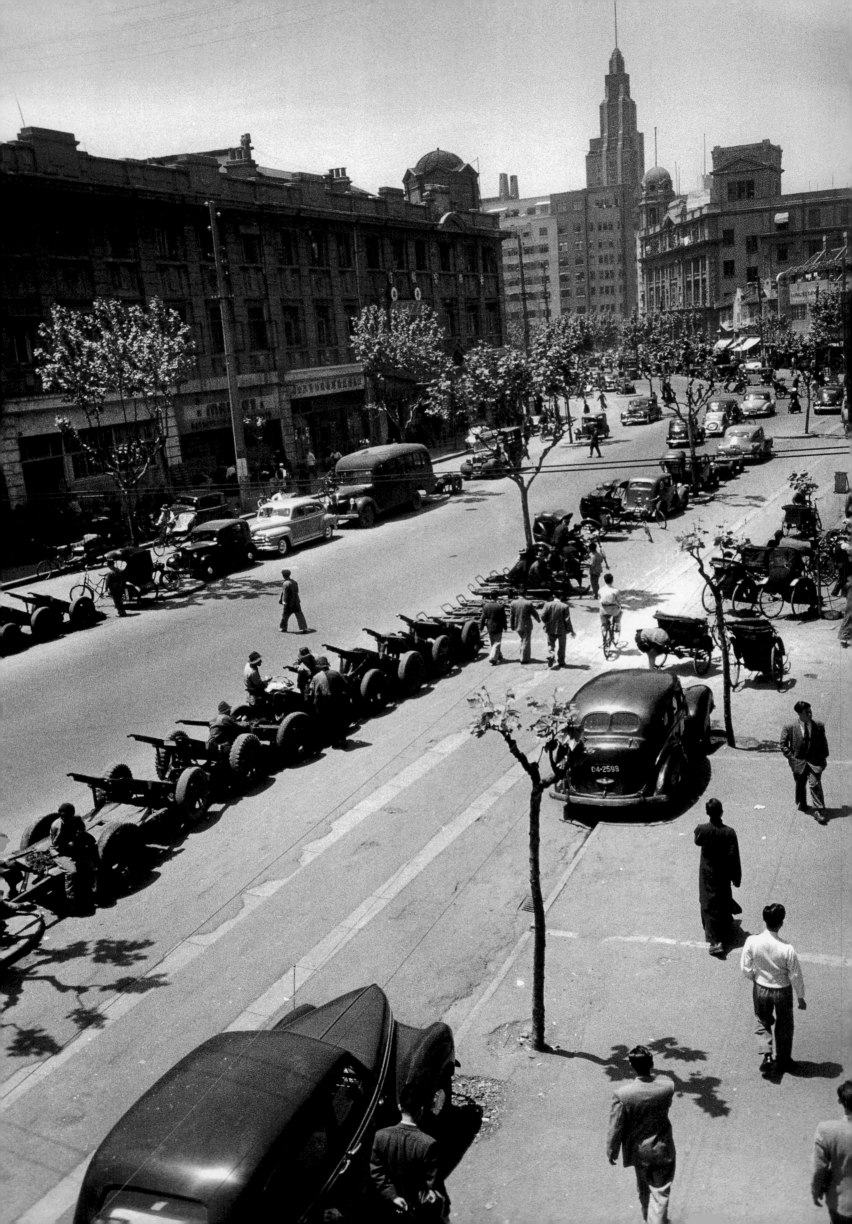

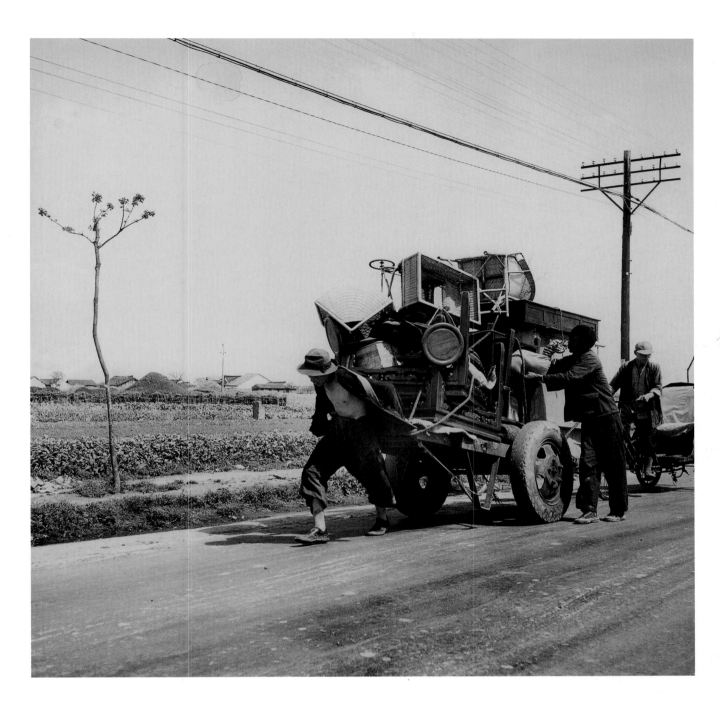

A villager hauls his possessions toward the city.
Shanghai, May 1949.

Handcarts and pedicabs stand idle as the
city empties. Shanghai, May 1949.

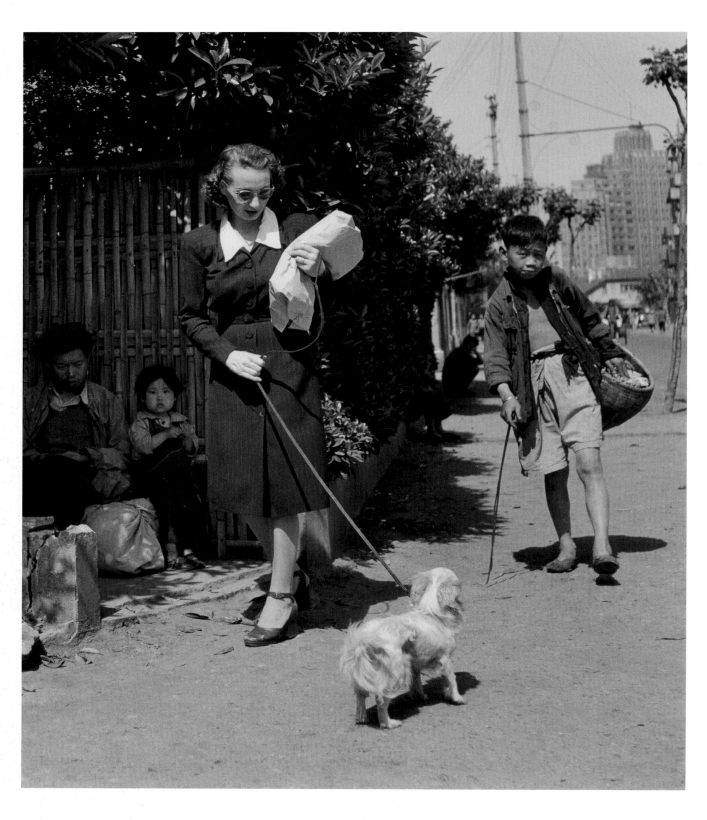

A European woman walks her dog in
the French Concession. Shanghai, May 1949.

Foreigners relax after tennis as the Communists
draw closer. Shanghai, May 1949.

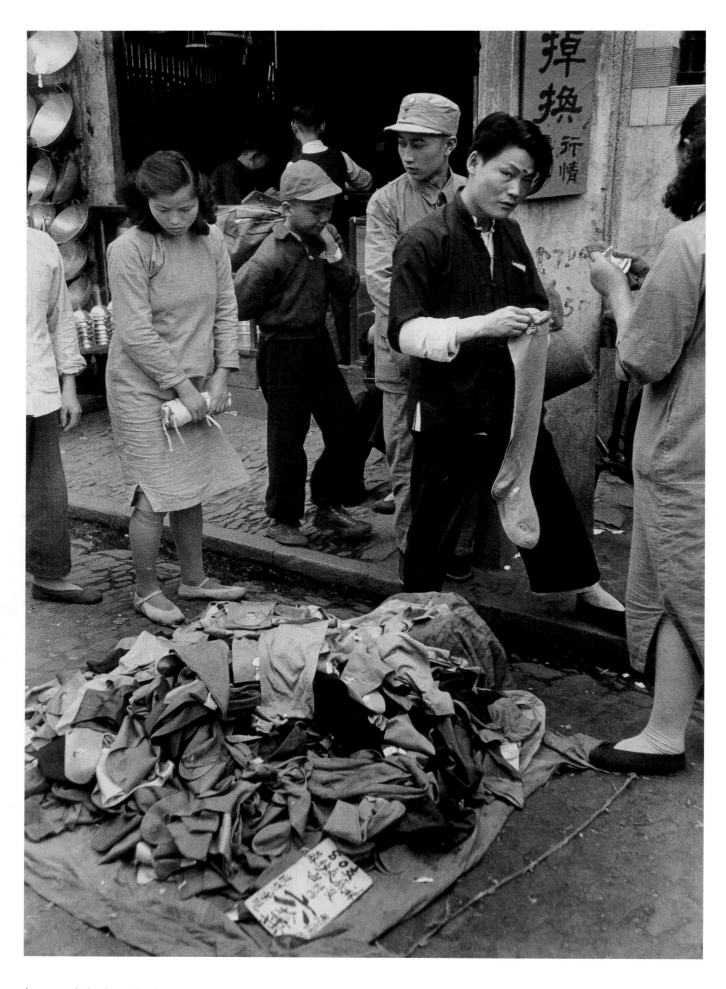

A street vendor hawks merchandise at a
cut-rate price. Shanghai, May 1949.

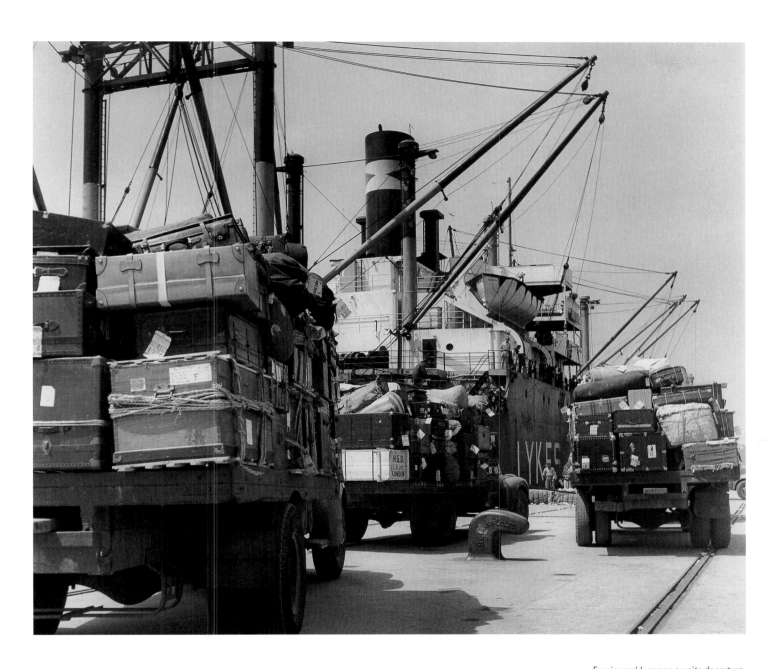

Foreigners' luggage awaits departure.
Shanghai, May 1949.

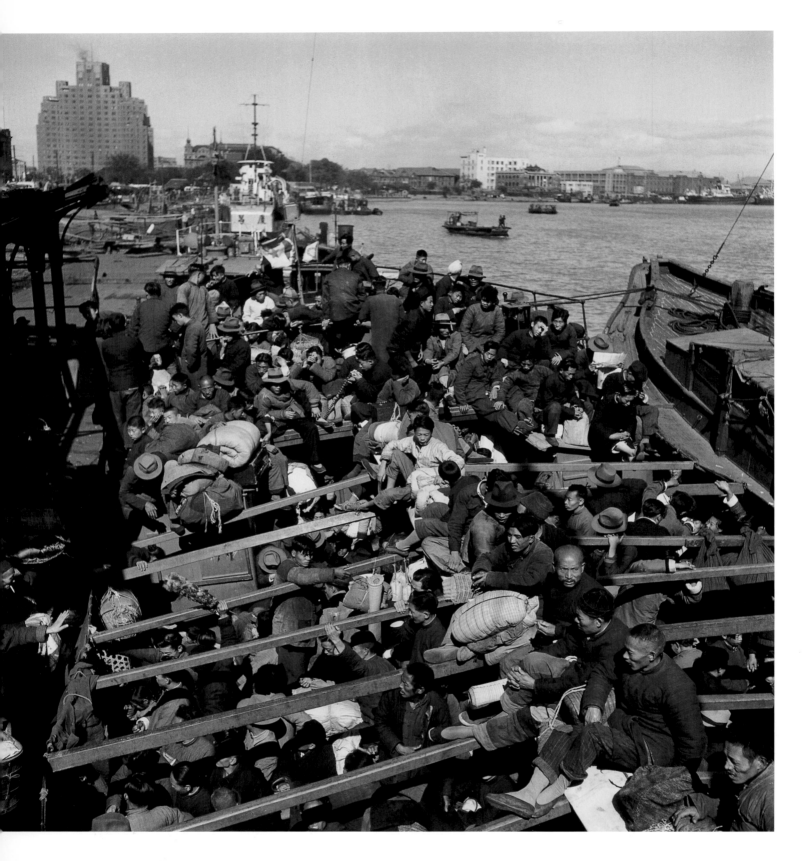

Passengers with parcels and bedrolls crowd the
deck of a former U.S. Navy supply vessel bound
for Ningbo. Shanghai, November 1948.

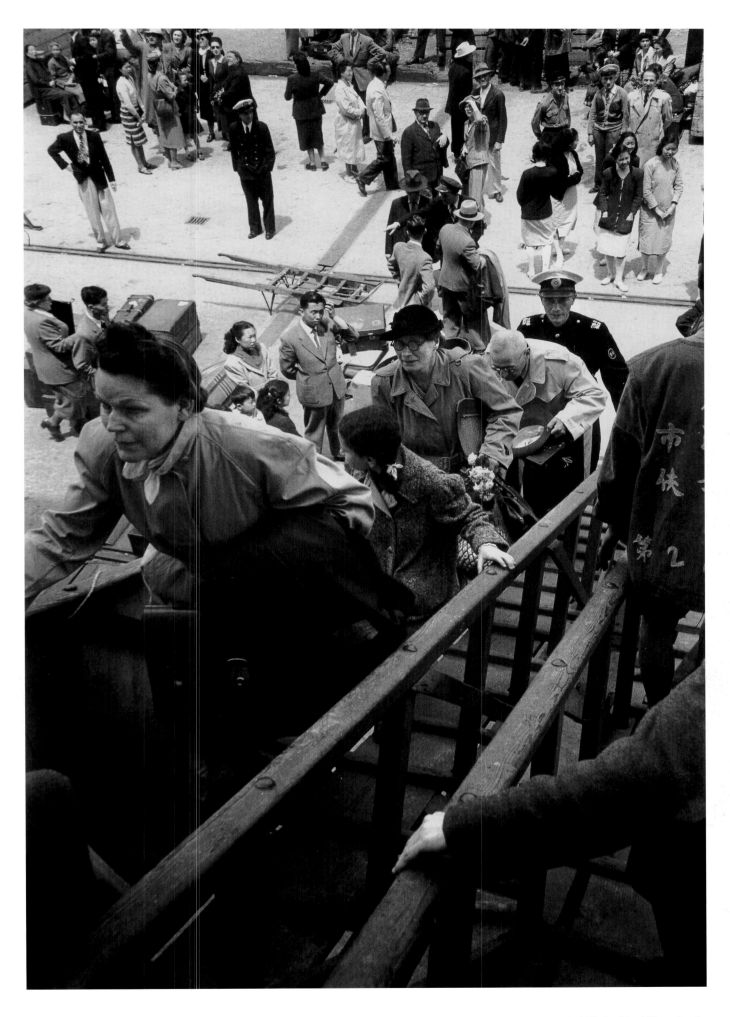

Foreigners board the USS *President Wilson* after the
Communists take Nanjing. Shanghai, May 1949.

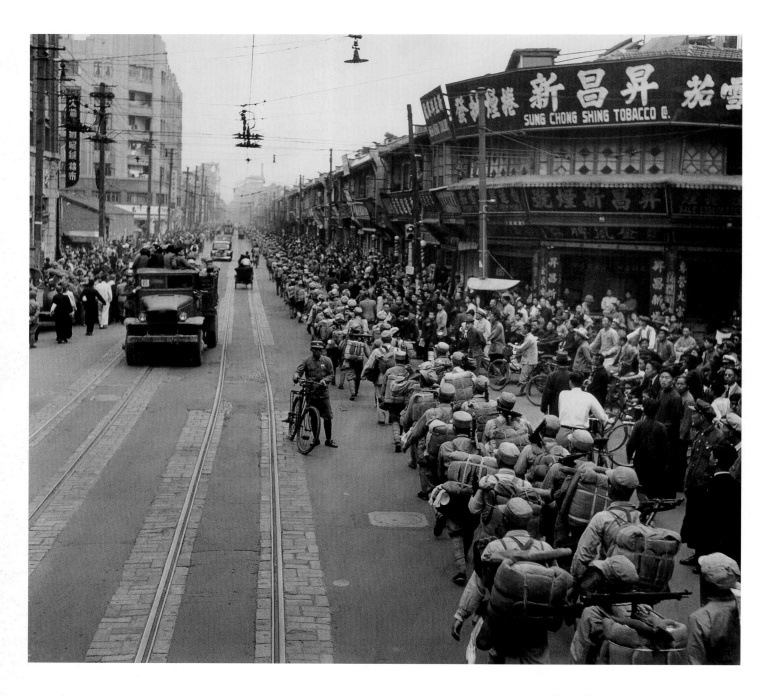

Nationalist troops parade through the city in a
show of force. Shanghai, May 1949.

Political prisoners under guard dig zigzag trenches to
stop the Communist advance. Shanghai, May 1949.

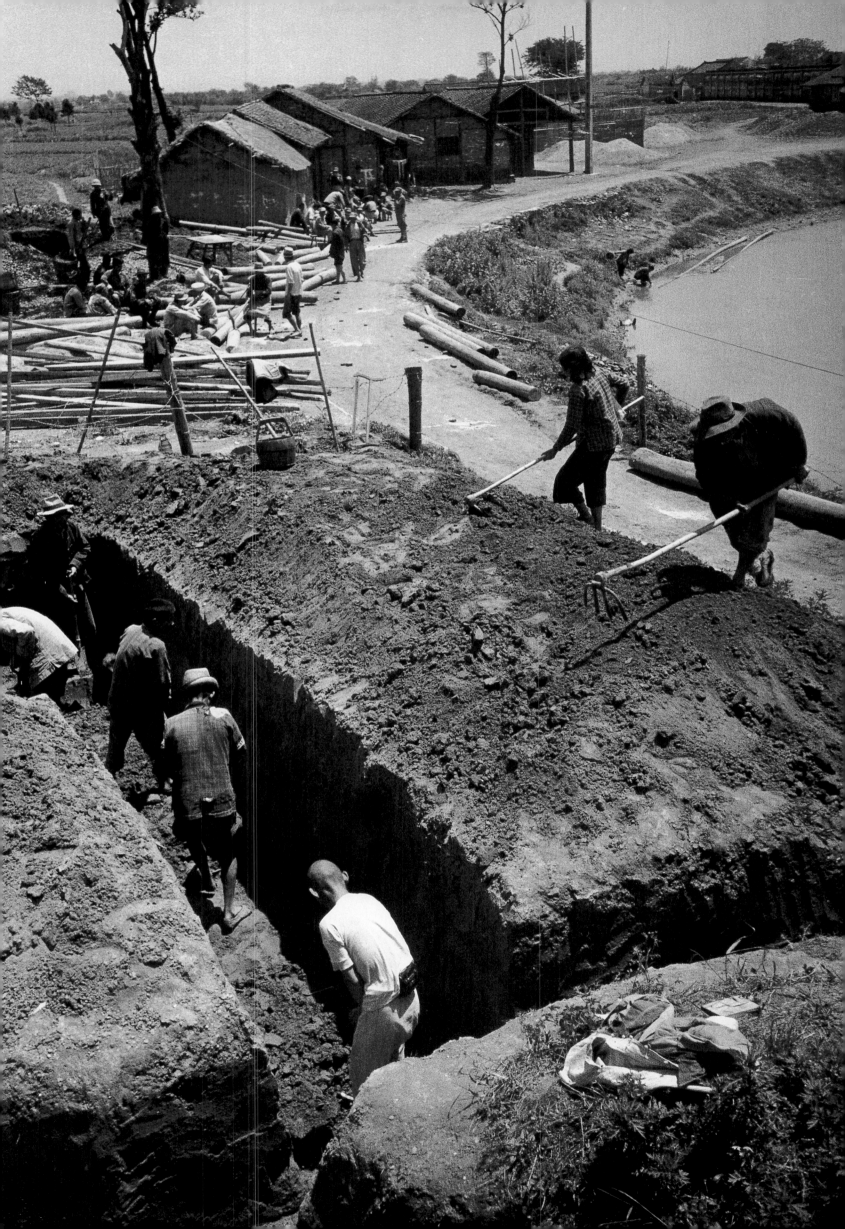

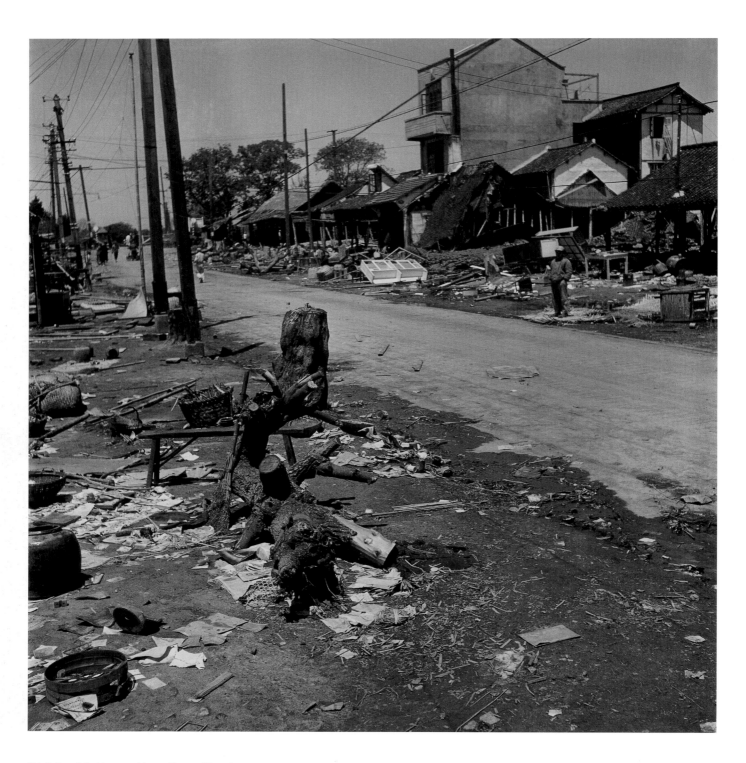

Debris from felled trees and burned homes litters the
wealthy Hongqiao suburb. Shanghai, May 1949.

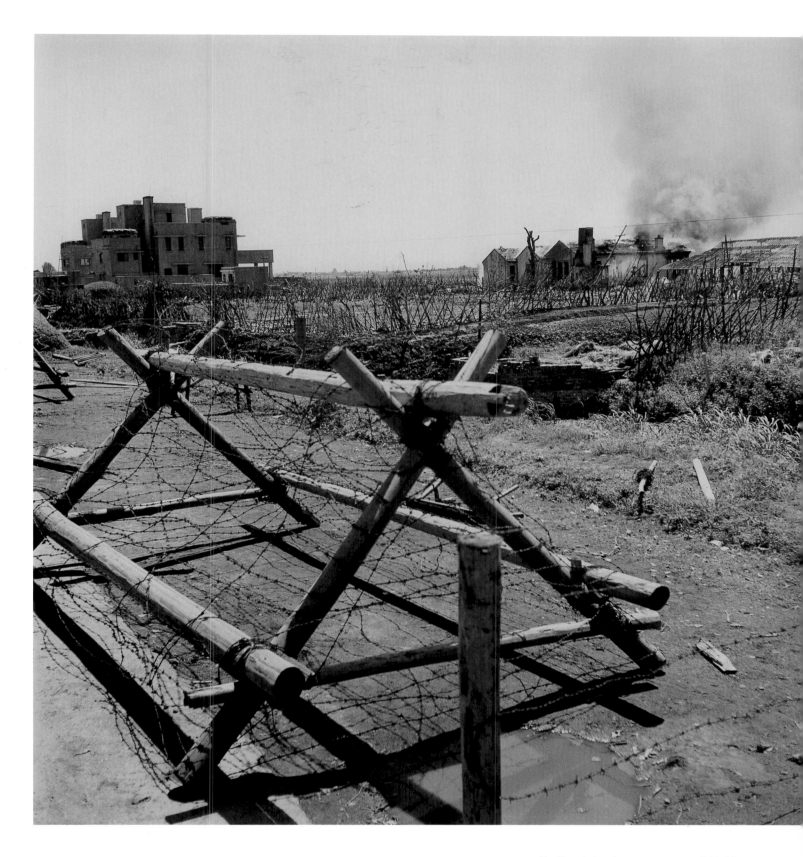

The Shanghai garrison creates an open field of fire.
Shanghai, May 1949.

Sampan dwellers slip their moorings, seeking safety away from the shore. Shanghai, May 1949.

OVERLEAF Loaded carts clog city streets in a chaotic exodus. Shanghai, April 1949.

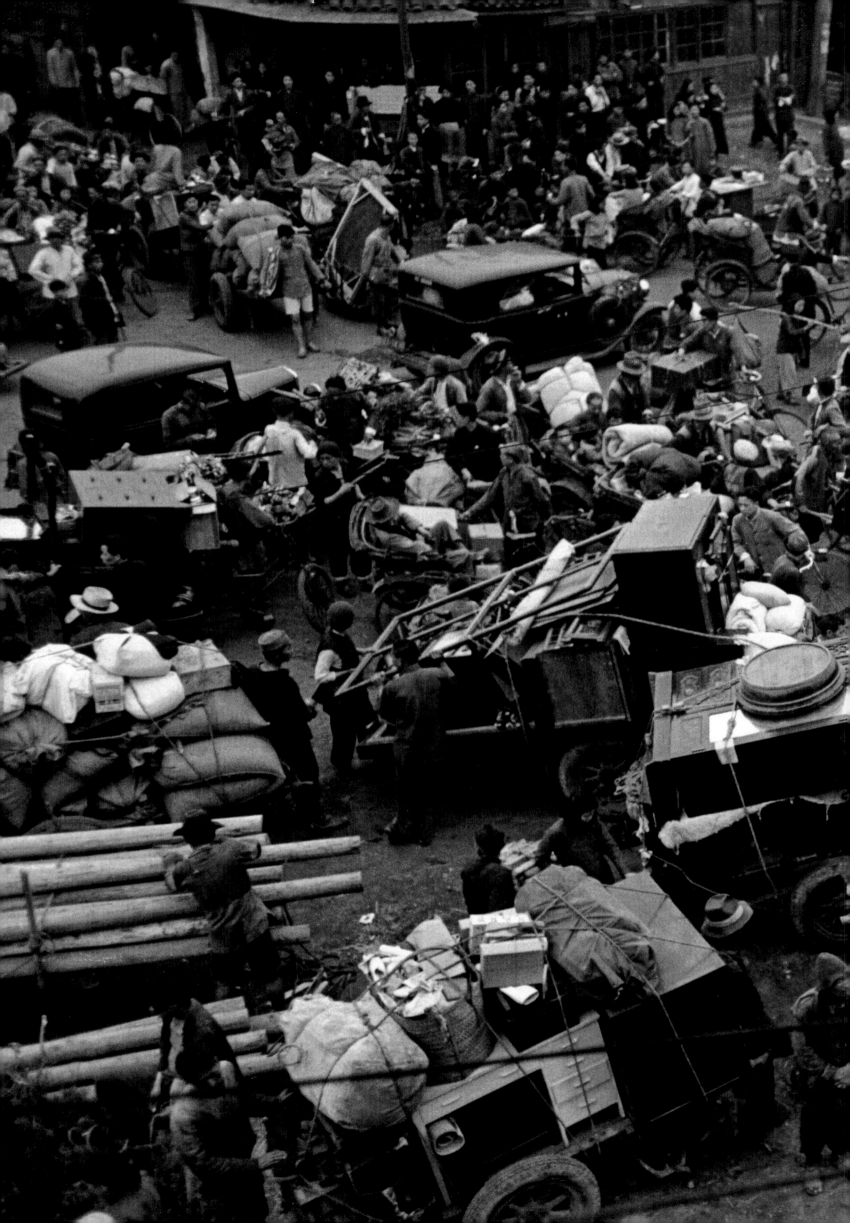

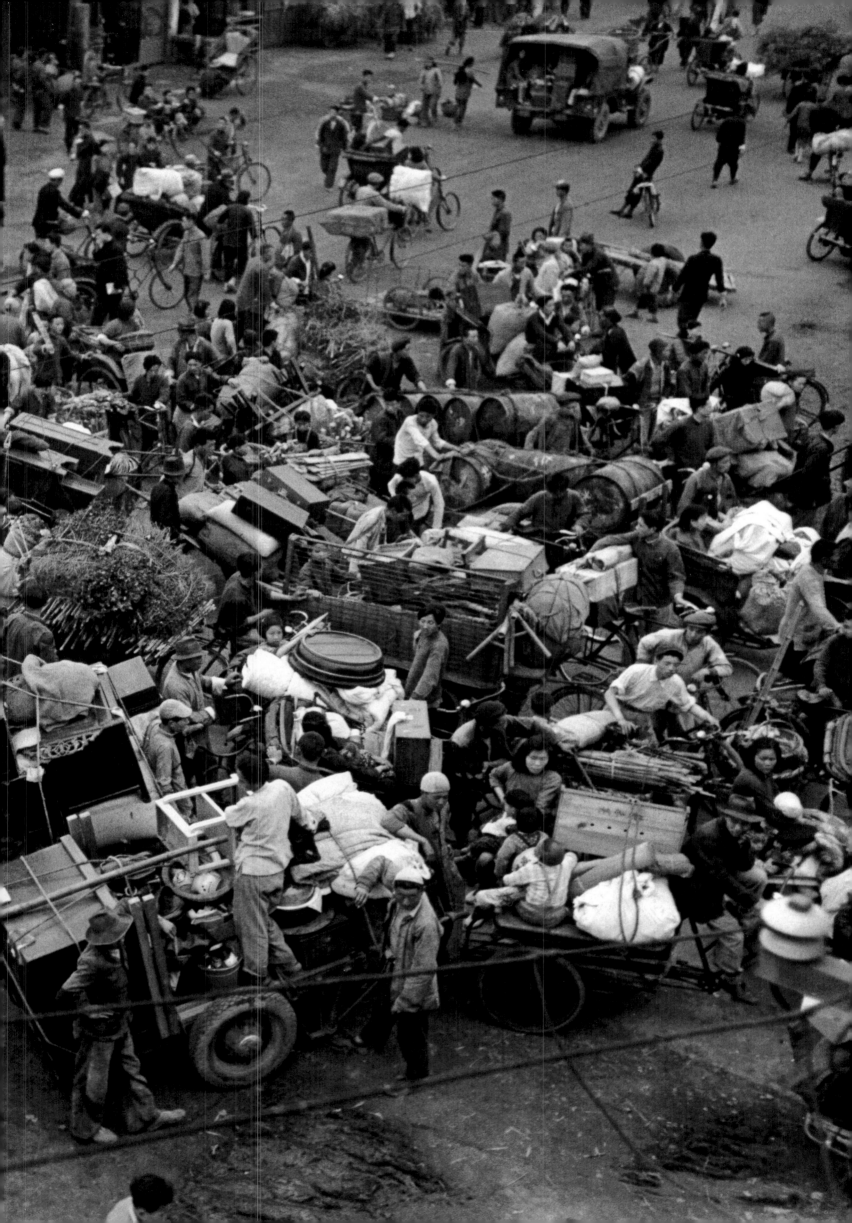

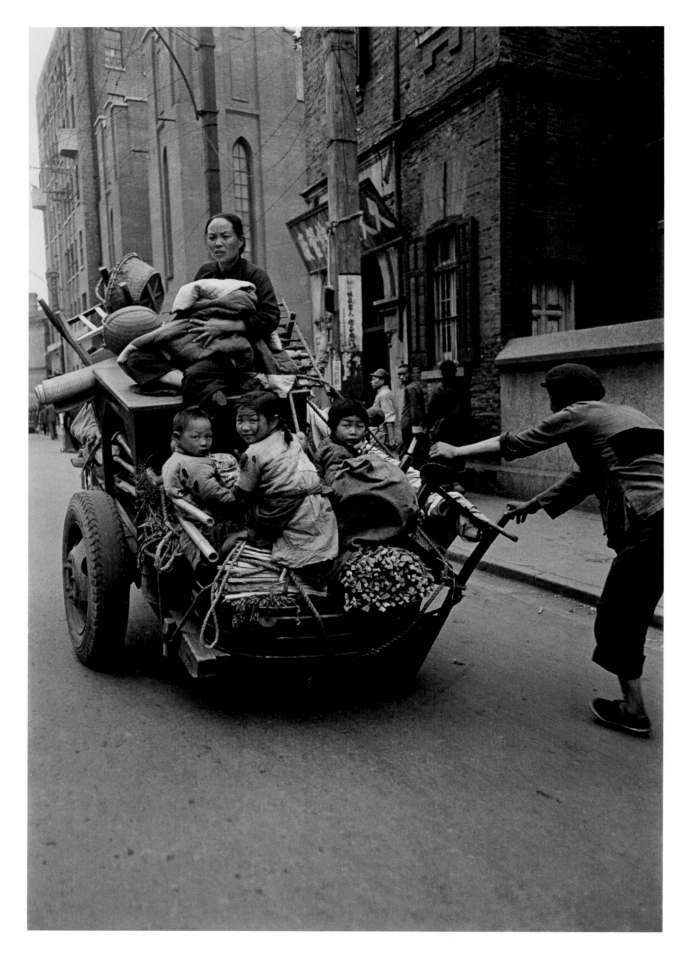

A family in flight. Shanghai, April 1949.